HORSES

INTRODUCTIONS BY
JANE SMILEY AND WILLIAM H. GASS

ALFRED A. KNOPF

NEW YORK 2004

HORSES

PHOTOGRAPHS

BY

MICHAEL

EASTMAN

This Is a Borzoi Book
Published by Alfred A. Knopf

Library of Congress Cataloging-in-Publication Data

Eastman, Michael, [date]

 Horses / photographs [by] Michael Eastman. — 1st ed.

 p. cm.

 ISBN 0-375-41468-1 (alk. paper)

 1. Photography of horses. 2. Horses—Pictorial works. I. Title.

TR729.H6E24 2003

779'.3296655—dc21 2003052931

Manufactured in Italy

Published October 11, 2003
Second Printing, March 2004

To my wife,

Gayle,

the love of my life,

and

in memory of my father,

Leonard A. Eastman

INTRODUCTION

There are plenty of reasons that photographing horses looks easier than it actually is. One of these is that horses are both inquisitive and observant. Invariably, they want to get close to the camera and inspect it. The natural, affecting, and graceful attitudes that they produce unself-consciously when we are just standing about with them vanish when we bring out cameras. Ears flop, noses get into the camera lens, energy subsides into lethargy, beautiful equines turn into nags on film. Compounding the problem is the history of equine art, which is as long and ancient as art itself—some of the first representations by humans are of horses, on the walls of the caves at Lascaux. Representations of horses proliferate in the art of nearly every culture except the pre-Columbian Americas, horses of every type, depicted in every attitude. It is easy to feel that horses are trite. Horses are simple. Horses have not changed.

It is true that horses are perennially mysterious. Their thoughts and feelings must be inferred. Their faces, especially, are enigmatic, since their facial expressions are not at all like ours. As my years with horses accumulate, I find myself shifting my focus from one feature to another. I used to be fascinated with their eyes, so dark and luminous and expressive, or their ears, such a sensitive gauge of mood and intention. Lately I have been gazing at their lips. Horses' lips, of course, are exquisitely utilitarian, since they serve in part the way our fingers do, to test and manipulate small items in their environment. With his lips, a horse investigates his grazing, moves things around, gets into trouble. Stabled horses often become adept at opening locks and latches with their lips. But their lips are also expressive. If their eyes give us a sense of their characters and their ears give us a sense of their reactions and intentions, then their lips, sometimes wrinkled, sometimes smooth, sometimes firm, sometimes relaxed, give us a subtler sense of their passing thoughts, notions they might not act upon but that are nevertheless present.

Horses' bodies are a paradox of large and small. At a thousand pounds, or thirteen hundred, or sixteen hundred, they often have imposing heads and shoulders and haunches, shining silky coats, odd cowlicks, long graceful tails. Lately I have been looking at their feet—the architectural clarity of the hoof, the pastern, and the fetlock joint. Though the hoof is a living thing, made of horn and bone and tissue, delicate in many ways, and full of joints, it is hard and shell-like, or even stonelike, a foundation as sturdy as the foundation of a house. But it is as graceful in its way as the hands of a ballerina.

Michael Eastman's photographs of horses invite this sort of browsing and reflection. His techniques of lighting and printing highlight features of his subjects in a fresh way that is not trite and

not simple. He captures momentary flashes of equine personality in a way that grows only out of painstaking concentration and lengthy relationship to the animals he is photographing. This is readily apparent in Eastman's portraits of the horses' faces. On page 9, for example, the lighting makes the molding of the face almost palpable and permanent, like that of a sculpture, especially in the shining hollow above the eye. Equally evident, though, is the passing expression—the ears are at half-mast, the eyelid is relaxed, the mouth is quiet and self-confident. This is not just a representative horse, but an individual horse at a particular moment. This is a true portrait.

Light is Eastman's drawing pencil. In the photograph on page 25, a dark-colored horse is turned toward the sun, and the light etches the outline of his nostril, his upper lip, his eyelid, his eyelashes, and the strands of his forelock as they blow across his forehead. Against the blur of his side and the vapors of the background, the individual hairs on his face are distinguishable, as are the longer hairs under his jaw. In the photograph on page 42, light is used to make a gray horse glow against the landscape, as if he were about to float off the flat plane of the picture toward the viewer.

Not every photograph is a portrait—some are dramas. On page 7, two horses are engaged in a dispute. The great arc of the near horse's body and tail sets off and encompasses the frightened face of the other horse, especially the tiny dot of the white of his eye and the pale glint of the teeth between his parted lips. By contrast, the portrait on page 139 is one of intimacy. One horse, dark, bends down to scratch his leg with his teeth. His light-colored friend lowers his head, too, a look of affection—closed nostrils indicating gentle breathing, relaxed ears, a soft eye—readily apparent.

It is easy to take the beauty of horses for granted—almost every healthy horse offers some voluptuous curve or elegant line to the eye of the viewer. Many horses never have an unbeautiful moment, never make an awkward movement. We accept that it is in their natures to inspire our admiration. But stripped of movement, rendered two-dimensional, still, and silent, they often lose a dimension of their presence. Rare, indeed, is the photographer who startles us anew with a fresh revelation of so familiar a beauty. Nevertheless, look at page 33, at the dark eyes of a gray horse gazing over his stall guard, the fine hairs of his forelock so bright that they almost give off light, or at page 104, a black horse in a field of flowers, the planes of his body rendered with precision by the reflection of sunlight on his coat.

Best of all, Eastman allows his subjects to regard him. The photograph on page 49 catches that sudden glance every horse lover has seen—Who are you? What do you want with us? But my favorite is on page 47. The horse is quiet and confident. Eastman has caught the elegant beauty of his eye, his profile, his cheek, the smooth shine of his coat, even the cowlicks on his chest. The horse, though, with his ears and his eyes, has observed his observers and reminded us that horses are not just creatures in our universe, to be done to or feared or admired, but that we are no less creatures in theirs. Our opinions are matched, in the end, by those they have of us.

There are 118 photographs here. They have remarkable texture and movement. They portray individuals and groups. They are strange—not like any other horse photographs we have seen, possibly because they do not portray the horse as a useful animal, doing a job and posing prettily in a green landscape. Like the cave drawings in southern France, what they portray is "horseness"—would that be called "equinity"?—eternally elusive and inspiring.

—JANE SMILEY

MICHAEL EASTMAN'S HORSES

These are quite ordinary horses. Riders rent their backs. Owners board them out. They never race. They occasionally run, or roll in the dust. They graze, commingle, grow curious together, sometimes huddle. They do not prance, parade, or join sheriffs' posses. The gods do not saddle them. They do not fly through the sky on magical missions or bear ladies clothed only in manes and tresses. They are friendly but wary, so if you wish to photograph them, you must move with slow deliberation, as confident and composed as you intend your picture to be, avoiding any sudden gestures that may startle them. If you seem safe and familiar, they are likely to nose your nose, and that's too close for the camera. If you alarm them they whisk off in a kickup of dust. Even standing still, their muscles twitch, their tails flick, and light slides like water down their flanks.

It will not be wise to try to win the horses' affection by plying them with treats. They will merely crowd around your hands when your hands should be serving the camera. Then they will offer you only two attitudes—expectation and disappointment—and toward one another they are likely to be snappish. You must be of only casual interest—in effect, not there. So you must be present often enough to earn indifference and in that way disappear.

It is difficult to observe horses with a clean and honest eye. They have lived too long in human history, become familiar with our hunting habits, sometimes survived our fondness for war, served our love of travel, assisted with the cultivation of our crops, offered companionship, given their lives. Horses are myth and movie stars, the objects of syrupy affections, and are consequently as difficult to photograph as sunsets, babies, pets, and motorcars. They have had to pose for painters at an oat an hour, and our parks even now endure the arrogant generals they have had to rear up and pretend to snort for.

No other creature, apart from man, has a more frequent presence in song and story. Shakespeare's references to horses, as recorded in Alexander Schmidt's *Lexicon*, are longer by an inch than that for dogs. Dogs hunt, warn, fawn, but horses have been the autos of the ages. In Shakespeare we encounter the "horse of a different colour." At the right moment, a horse can be worth a kingdom. They still measure speed when we want to flee "as fast as a horse can carry us." Trucks may be faster or more powerful but horses are under their hoods. Oftener than male characters go to women, they "go to horse." Horses were also a gauge of military strength since we once asked, weighing the risks of war, "How many horsemen the Duke is strong . . ."—and, indeed, of prosperous achievement itself we bragged that we "were manned, horsed, and wived." In one of *The Tempest*'s many great moments, Ariel

describes for Prospero's benefit the drunken behavior of three craven varlets (Caliban, Stephano, and Trinculo) by invoking not quite as many animals as took passage on the ark:

> I told you, sir, they were red-hot with drinking;
> So full of valour that they smote the air
> For breathing in their faces; beat the ground
> For kissing of their feet; yet always bending
> Towards their project. Then I beat my tabor
> At which, like unback'd colts, they prick'd their ears,
> Advanced their eyelids, lifted up their noses
> As they smelt music: so I charmed their ears,
> That, calf-like, they my lowing follow'd through
> Toothed briers, sharp furzes, pricking goss, and thorns,
> Which enter'd their frail shins: at last I left them
> I' the filthy-mantled pool beyond their cell,
> There dancing up to the chins, that the foul lake
> O'erstunk their feet.
>
> (Act IV, Scene I)

In a moment, when the trio enter, Trinculo identifies for Caliban the puddle they have swum in. "Monster, I do smell all horse-piss; at which my nose is in great indignation." To piss like a horse, especially after imbibing, is still a mark of prowess evident enough to give Rabelais's Gargantua and Pantagruel both pride and envy. After all, did not Gargantua flood Paris in this manner for no better reason than he could?

Dogs accompany the horse when their master is hunting, otherwise they merely try to keep up. Horse and hound are consequently a common conjunction. Still, of the pair, only the names of horses dot history. We know, for instance, the name of the horse Alexander rode—Bucephalus—and that Xenophon wrote a treatise on their training. Horses have been raced for longer than men have competed on foot. Even now nobody bets on the winners at track and field meets, though dogs do get a little action when the silly things run after that mechanical rabbit.

Of the animals that we normally encounter, the horse has the most imposing presence. Only a few are furry, so there can be no mistake about where their edges are. The skin stretches as tightly as shrink-wrap across their powerful muscles, and when they run these muscles ripple, light is reflected from their rise, shadows define their fall (page 142). It is not simply that horses are more massive than we are. Their strength, their physique, is natural to them, unlike the professional strongman who must oil himself to glisten as a horse does, who poses on a bit of pedestal, flexing his biceps—proud of the calves, pecs, abs it has taken his weights years to fatten. So it is only short of amazing that such power becomes ours when we mount; that our view is what a prince sees from his litter; that between our knees we squeeze pure animal. Yet mounted, and as one with the horse as the torso of a centaur, we see the least of it. Michael Eastman did not try to photograph a horse while astride.

But how much muscle can be safely employed to pass thread through a needle? As Thomas McGuane points out, in his charming collection of essays, *Some Horses,*

> Horses occupy a special place because they require so much care, and because they are curiously fragile, possess the prey species' excessive faith in the value of flight. A friend of mine in Oklahoma said to me, "God made a perfect world but he would like one chance to redesign the horse." Certainly, some work could be done with feet, hocks, suspensory tendons, navicular bones, all of which seem far too delicate for the speed and weight of the horse. And too often, the fifty feet of unsupported intestine acquires a simple loop and kills the horse. If the horse were a Ford, the species would vanish beneath lawsuits engendered by consumer-protection laws.

Exotic birds are showy, the great cats are sensual, colts are cute, gazelles are graceful, but it is the horse that is sexual—the expressive neck, impressive shoulders, immense chest, thrusting haunch. Apart from the animal's weight, only the horse's hooves are really dangerous, and even these are normally used to run away. Horses do not stalk their prey, they graze, and chomp only at the bit. Delicate they are indeed, for all their size and strength, and some of the horses here wear rubber cuffs to protect their shins from nicks and cuts, even though they stick to trails and sleep in stalls. So they do not charge like the rhino full of public bravado, or slither about like the snake on private business. Originally wild—bound, yet to a free-ranging herd—the horse will still allow itself to be harnessed, saddled, tamed, shod, trained to be a menial, do dirty work.

Not long ago horses were everywhere and unremarked. Corrals, coach houses, stables, barns were built for them. They carried the mail, pulled stages across the plains in teams, drew carriages around the park on Sunday, hauled wagons to warehouses. Now horses excite us. As a parade approaches we get our cameras out, and in scarcely more than seconds we have shot a mounted policeman or captured a team of Clydesdales drawing a float. How easy taking pictures has become, surpassing breakfast biscuits in simplicity. Once the subject had to slow to a stop while the photogra-

pher wrestled with an awkward box, got it sitting steady on its tripod, measured the light and determined its source, put his head in a hood, bulb in hand to squeeze one off, and hoped the light would remain adequate, its source unchanged, while he lined things up and framed the scene.

Our subject is Cheryl, aged five, on her first pony, at her first fair, after her first face full of cotton candy. Our equipment is heavier than that for golf. If Cheryl would stop looking frightened, if the young man holding the reins would cease smirking, if the pony wouldn't toss his head, if Cheryl weren't holding his ears . . .

These days the camera needs only enough light to do dots. And every minute, the world over, more pictures are processed into packs than office memos are jotted to be circulated, though both will weary sated eyes or serve as subjects of uncivil thoughts. Peter Turner's measure is bulkier. He begins his *History of Photography* by observing that now there are more photographs than bricks. On account of the camera we have seen nakedness, atrocity, catastrophe, accident, villainy, war, outer space, the depths of the ocean, deadly microorganisms, unlikely oddities, cruel customs, defeat and victory. A picture is no longer worth a thousand words. It is worth nothing. Except to Mom and Dad and Cheryl. And what we most want from our snaps is focus, clarity, vibrant color (as the ads promise), because we thought we were interested in our subject when we took the picture. We want it to be a memory. Of the Grand Canyon. Uncle Averill with a fish. The old Dodge. Minnie at the beach back when suits were long and saggy and she was skinny. A picture is additionally a good one when it seems to be a tolerable likeness, provokes reminiscence, causes chuckles or perhaps expressions of envy from those who did not go on the same vacation. In the daily papers, in magazines, the photograph brings news, tries to sell us something, is lewd or in some way arresting. Otherwise, why would it be there?

We expect it—the photo—to relieve our bored eyes. A page of solid type is dull, intimidating. If it doesn't have pictures we must conclude that our nose has been caught in a book. A feed bag would be a better place for it—blind-deep in meal.

Suppose we are eager to find out the fate of a little wager we've made. We open *The Racing News* and there is the finish of the cup race at Pimlico. It's Ramrod by a nose. Even if the judges read the finish-line camera in favor of Daisy Petal. How could they have given the victory to her? It was Ramrod right enough. Yet the finish line is drawn only on the film. The horses are flat as newspaper, made of ink dots, just as the track is, and only two inches high. The race was run yesterday. The track was far away. Nevertheless, in front of us is Ramrod's nose leading by a flaring nostril. Not even close.

Unless we are reined in by some oddity and alerted to fraud, or have a bet down that dims our eyes with desire, we will normally accept the image for the fact, even as evidence for a truth—that John Wayne is alive and selling beer—although we know that images can be doctored, shots cropped, pixels moved. We apparently do not need to be taught how to recognize pictures the way we learn a language. Michael Eastman does not photograph in American. More magically even than music, the image slips past cultural boundaries, although a French speaker will perceive a *cheval* and a German a *Pferd*, and those acquainted with horses will see more than merely tails, manes, and muzzles. They may also be familiar with equine anatomy, from feathered fetlock to gaskin, or with the horse's Darwinian history, from the two-foot mini of the primeval Great Plains to the heavy armor-bearing horse of medieval times. They may recognize breeds from Percheron or Morgan to mustang—the show-offs—and may be able to name all the coats by their colors—dun roan gray bay sorrel piebald chestnut—as easily as the alphabet. Yet for each of us, no matter our level of expertise, there—feeding in a flowered meadow, a hind hoof raised and tail shooing flies—is the horse in its splendor (page 104), the line of its back like a scenic road, tight into its silhouette, glistening as though polished for inspection.

When we look through a window we expect to see the world, and the picture yields an even handier sort of view: fixed, framed, portable, precise; but most pictures, particularly of subjects like horses, are predictable, and the information they provide is well known and forgettable; however, Michael Eastman's photographs are different than most in every respect. They immediately ask more of the eye. These horses, their heads, have what Heidegger called *Dasein*—"being there"—insistent electric presence. The interest Cheryl can elicit from the lens depends entirely upon the love of her parents. The pony is cute in an entirely generic way, and so is Cheryl—her birthday ride, her excitement, her concern, her hold on the pony's ears—despite the personality she may wear at home or school. Our pictures usually capture clichés. Indeed, that is one way the commonplace is created.

Whether in physical form or silhouette, in blur or shadow, in detail or entirety, these horses have an individual reality that the photographs forcefully project. For instance, there is the head of "Old Horse" (a name I have given him on account of the wrinkle-like veins on his muzzle and the crosspatch countenance that we encounter more than once in this collection, pages 80, 132). This is

a horse who has seen much, disapproves of more, and says so often. He has a white blaze that has invaded his nose and leaked upon his lower lip, as well as hidden eyes and a coarse mane. Unless we are distracted by the horses on nearby pages, each photograph will draw us into its details, always so beautifully caught and rendered: perhaps Old Horse's pimpled upper lip, apparently a characteristic of similarly blazed faces (pages 54, 32), or maybe the twiglike vein formation below the eye will reward our attention. In this collection there are postures you and I wouldn't dare be fixed in, contortions perhaps not as invariably graceful as a cat's, yet always strong, controlled, and expressive: reclining (page 145), running (page 35), bending (page 86), rising (page 109), rolling over (page 5).

Unless we own horses or ride often, we aren't likely to be experts about manes, eyes, nostrils, ears, hooves. Here, for our education, are manes that are moplike or flowing, flopping or waving, trimmed, coiffed, blond and tousled. There is the horse (page 120) whose crest is like the bristles of a brush, reminiscent of the crown across an ancient Greek helmet. Another (page 108) is beautifully braided with ears like horns and an eye that is shaded. Other ears resemble seed pods (page 97) or fall leaves (page 20). Standing from the white head and suspicious eyes of the horse on page 52 like radar receivers or the rinds of fruit, the ears are plurally expressive forms. Alertness has no finer flag.

The eyes of the horse are notorious for mischief; they melt like chocolate and our hearts follow suit; or they stir like slightly creamed coffee . . . because, from a distance, a friend has entered them. Horses, like cows, can stare like owls (pages 39, 70). Sometimes a horse will scrutinize us with the disapproval of a superior (pages 91, 136), or whinny with displeasure (page 80). Have we patience? Can we run, wait, endure? Have we loins like theirs? Occasionally, they even smile (page 25), though these are inferences we make, transforming them into centaurs with a correspondingly half-human consciousness.

In *Gulliver's Travels* Jonathan Swift depicts his horses, the Houyhnhnms, as far more sensible than humans are: "Upon the whole, the behaviour of these animals was so orderly and rational, so acute and judicious, that I at last concluded, they must indeed be magicians, who had metamorphosed themselves upon some design, and seeing a stranger in the way, were resolved to divert themselves with him." The Yahoos that Gulliver encounters on the same island are humanoids, or possibly even our foul species, described, with brutal honesty, as far as the T in "malevolent": "Although there were few greater lovers of mankind, at that time, than myself, yet I confess I never saw any sensitive being so detestable on all accounts;

and the more I came near them, the more hateful they grew, while I stayed in that country." Since Swift's time, however, human beings have improved themselves—haven't they?—and are now rational, peace-loving, generous, and kind on every occasion. Alas, irony will not redeem us either. While we have given up public executions for programs of genocide, our horses maintain a dignity we only fancy; they do not kill their fellows; they serve their superiors loyally, are inherently temperate, stoic to a fault, as well as splendid spotters of snakes. If he were writing now, perhaps Swift wouldn't call us Yahoos—we are not nearly as nice as apes—but would pick a plant for us to resemble instead. Kudzu would be my choice.

Not everyone is ready to give the horse high marks for brains. If they are fragile, they are also clumsy. Is this possible? According to Willa Cather, Sarah Orne Jewett once remarked that mules were grammatical. They were too sure-footed to slight syntax, whereas a horse might get himself tangled up in a sentence as though it were a picket rope.* But horses are nimble, too, with marvelous muscle memories and a valuable homing instinct. Like most animals, they are as smart as they need to be, whereas we are too smart for our own good.

Eastman allows light to play across the face of the horse that appears on page 13 so beautifully that not only is the eye brushed but rivers of sun run through the dark hide of the forehead as though making a map for an unknown Africa. Over the brow loose strands of hair pour past the tip of an ear. The skin beckons our fingers. Its touch will be curative.

Horses keep their eyes in open pockets. The details are particularly precise on page 54, where the darkly curved lid lines are prominent, as is the eye's inside shadow, even to the delicate lashes. At any change, nostrils flare, eyes widen, ears perk, a muscle, patient for a long time, twitches. Someone new has been added to the meadow . . .

Cheetahs run faster than horses—though not for long. An elephant can drag a truck from the mire with perhaps a prod, but teams of horses are able to pull a stage for many a dry and unrewarded mile. Eastman has included here several series that constitute an exquisite tribute to that pioneer in picturing animal and human action, Eadweard Muybridge, author of *Horses and Other Animals in Motion*, a work based on images commissioned by the then governor of California, Leland Stanford, in order to settle a bet: namely, whether all four legs of a galloping horse were ever off the ground simultaneously, as Stanford claimed. To get his proof,

*Willa Cather, *Not Under Forty*. New York: Knopf, 1936, pp. 88–9.

Muybridge devised a system of twelve cameras in line and appropriately timed. To realize his homage Eastman required but one with a rapid-fire feature. The frames on pages 22–23 demonstrate how far technology has come since 1878 while making a modern virtue of nostalgia. In the background of the photographs on page 100, the modest ranch Michael Eastman often chose to visit can be faintly seen. It is near his home in St. Louis—an easy drive—and stables about 120 possible subjects. There Eastman awaited the right light, an interesting sky, a curious stallion, a splendid pose, with patience and faith they would arrive, as Muybridge did for days in order to render the landscapes of Yosemite.

Shots organized in Muybridge's manner show a horse (page 45) racing alongside a fence with all four feet in the air as if it were taking off. However, the camera, at the end of Eastman's sweeping arm, extends the movement to the earth, the trees, the fence, rails of which seem to be streaking through the horse itself. Perhaps the fence has a slight lead. On page 35, a horse with flooding mane and trailing tail gallops into the dust-made wake of another, carrying a white patch upon the cannon of its right rear leg that looks as if it were an X ray depicting the bone as we might innocently imagine it. Within that streaming mane two little white dabs of the horse's coat gleam as though they were the sources of the wind.

In short, this volume gives us most of the kinds of pleasure pictures habitually yield (if we subtract the daily news), including the requisite glamour shot: the blond bombshell on page 53.

If Cheryl's pony, tired of having his ears pulled, tosses his head at the wrong moment, the souvenir picture will be blurred in a ruinous way; however, in Eastman's hands the blur is not only a sign of movement, it is transformative. The world rushes past the head of the horse on page 11 like water, and like water washes mane, ears, muzzle into poetry. Mustard gray streaks appear as if they were themselves strands, and form halos about the ears, melt the nose, outline the eye. I am not merely a picture, this image says. I am a work of art, a photograph. Indeed, so were others, but they may not have insisted on it so firmly as those on pages 34 and 35 do. Up to this point, I have been using "photograph" and "picture" as interchangeable synonyms for the latter, which is actually the lesser of the pair. Pictures? Tourists take pictures, movies make pictures, the pages of newspapers and magazines are distracted by pictures, in catalogs are pictured things for sale, between adhesive corners I stick my pictures, behind the sofa hangs a picture, in my billfold I've creased the picture of a babe I sometimes pretend is my wife; but books are not normally filled with pictures, pictures are pedestrian, even when the walker is wearing expensive shoes; pic-

tures are about their subjects and even then good only for information and utility, titillation or shock, evidence and instruction. Pictures work for a living. Yet it is the photograph that graces collections and fetches the fancy price.

The edges of a photograph are fundamental formal elements as are the rectangular limits of a painting or the proscenium arch for a play. The edges of a picture, on the other hand, are merely mechanical necessities. The photograph itself aims at Being—that *Dasein* again—not use. It is self-contained, and its success depends upon the number, kind, and connections of its internal relations. Beyond its borders lies the void, not more world, not more of Carlos, whose smirk was cut in half like the rest of him, leaving the sliver of an arm, along with the sleeve of his Hawaiian shirt, in place to calm the pony and steady Cheryl—the slice an accident of aim. Similarly, the bits of mane and areas of coat, the eye of the horse on page 13, may be isolated and pictured parts, but they make a photographic whole. When a picture is editorially scissored, it becomes smaller; when a photograph is professionally cropped, it becomes whole.

The elements of a photograph form their own community. The smokiness of the mane on page 35 resembles the vapor trail just ahead of its head—that's what counts—one foreleg is swallowed by a resembling dust—which matters—the horse's dark legs and black belly are as fastened to their shadows as they are to the body. The near black background, as well as the nubbled ground itself, are as important to the photograph as any other feature. The fact that the horse's scurrying back has been lined up and blended with the edge of a distant stretch of trees is essential. Pictures are preoccupied with terms, photographs with their relations. On pages 114–115, in a hair-raising photograph, four horses gallop dramatically toward the camera. Behind them flow bright white streams of mistlike dust. A line of trees cups the scene. Elements (horses) bunch up at our left, widen at our right. Each is fanning out yet intent on the man with the camera. The photograph's magical force depends upon the placement of the animals, the angles of the trailing plumes, all of which aim at the point where the wood opens and disappears into gloom. Above, the arc of the dark sky curves in subtle harmony with the tops of the trees, and clouds shaped like brush strokes recede in the same way. The forward earth shrinks into a paler distance. The shadings that signify the woods and those that stand for turf modulate marvelously. The horses' sight lines converge in a future that is a perfect opposite to the vanishing point of the composition. Which is moving with more determination, the picture's oncoming horses or the photograph's receding landscape?

The horse on page 69 is almost pure photograph, simplified to silhouette in a dance of light, aura after aura gathering about a deeply red-brown form. The photograph can dispense with gestures in the direction of a meadow-time reality and insist upon its own nature, one of artifice, but equally sensuous and alive, equally other, as though shaped like our first clay by the breath of life. Because the photograph is its own world, in that world everything must matter. As Plato described the harmony of the just state: there every man does his own work well.

In very ancient days it was believed that an evil-minded tailor, wielding a pair of long-bladed shears, might cut your shadow from you while you lay asleep, only to roll your psyche up like a bolt of cloth and make off with it under his arm. Because your shadow was a somebody then. Moreover, if you sold your soul to the devil or were shorn of your shadow by your tailor, you would no longer have a reflection in your looking glass to prompt a bit of primping, nor could you stand in anyone's sun again as Alexander once darkened Diogenes. One day, though, you might gaze across a crowded café and see your soul suiting someone else's intentions like a Harris tweed.

Photographs have many hierarchies, but that does not prevent a serving nail from being vital to its superior shoe, the shoe essential to the hoof, the hoof to horse, and horse to rider—Richard III, now unseated, afoot, and sore beset—and the king of course to kingdom. On page 106 four stallions race playfully down a track, two a blur of mane and coat, a third flat against the earth beneath their hooves, the fourth running on the inside, blotting out the three-rail fence—the last pair shadow and silhouette—leading by a head. In a photograph, appearances become realities. Turn to page 145, where a horse is enjoying some late rays. These enlarge, join, and double him, so that he grows huge, with a second muzzle shaped like a seal's smelling the presence of a fish. The oft-trodden earth he lies on has a texture no mill could match, as promising to the knife as the crackled top of a chocolate pecan pie.

Even after color photography became a commercial possibility, there remained among camera fanciers a distinct preference for black and white, not simply because black and white represented the old ways or because it was somehow "purer" and color a gaudy distraction, easy of effect and coarse, but because of what black-and-white work revealed when the bulb was in the hand of a master: the inmost properties of light as these qualities created the visual scene, light's ever so subtle gradations, its shaping revelatory power. The picture was made of images, the photograph of illumination—the world as it was when light struck. Resembling registers

of radiation, the camera recorded light's presence on a paper called sensitive for just that reason. Sun burned silver nitrate black. Eastman's monochromes accomplish a similar task. The horse on page 130 furnishes us with a fine example. If gray days were gray this way no one would ever complain of them. In an exquisite shimmer of charcoal and ripe olive we see the head and ears of twin horses from front and rear. Not only is the composition arresting (their ears are the wings of birds or perhaps bats), the deep green-gray of the entire photograph defines body lines, shades their coats from pitch to glisten, and gives to this meeting grave importance. It is a conversation of consequence between Houyhnhnms, perhaps, who are discussing what on earth to do with Gulliver.

Michael Eastman explains:

I liked the early photographic processes that Edward Curtis used for his wonderful Indian portraits and Carleton Watkins for his beautiful landscapes: palladium, platinum, Vandyke, and sepia. In their time, quality black and white printing was not available. With the horses, I used this nineteenth-century color palette purposefully. I found that the horses in black and white seemed too cold. The touch of color that I added warmed them both literally and figuratively.

The pale blues of Watkins's cyanotype prints of Yosemite make his scenes seem taken at a distance from the earth. Eastman's rosy browns range from the gentlest of hints in the dramatic landscape and posture on page 43, through the warm caress of the photograph on page 25, to the furnace tones of the combative on page 7. These hues could never appear in anything purely pictorial and are fully released only when they are swallowing an image aspiring to be a photograph (page 98).

Pictures are satisfied with the organizations that are automatic to ordinary eyesight, but the photograph suggests more than a few formal affinities with sculptures and paintings. The stretch and twist of some necks (page 47), the molded muzzles of many of these horses (page 59), their rich red-brown tones (page 143), make not a few figures seem made of bronze or chiseled from stone, and their placement in a clearing (page 147), say, or their absorption in the choreography of a prance (page 49), are as painterly as Corot in the country or Degas at the track.

So the picture and the photograph are like rural and urban cousins. And they request of their friends quite different indulgences. Yet oppositions in art are essential to its music, for, as the Greeks observed, the tension in the strings of the lyre help them resist the pull of the player's fingers so that when plucked they

throb their way back to rest, and the arc of a drawn bow is in agony until its competing forces are released to speed the arrow to its mark. Between nature and artifice, imitation and creation, content and form, idea and object, there is a competition that should be resolved in a successful work: natural detail in plenty there may be—yes—but also its rigorous organization; actual appearances should give way to unyielding realities; motion can be appreciated—yes—but in contemplative repose; we should enjoy Old Horse in the here and now as well as Old Horse in his celebration of what age itself is; above all, at the heart of the art must be manifest a respect for the subject, even for what is hateful, silly, or merely pretty, but never at the expense of a passion for form and the fulfillments of the mind. I believe Michael Eastman's camera has pictured these resolutions in photographs of a stunningly beautiful quality, because here are horses as horses are meant to be, as well as horses as they firmly are.

—WILLIAM H. GASS

HORSES

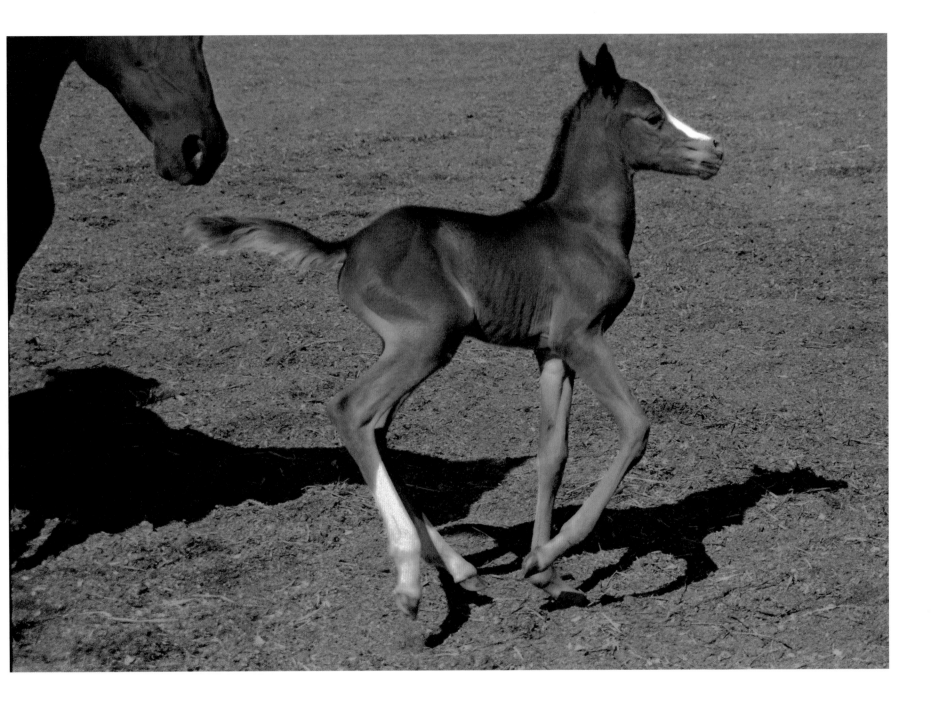

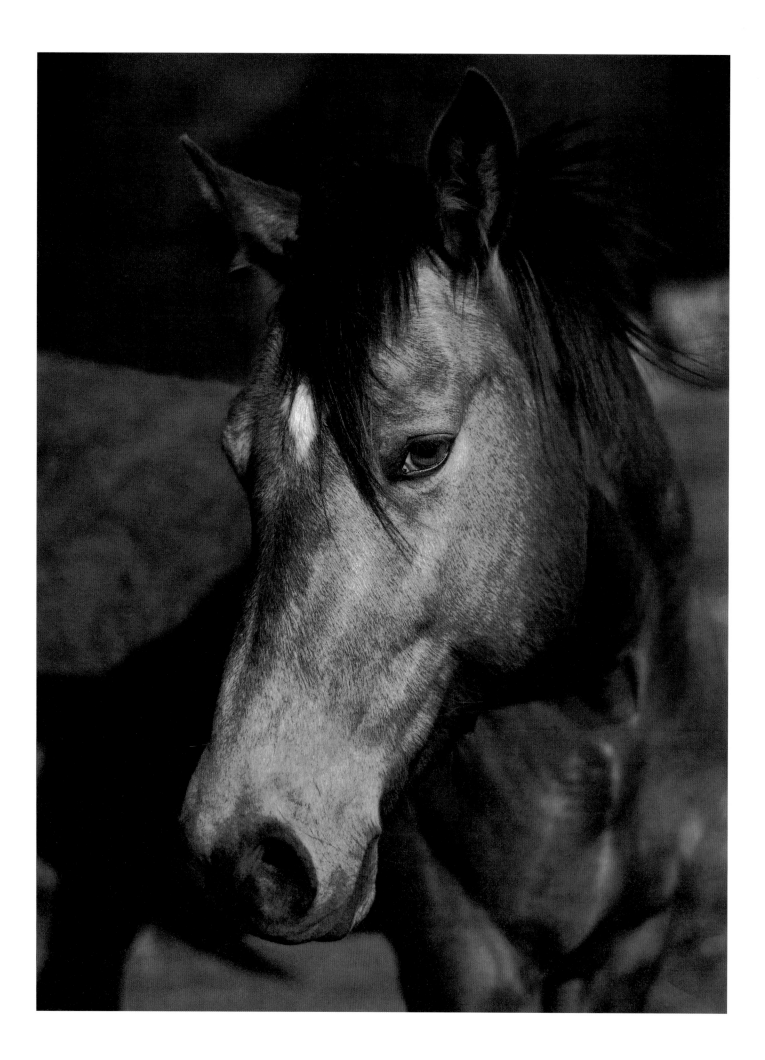

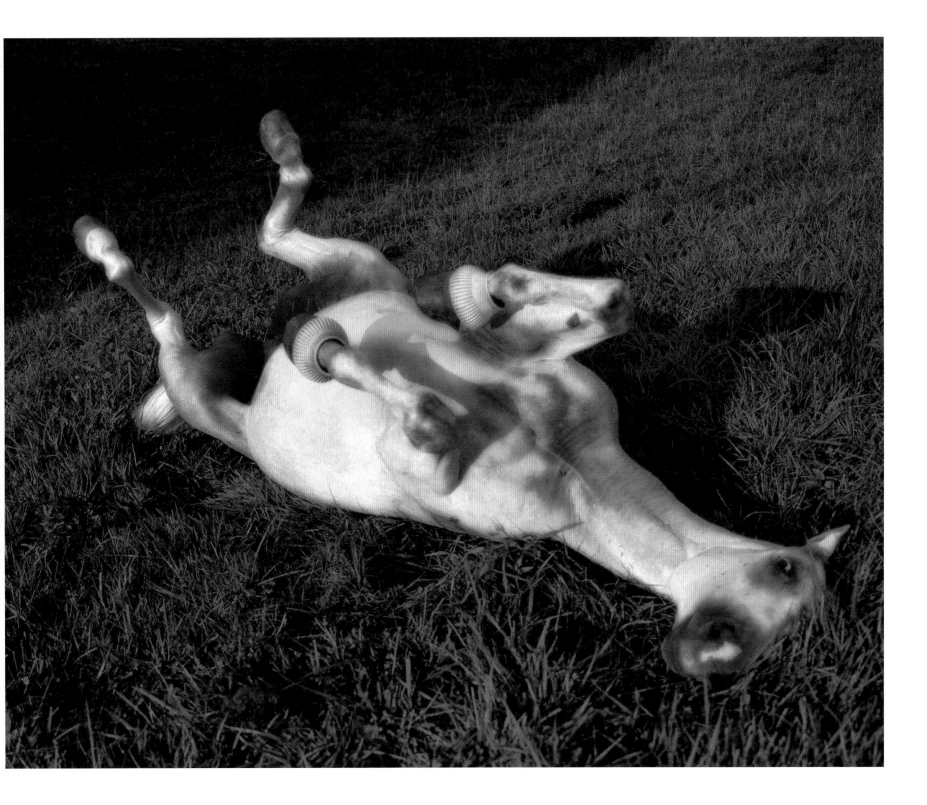

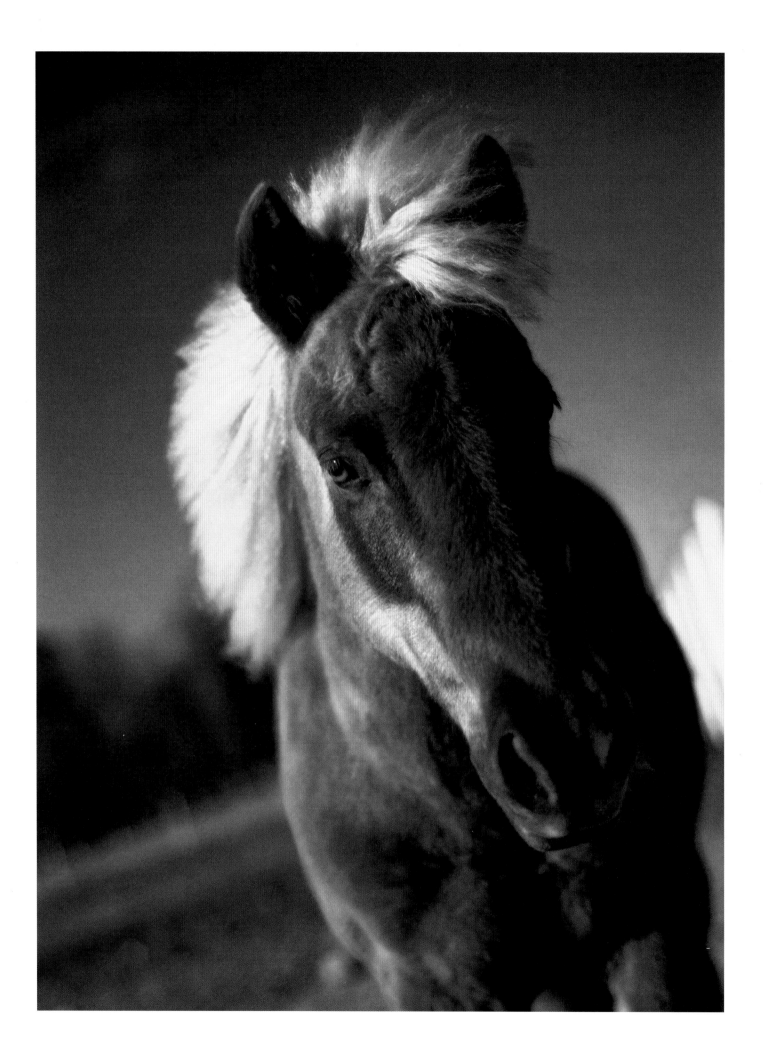

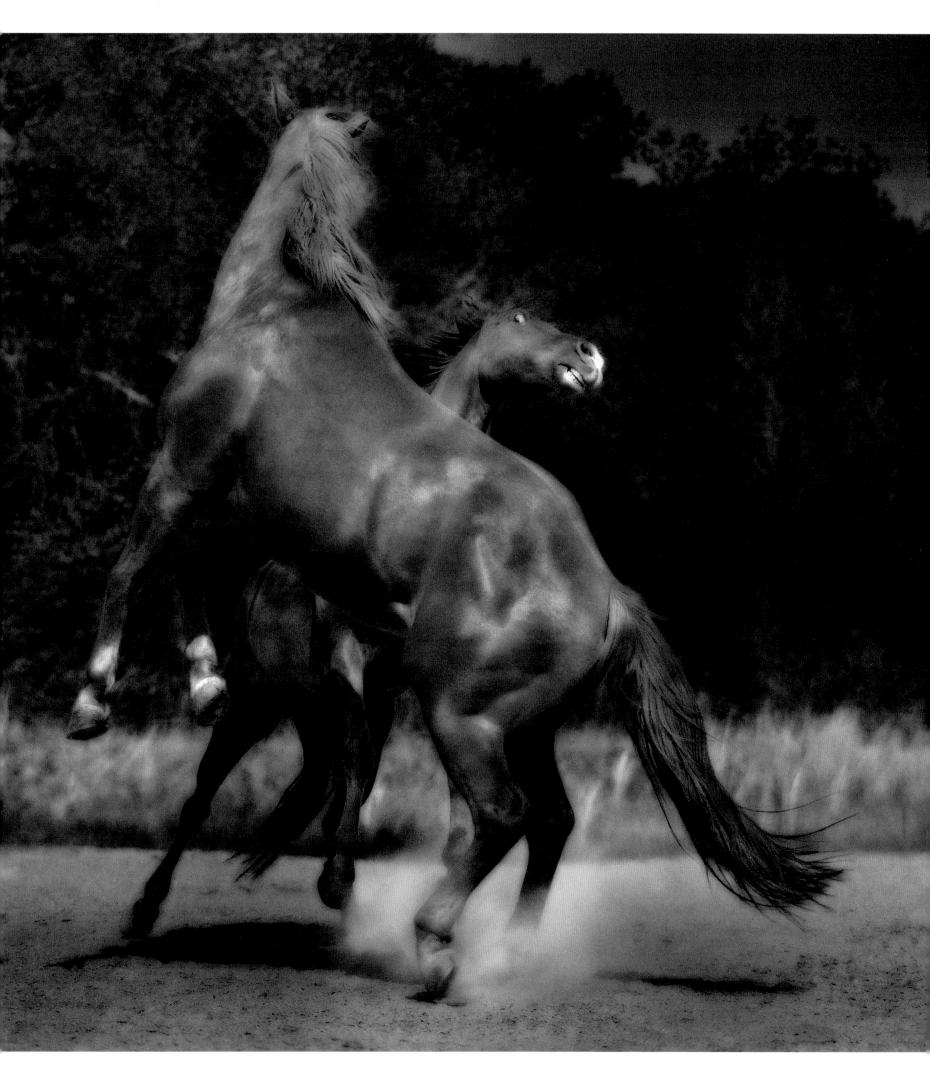

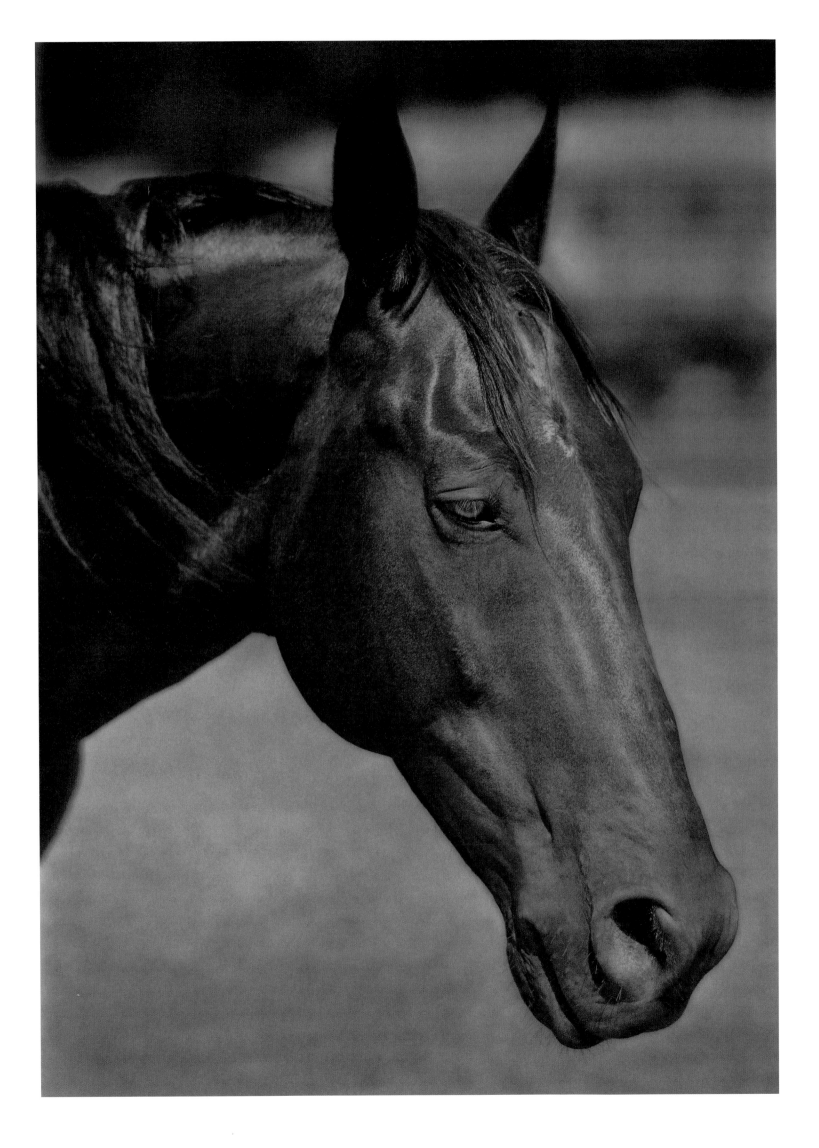

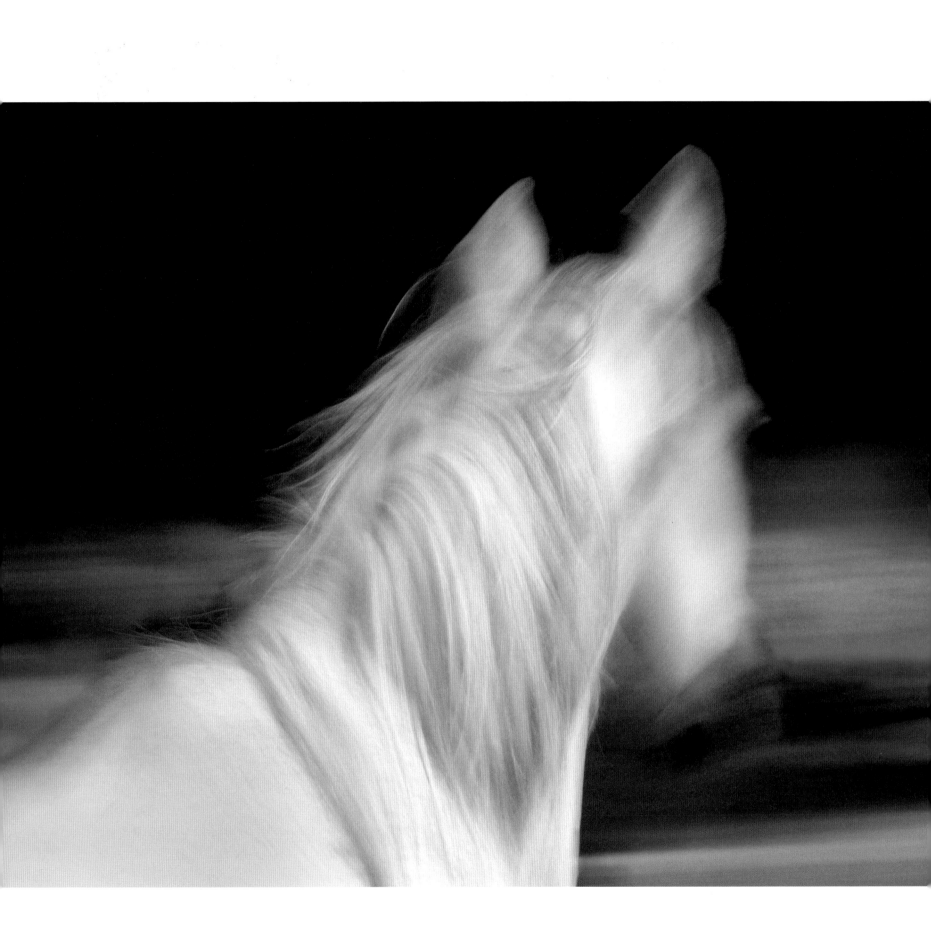

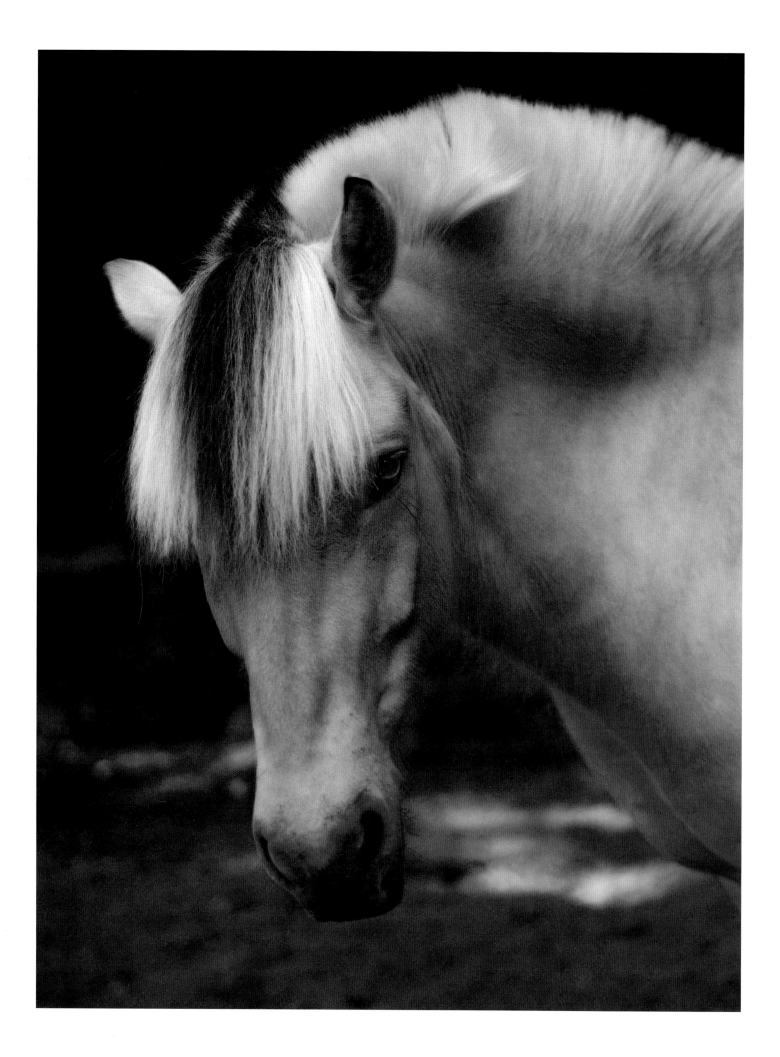

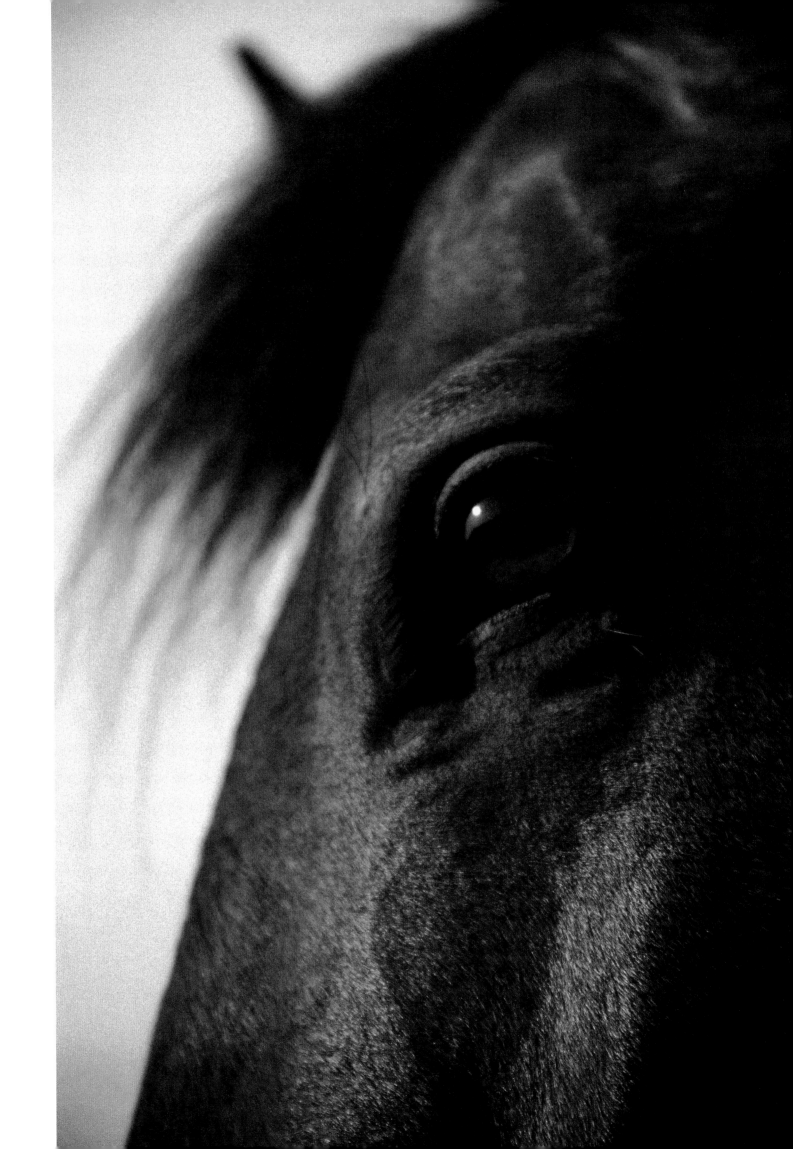

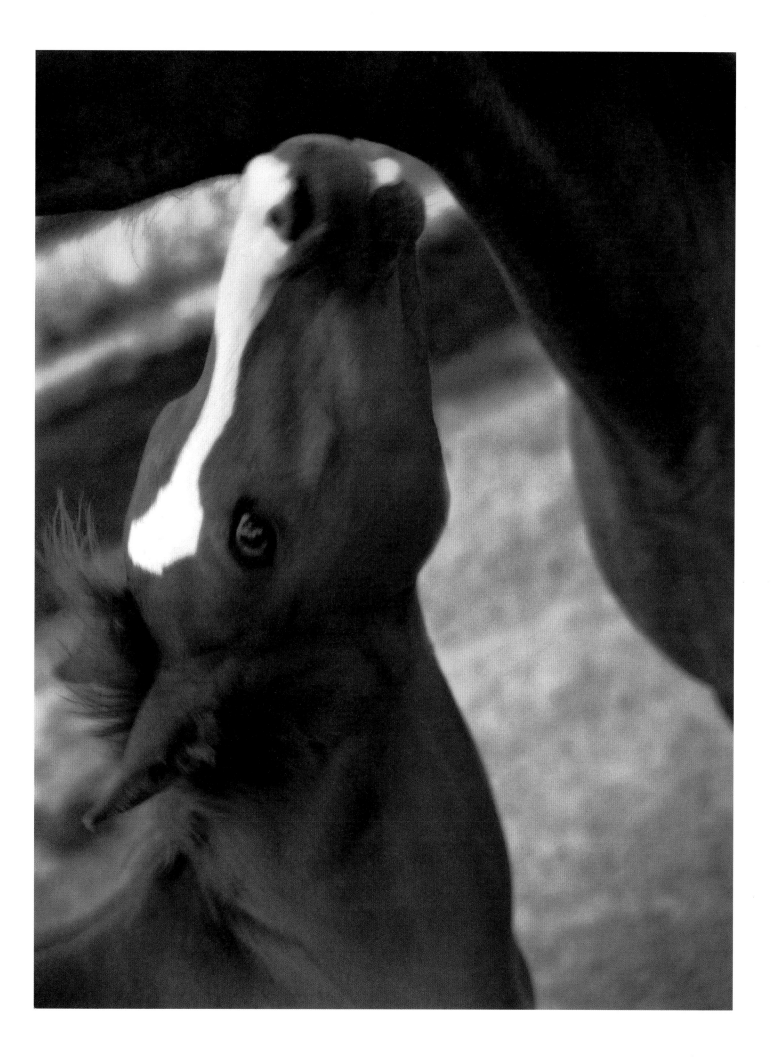

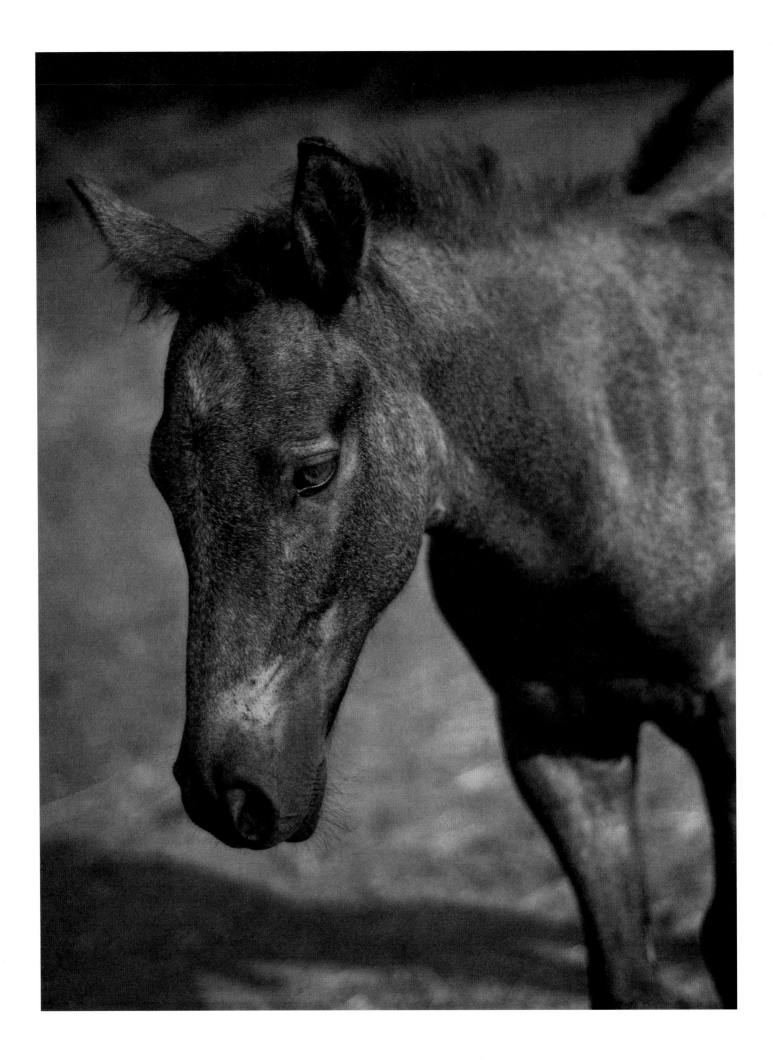

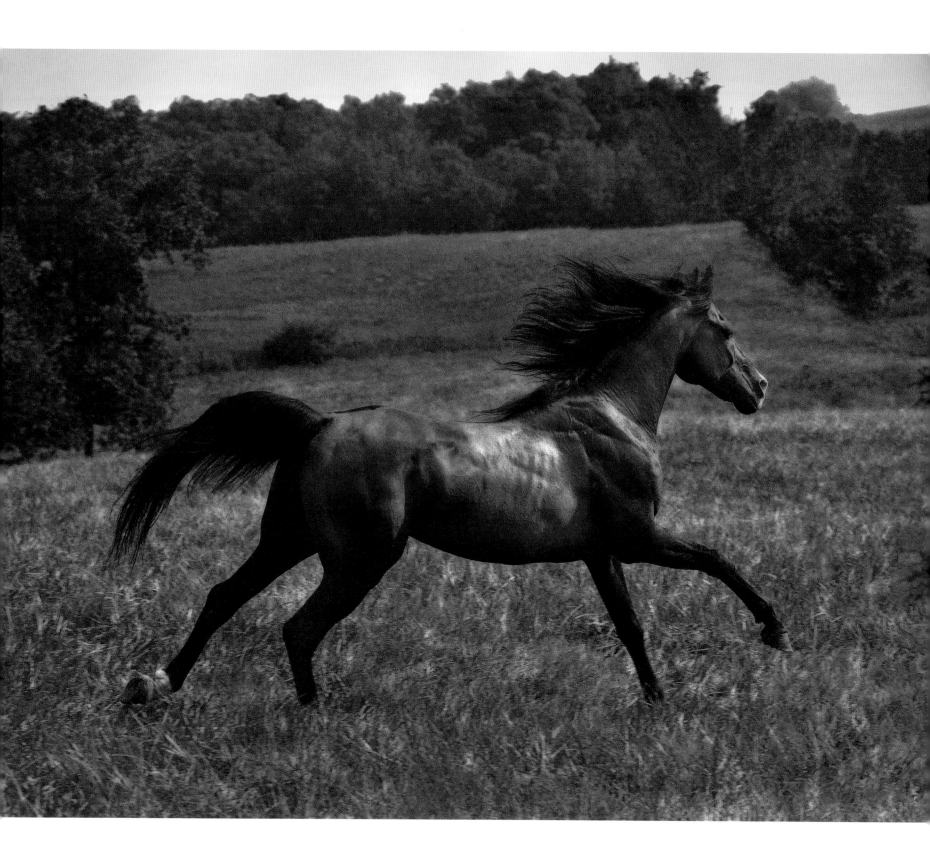

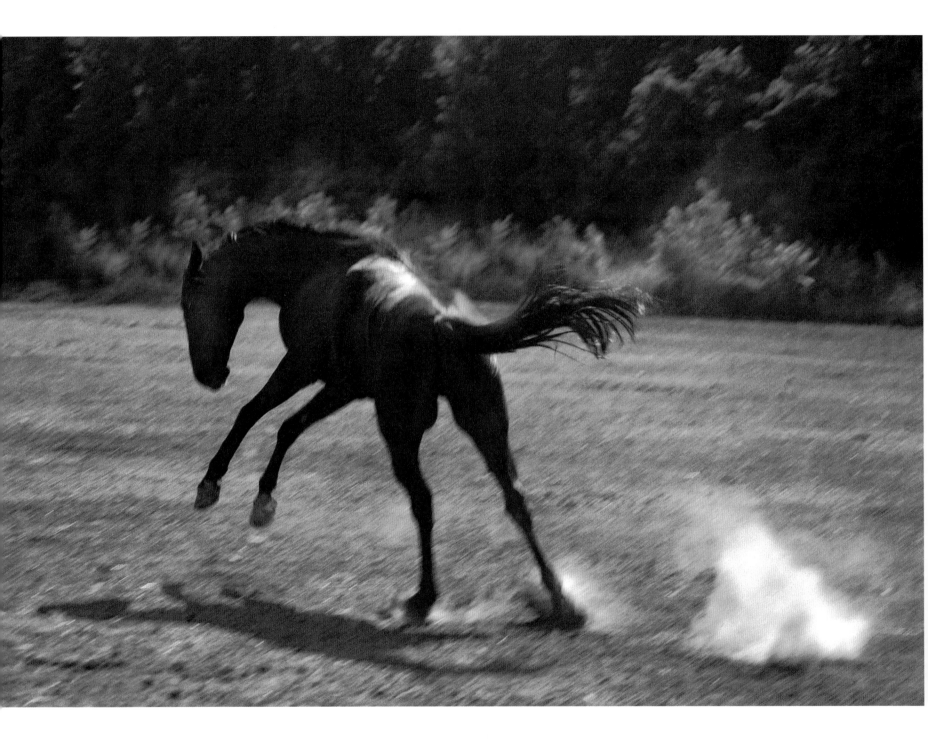

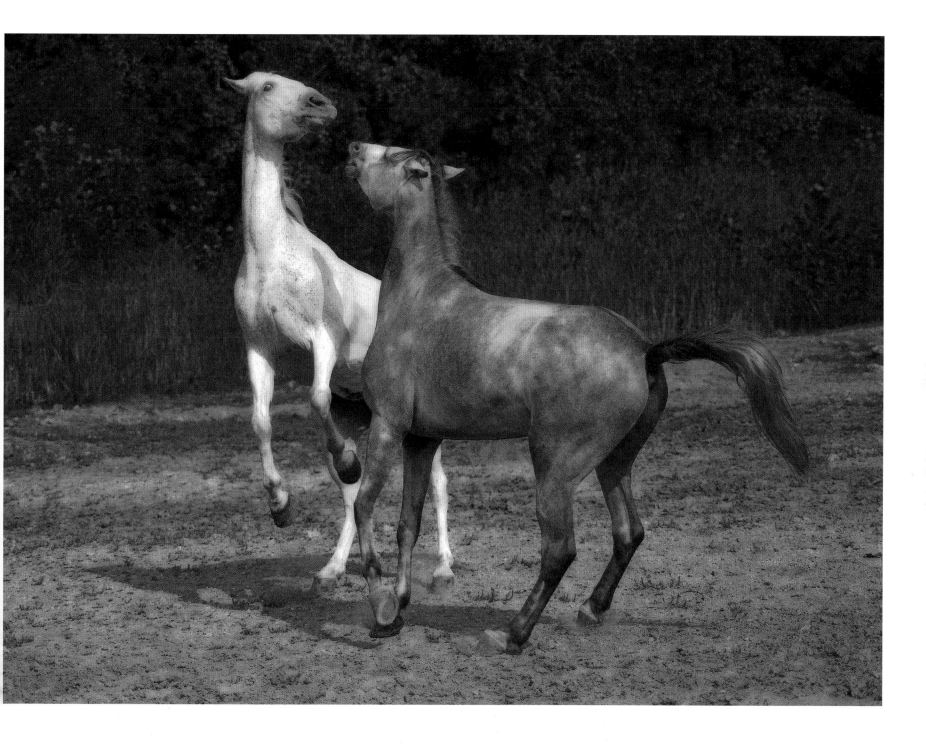

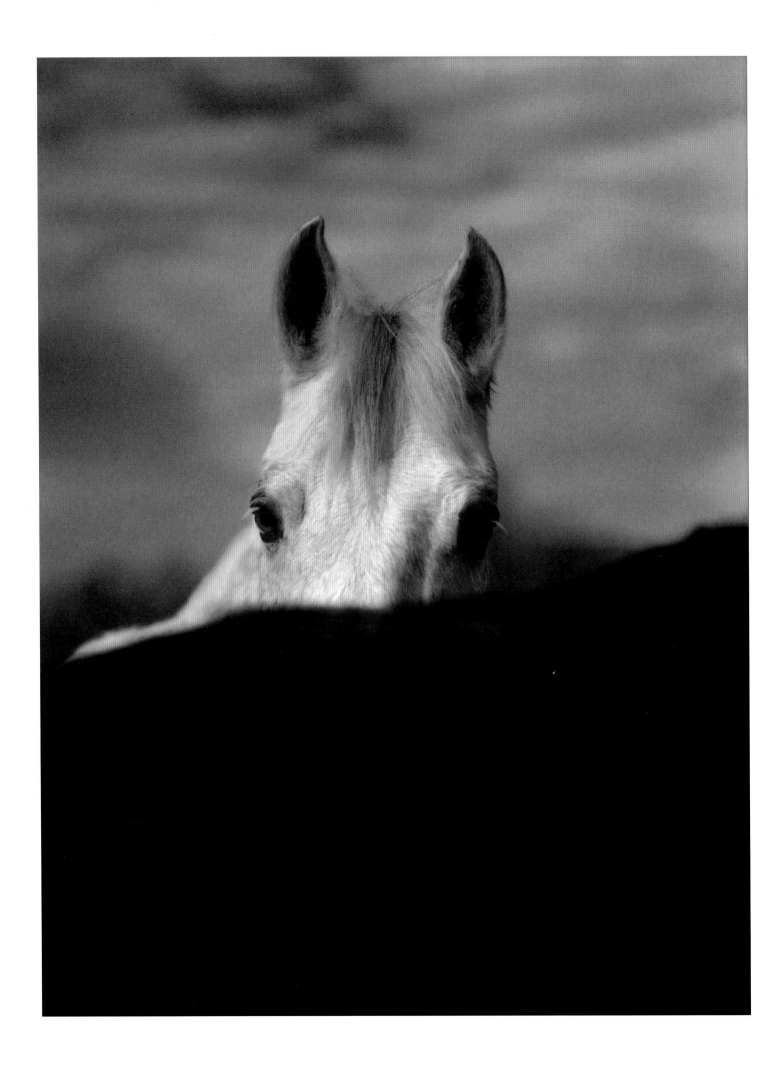

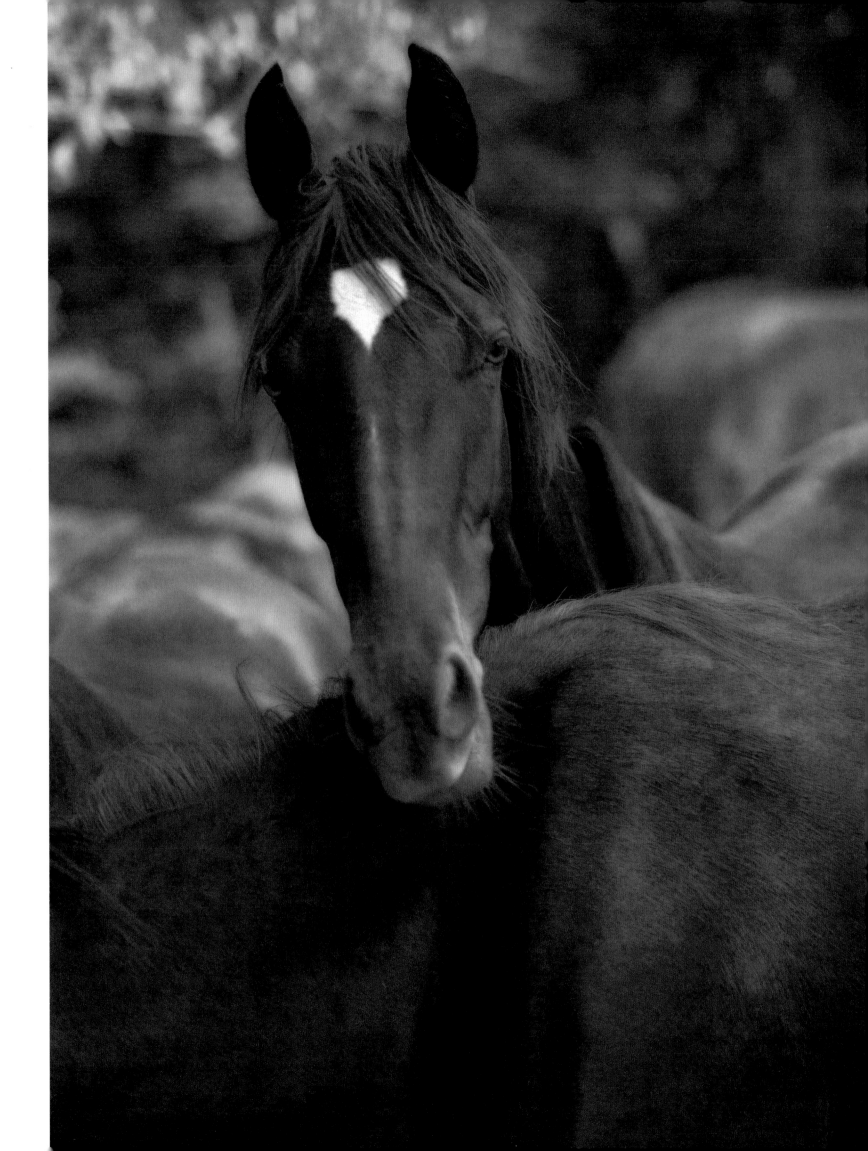

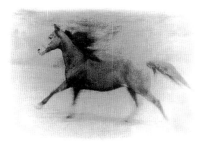
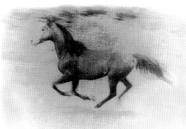
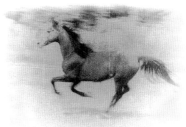
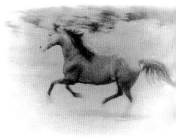

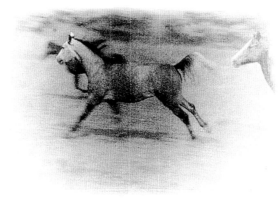
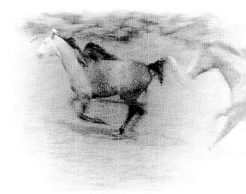

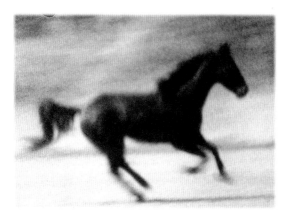
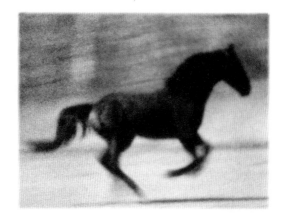
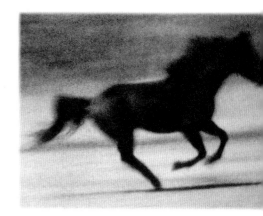

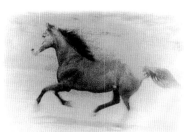
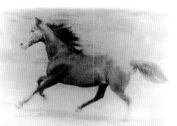
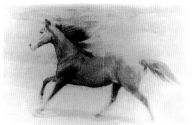

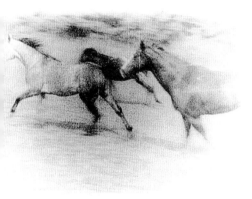
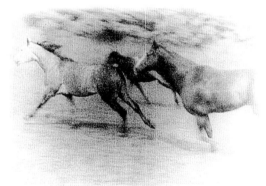
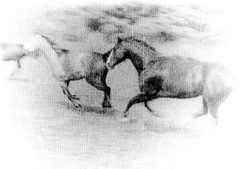

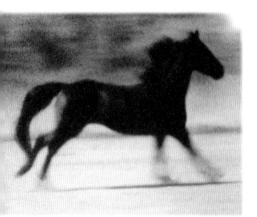

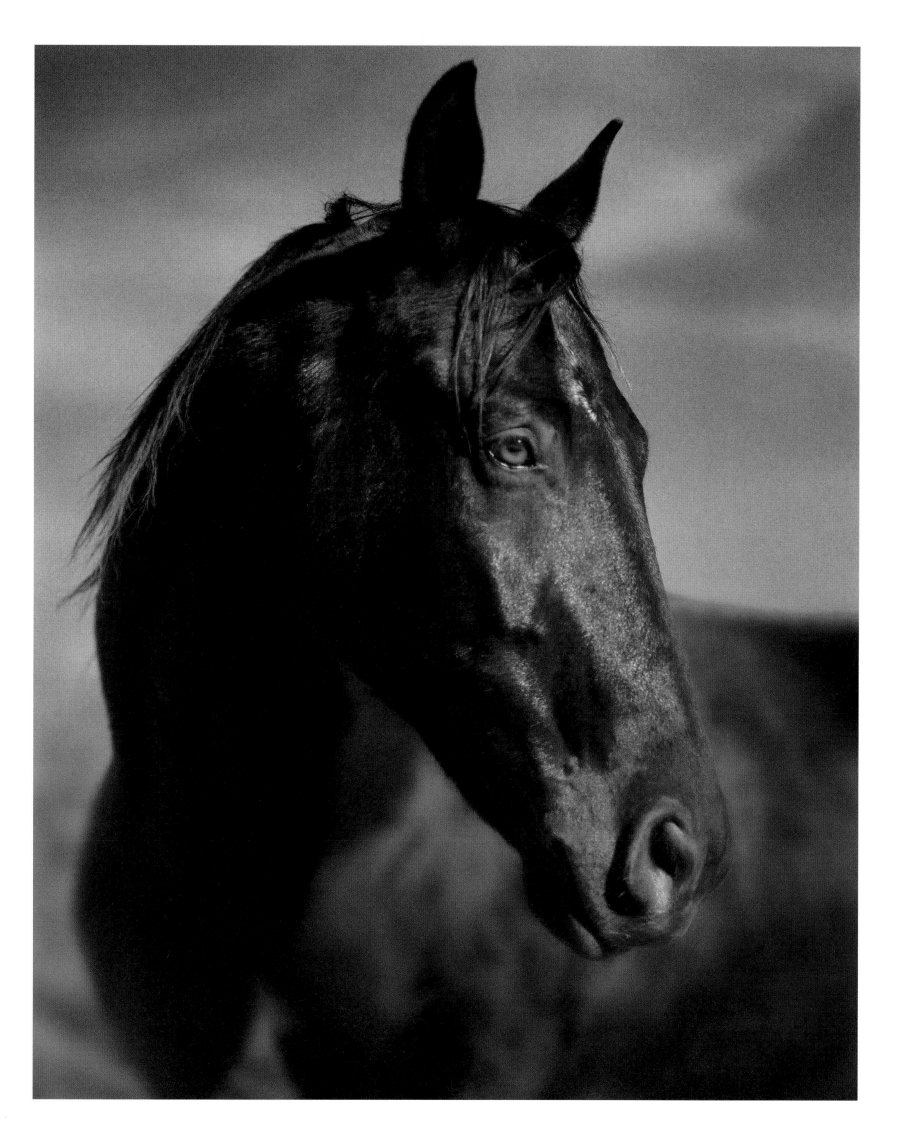

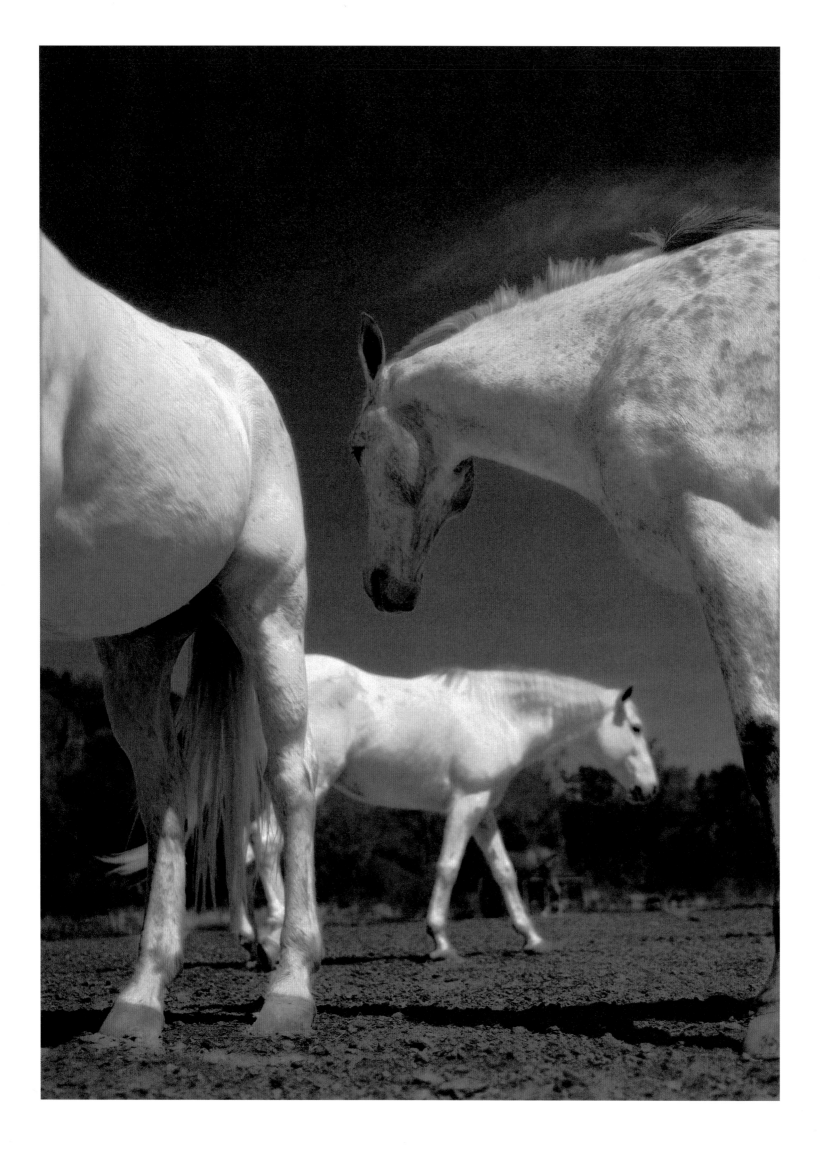

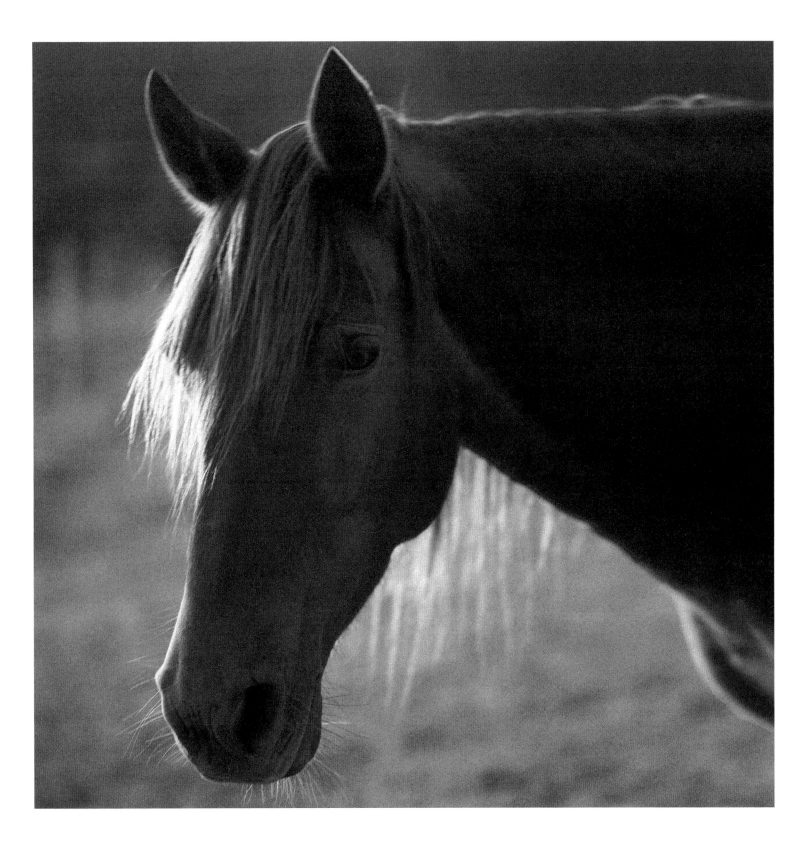

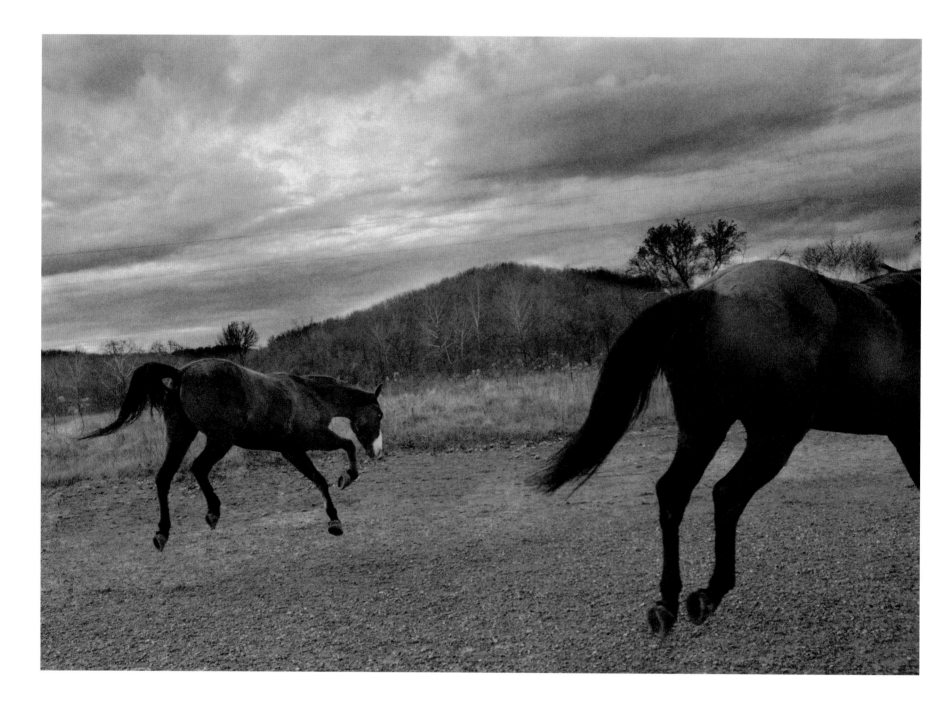

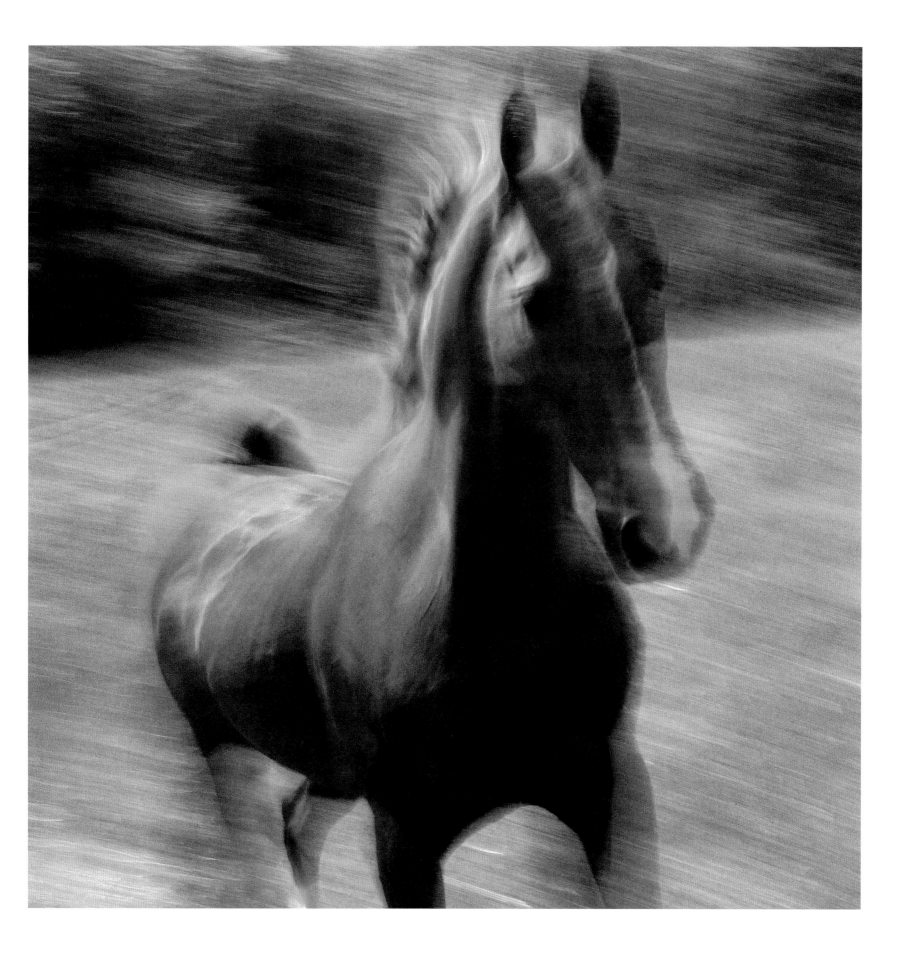

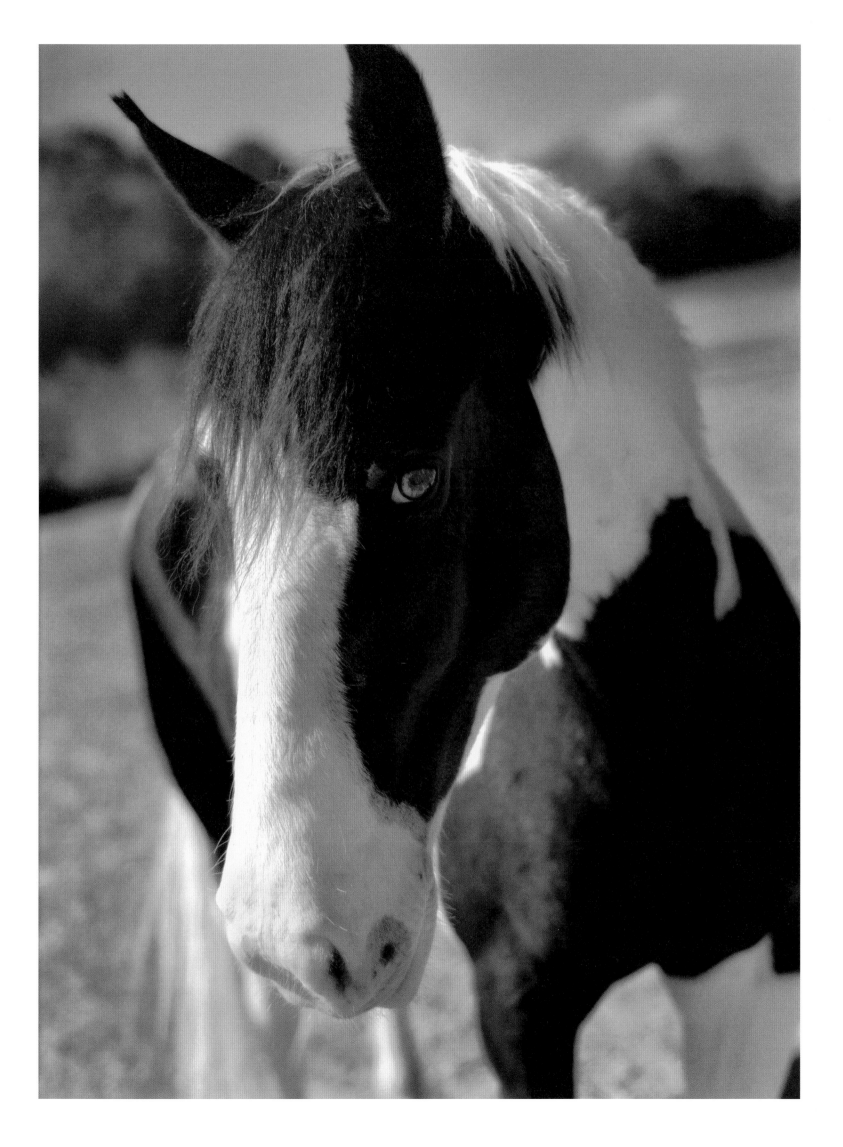

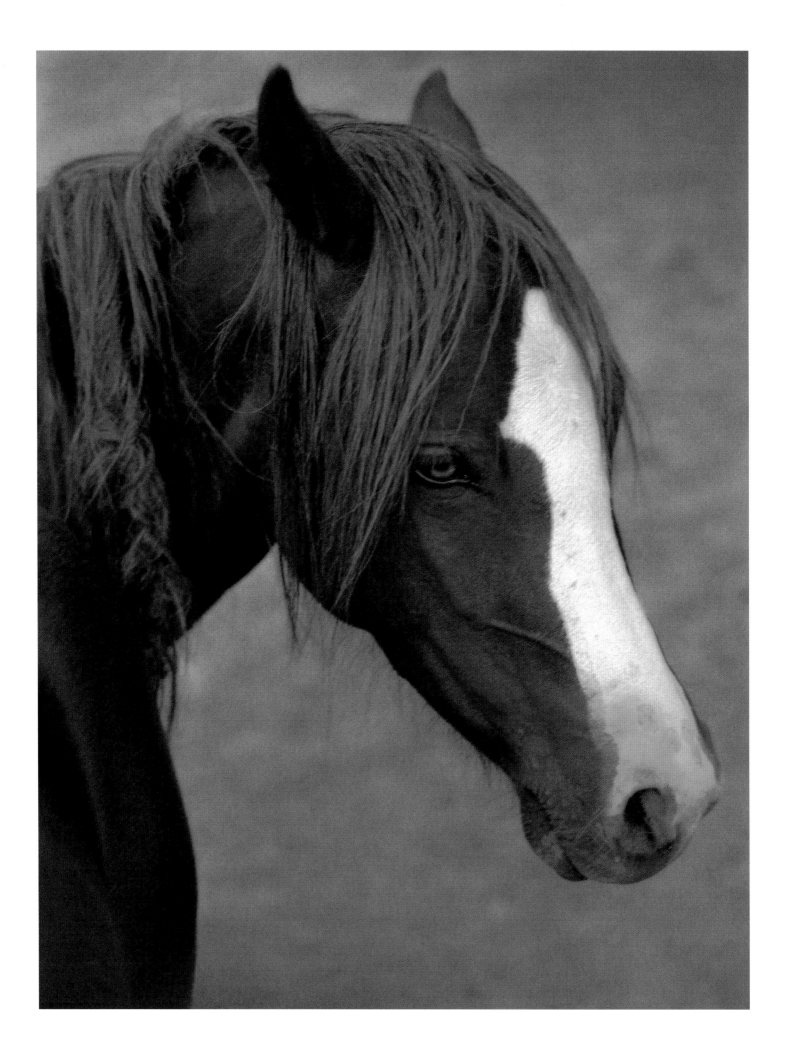

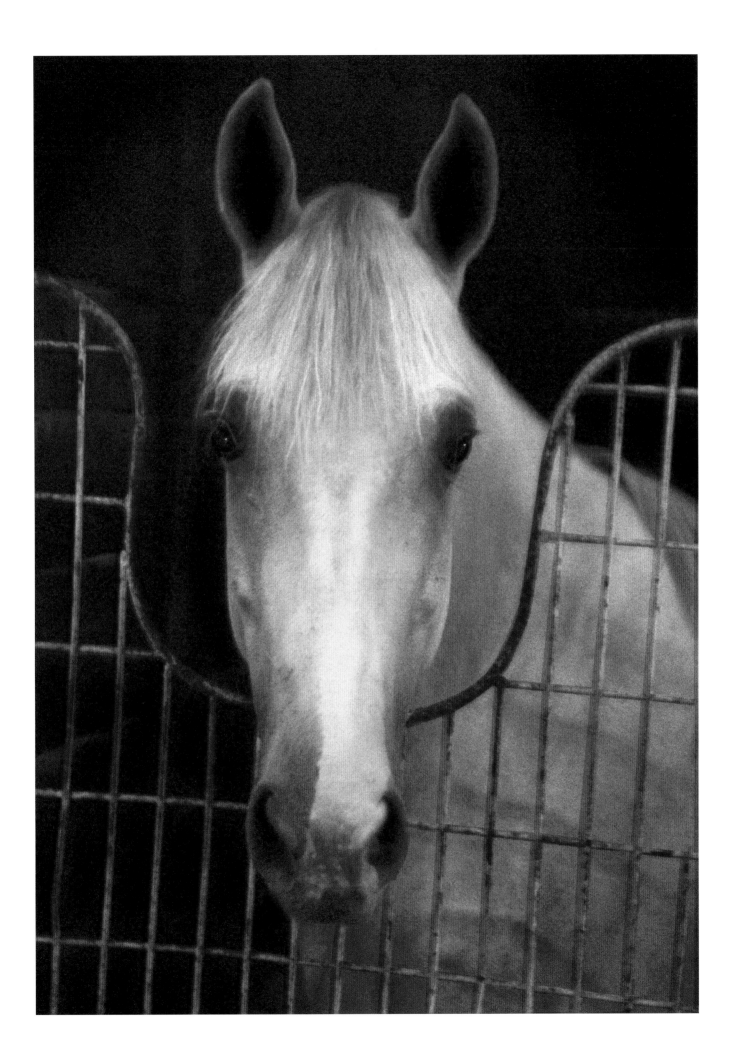

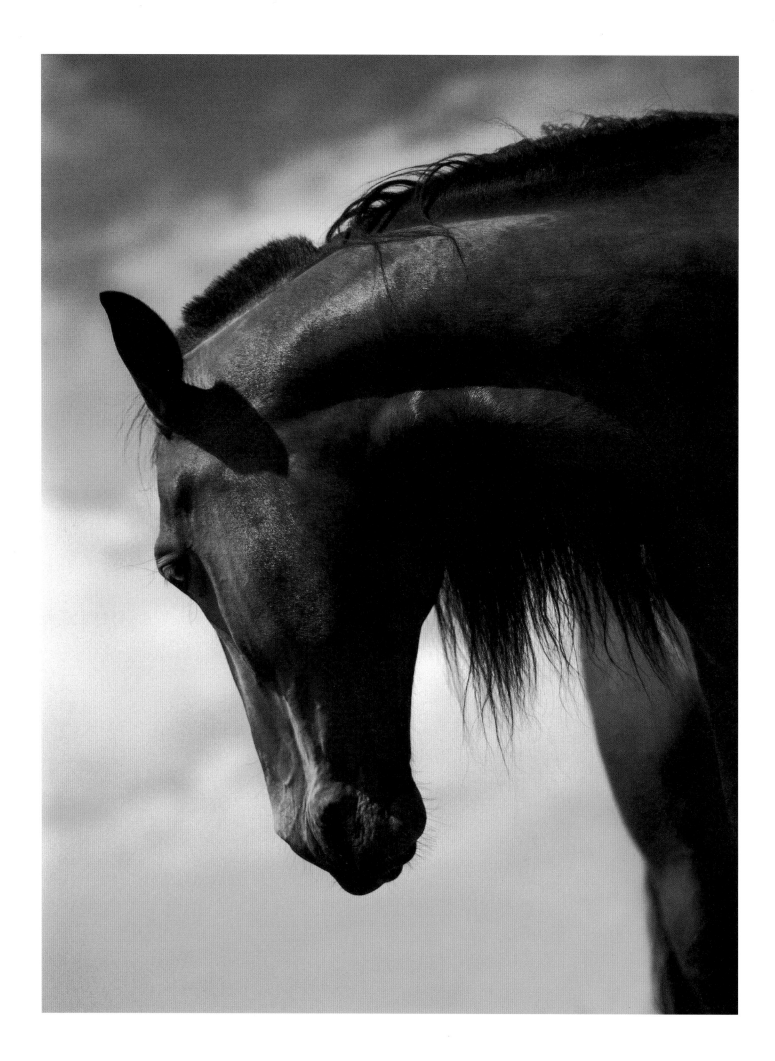

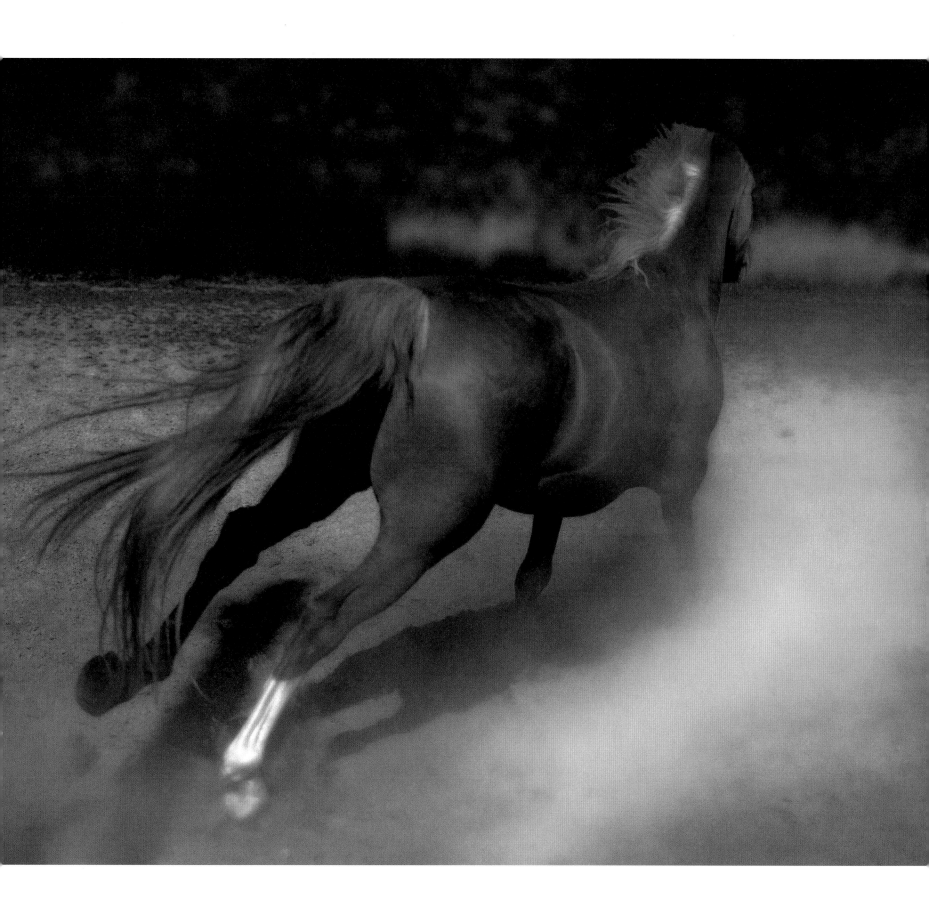

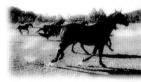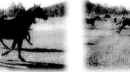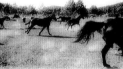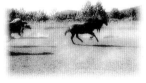

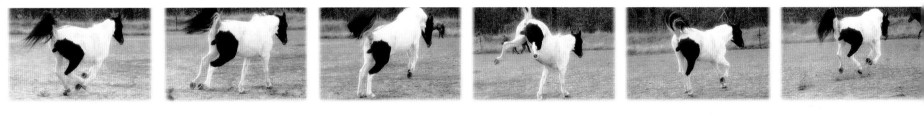

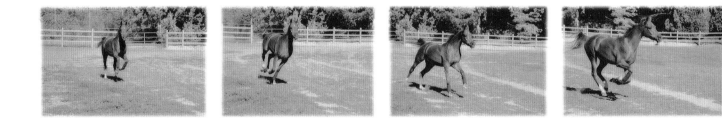

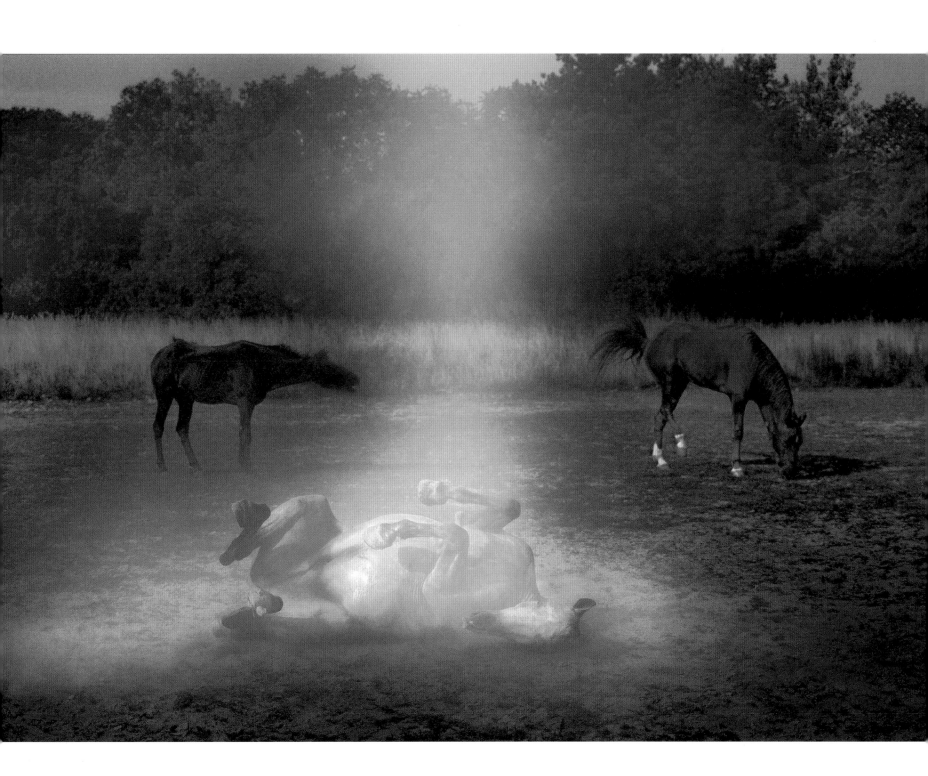

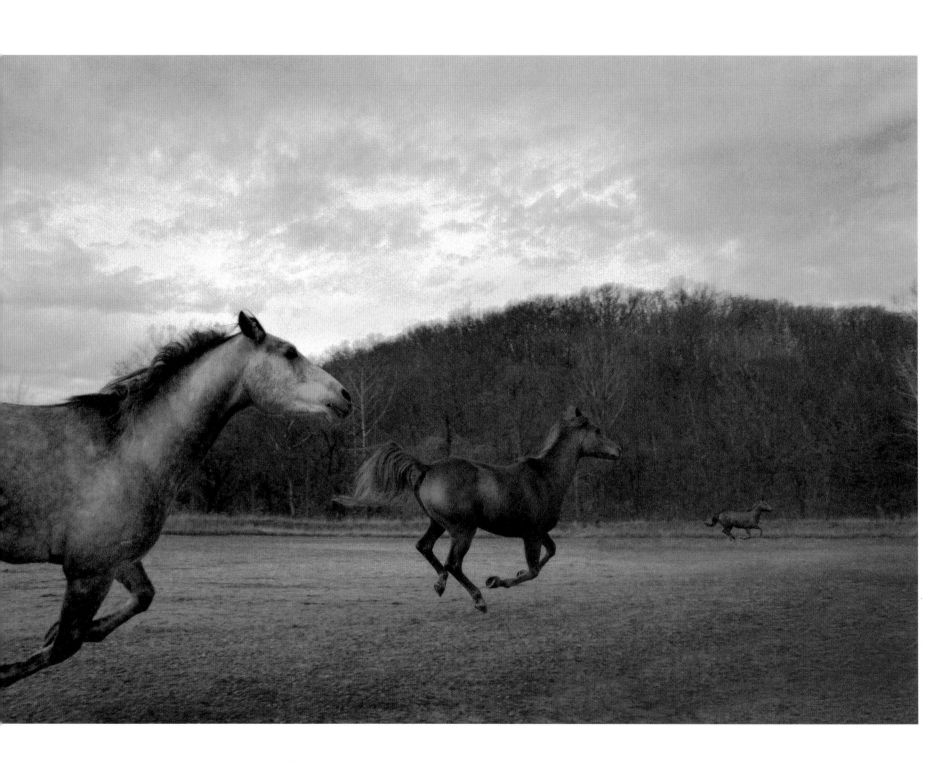

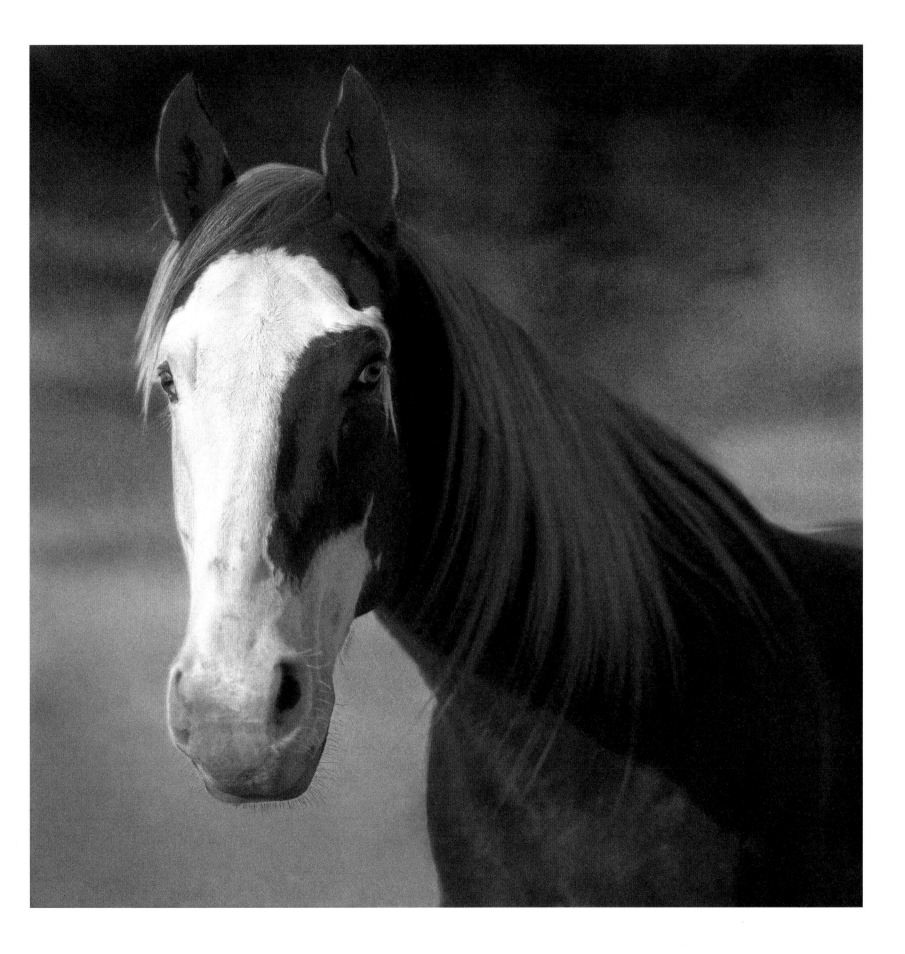

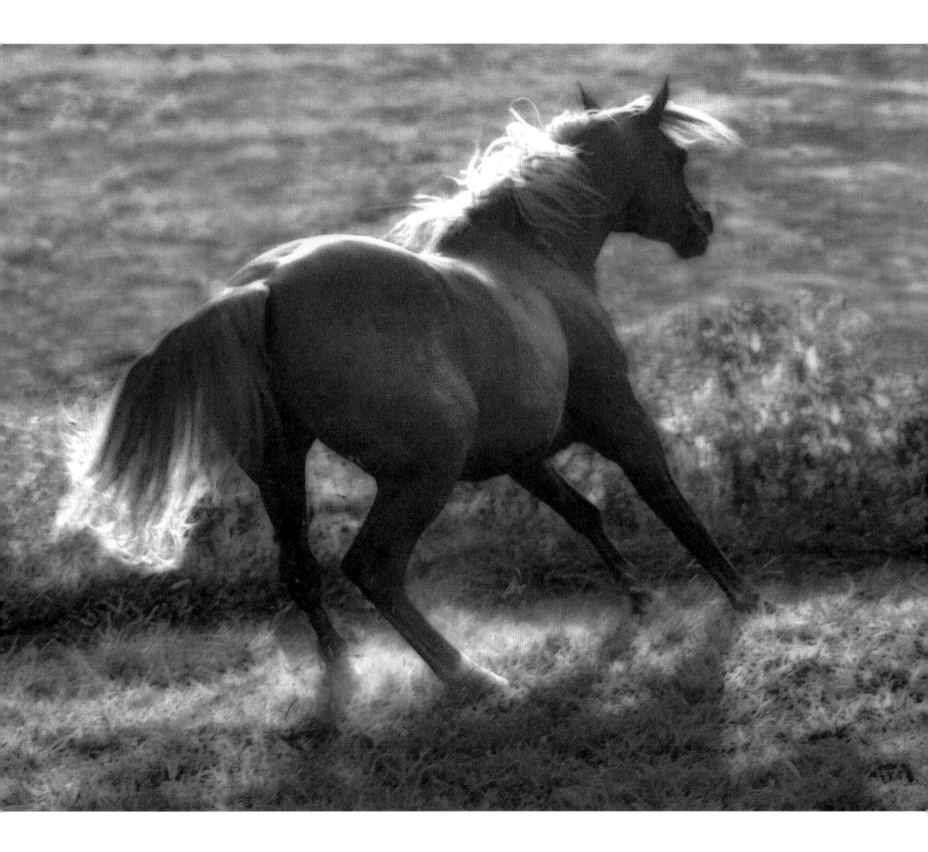

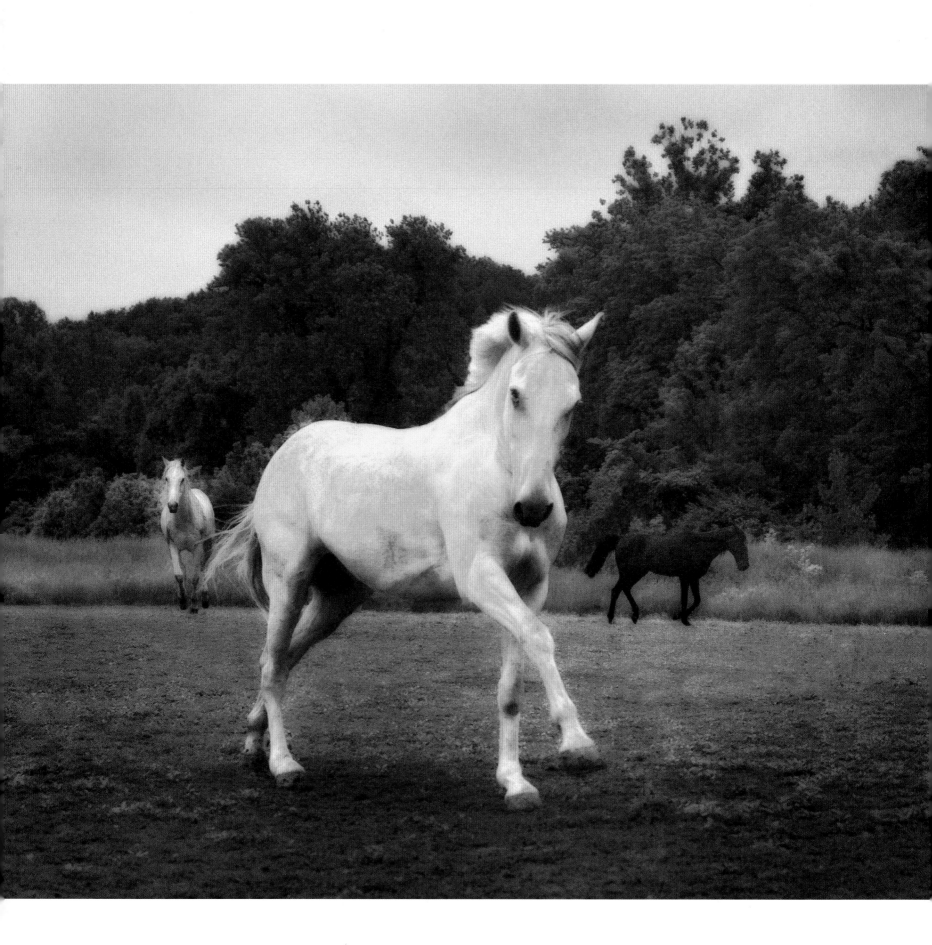

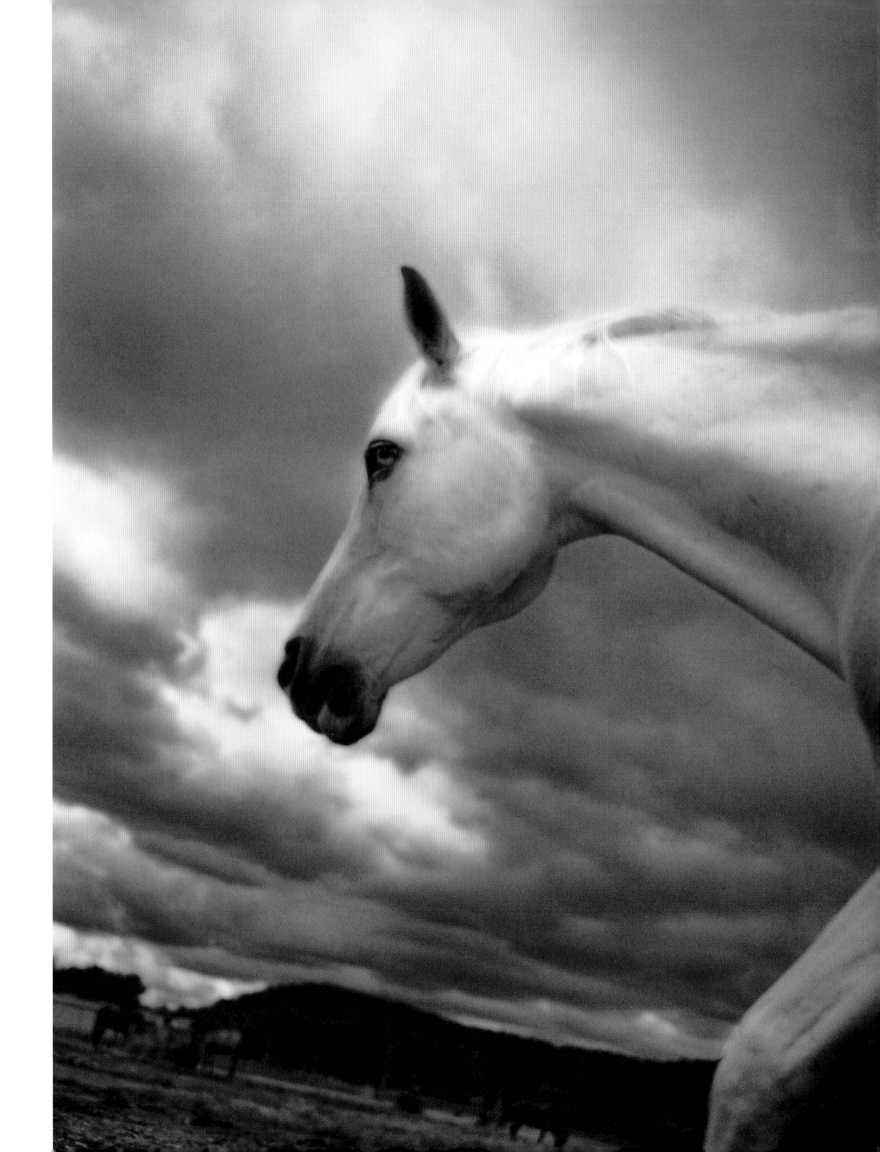

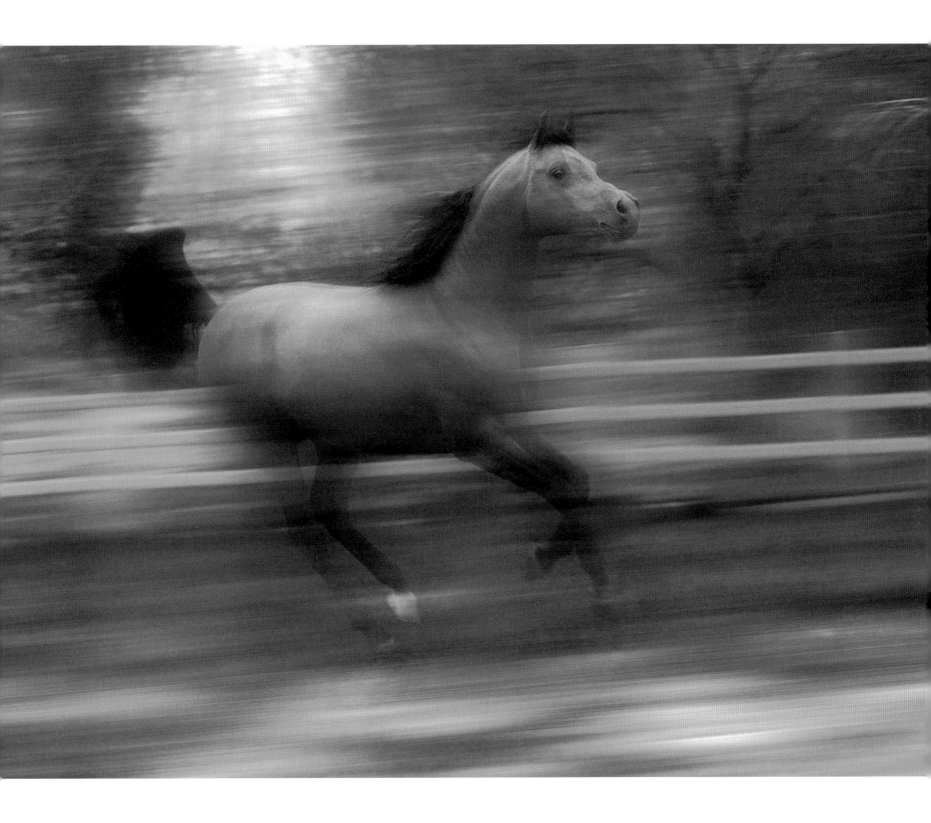

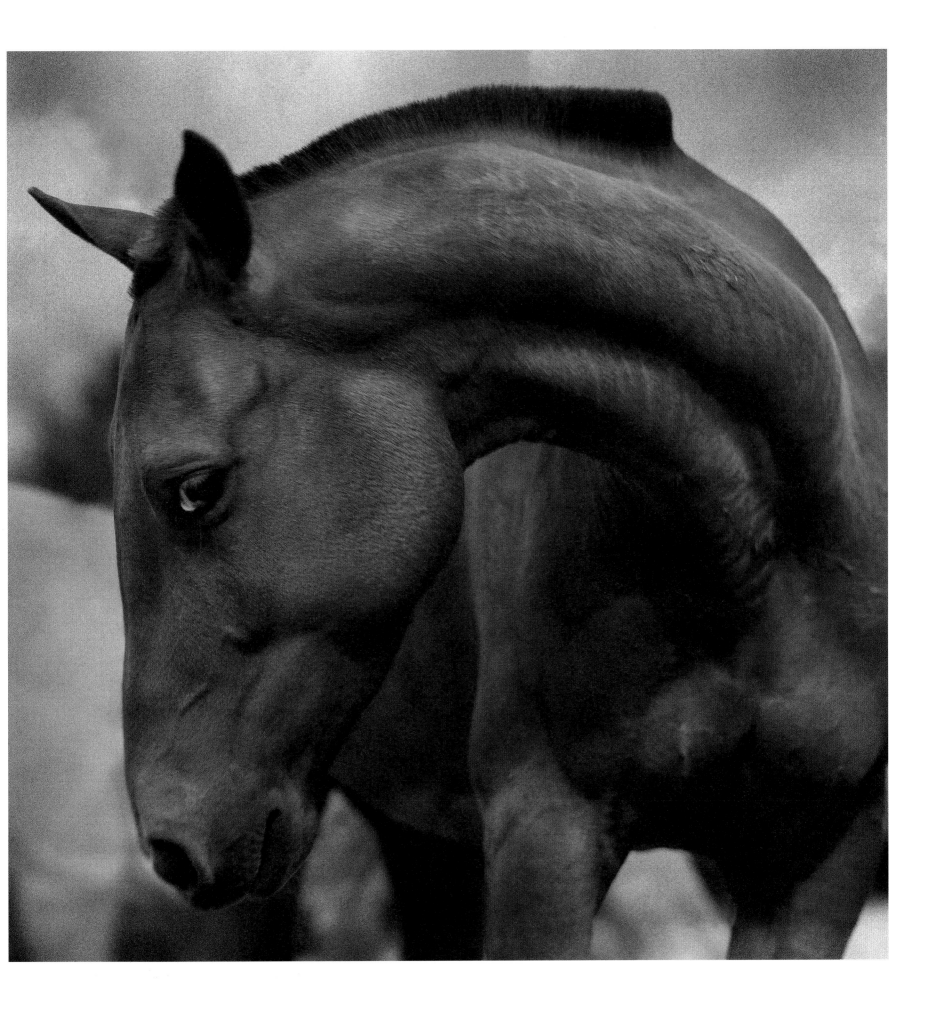

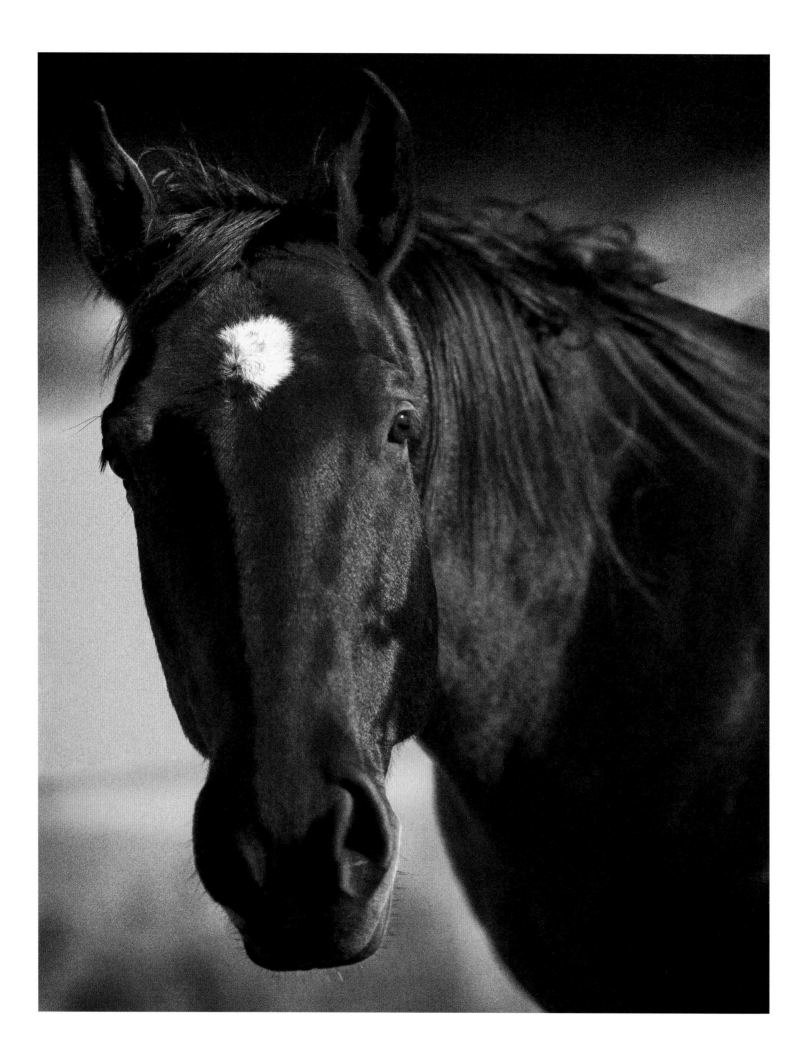

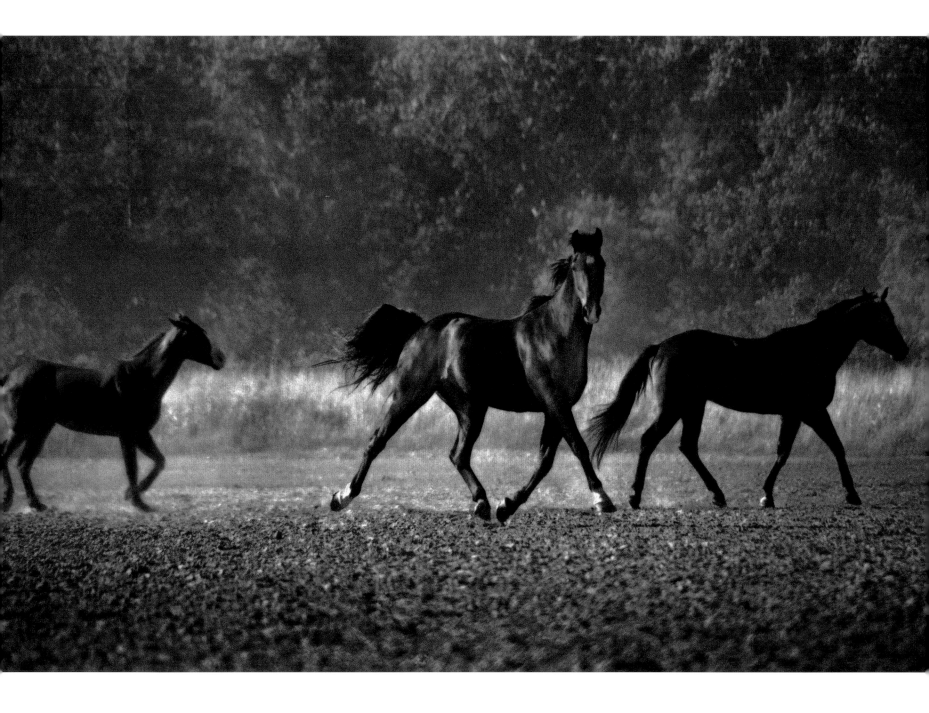

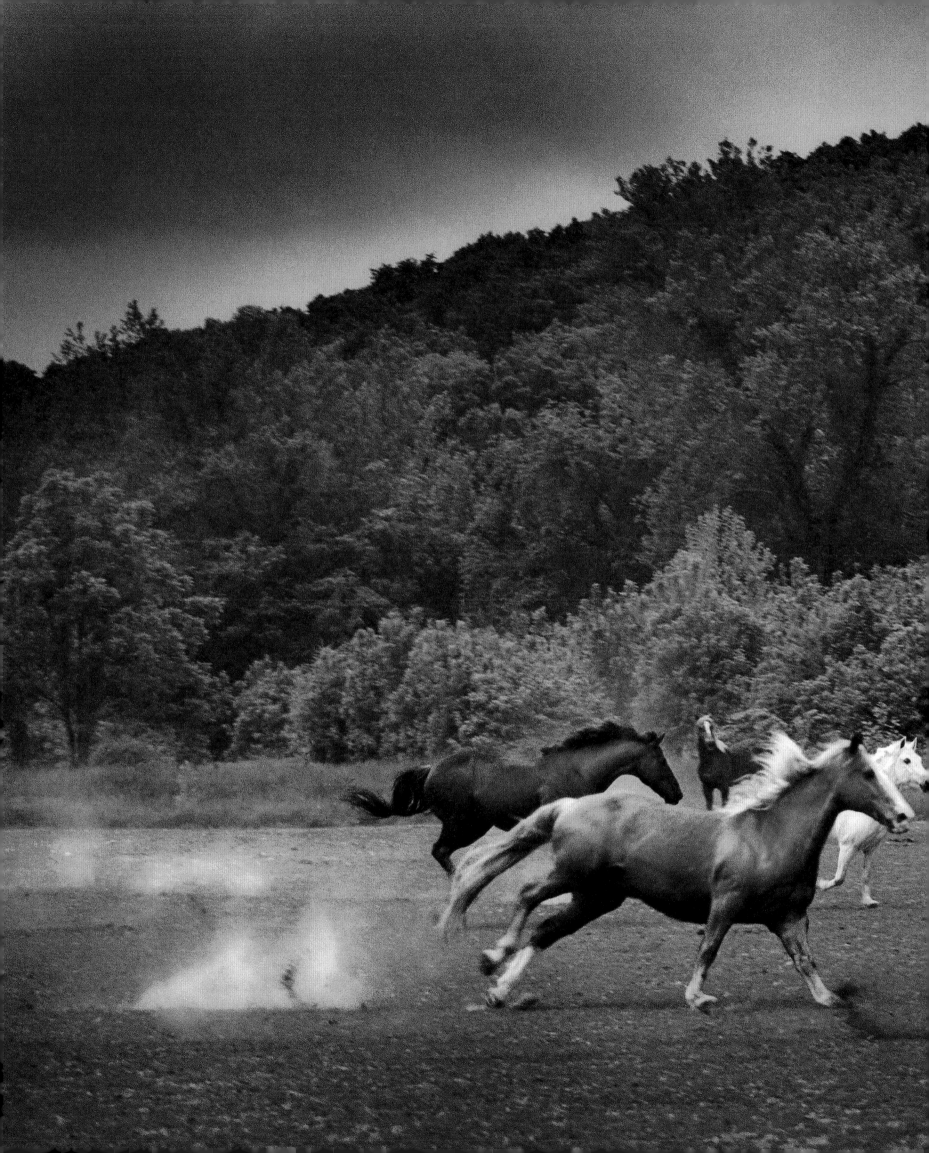

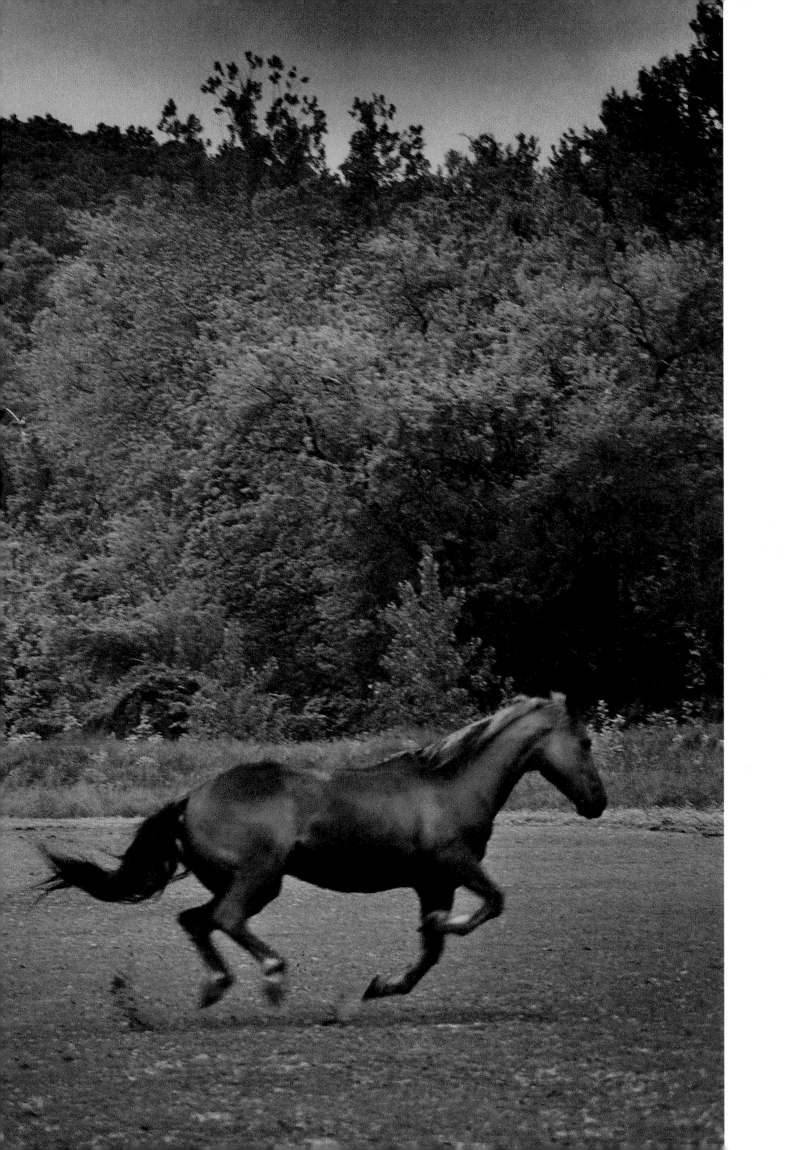

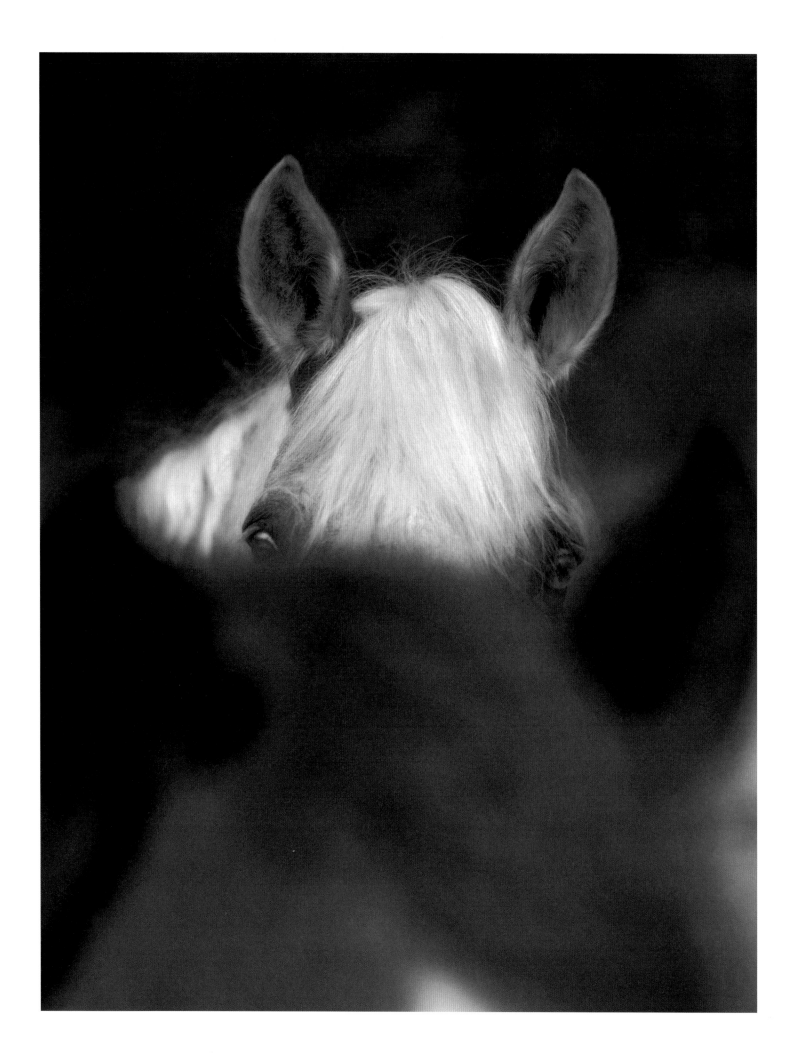

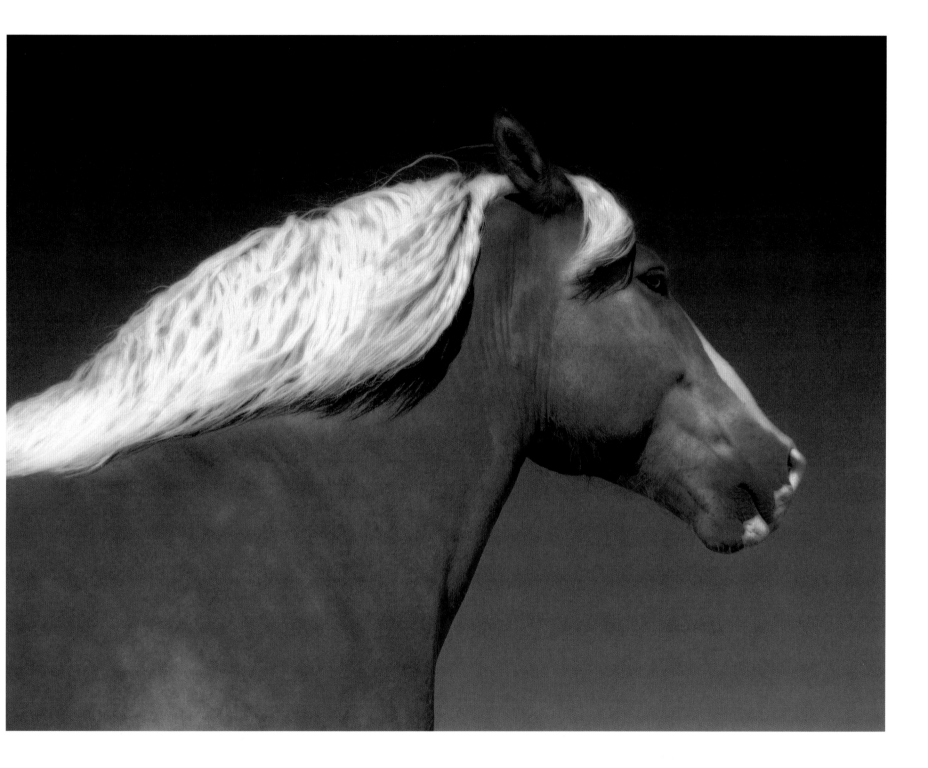

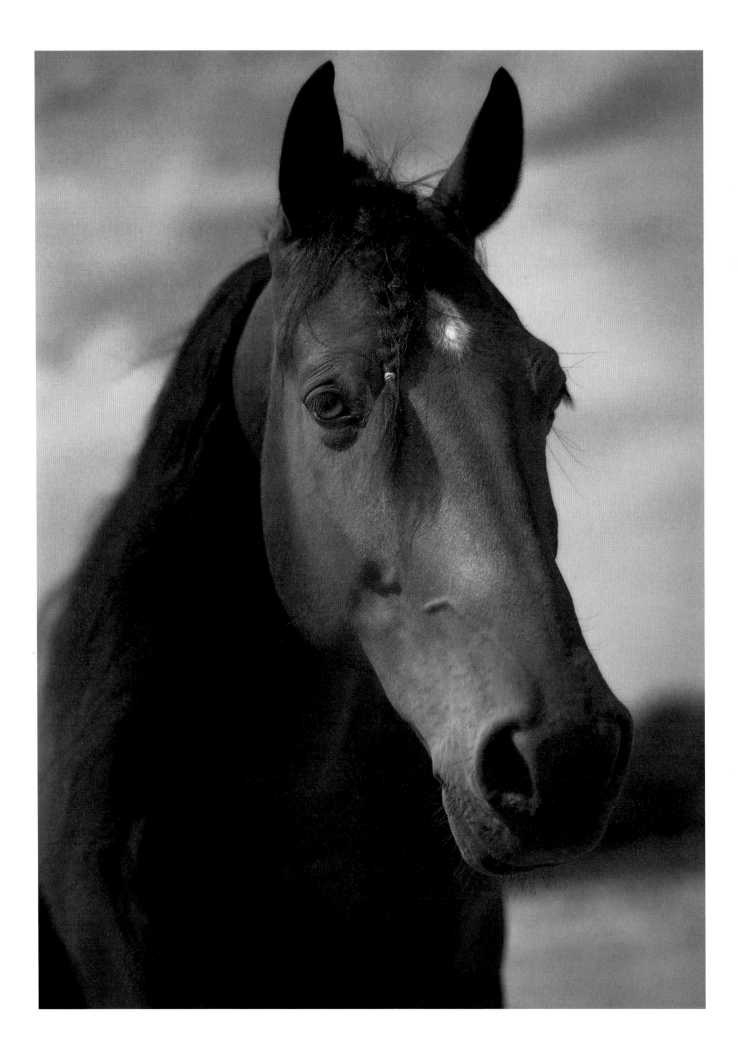

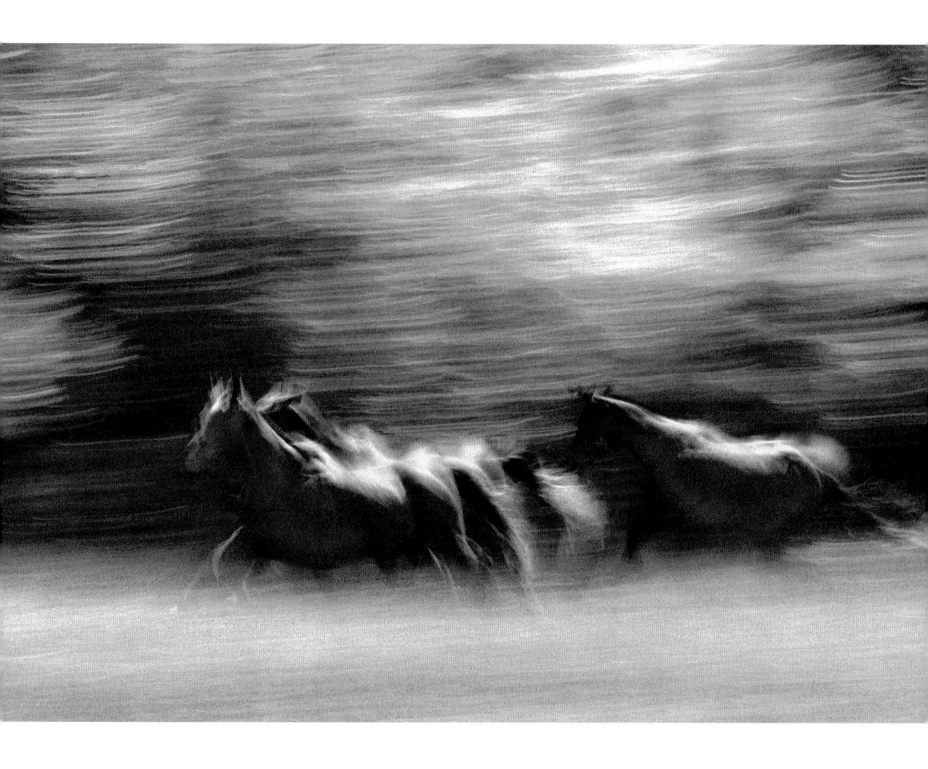

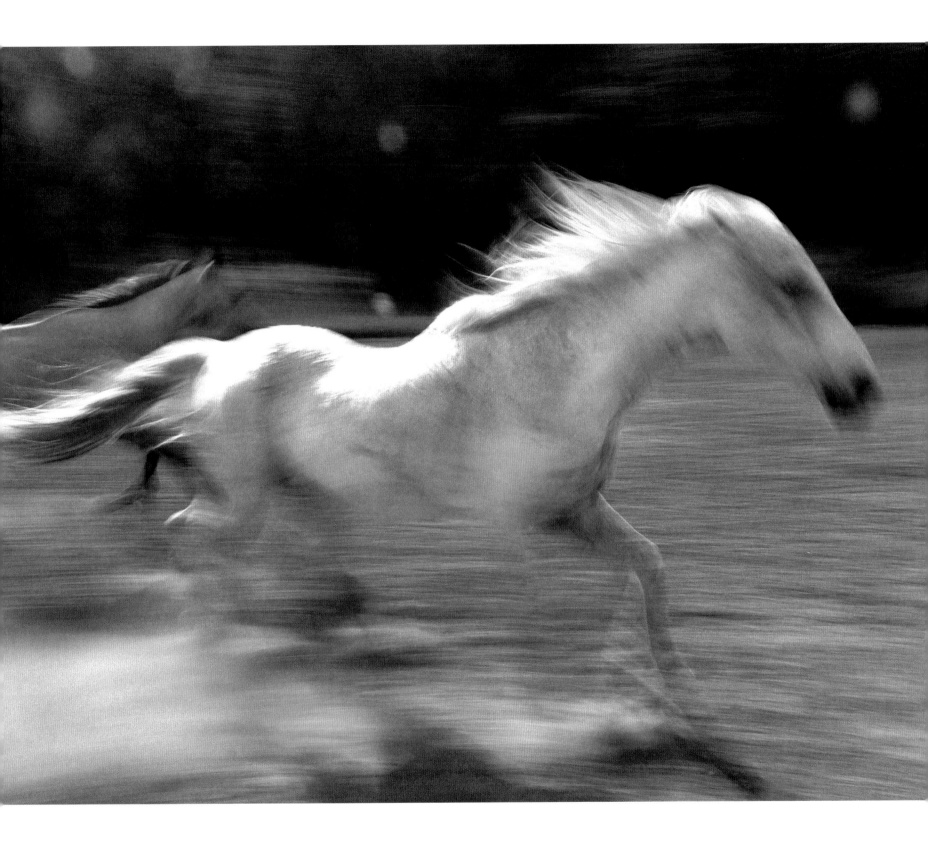

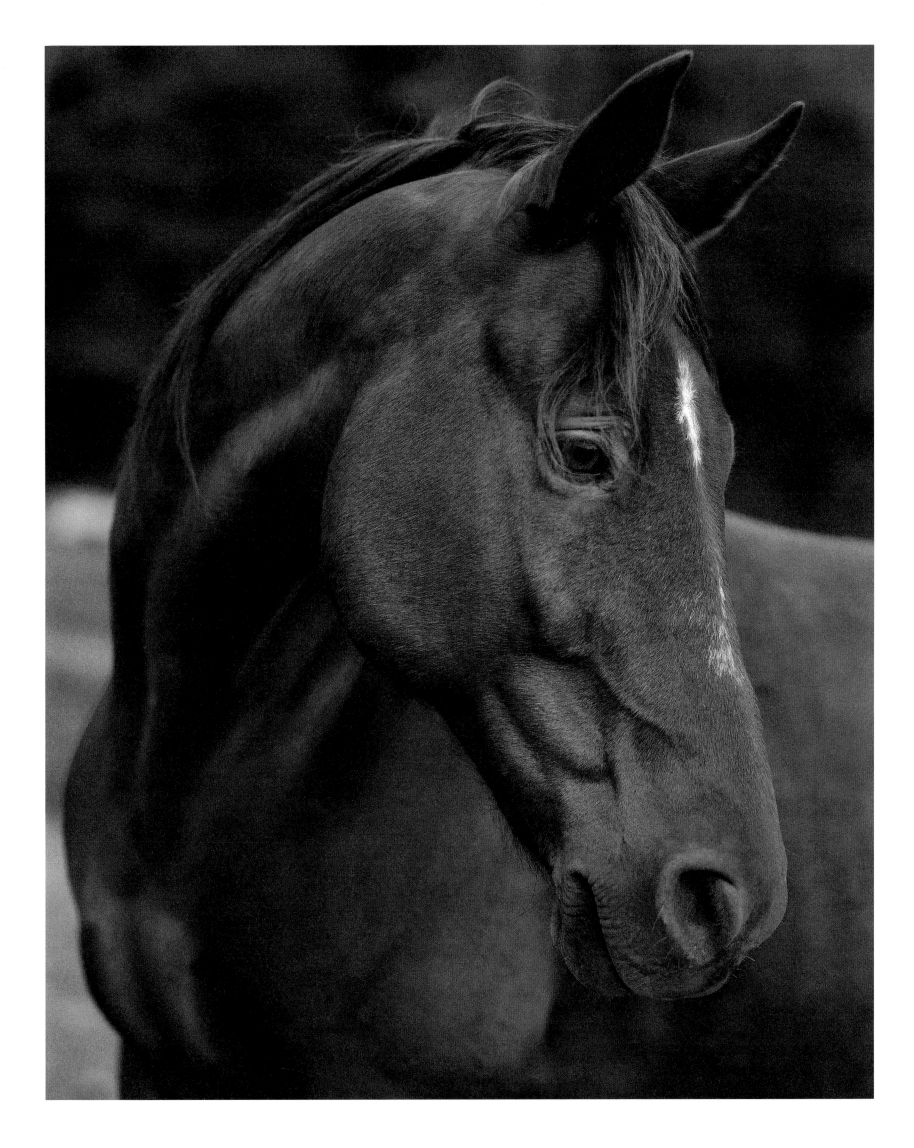

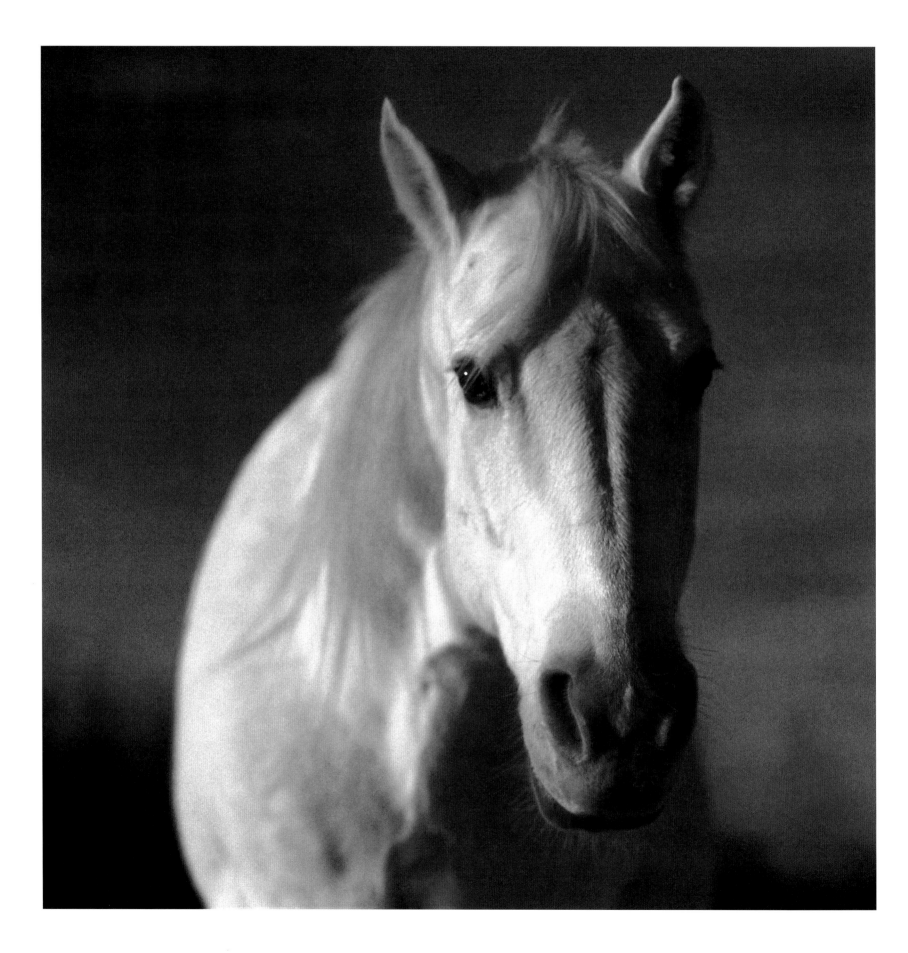

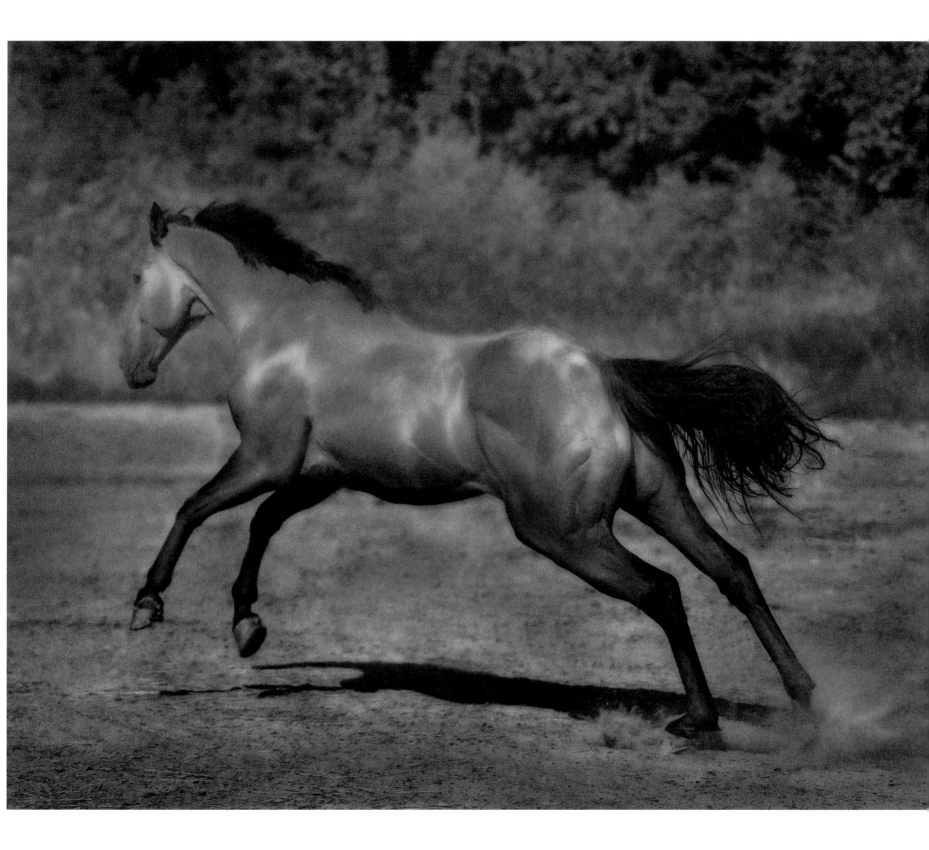

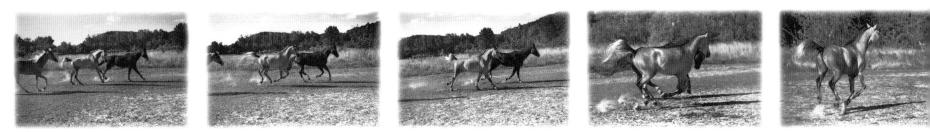

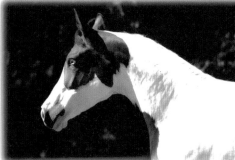

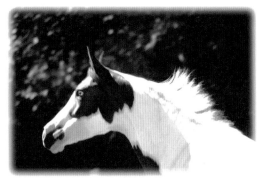

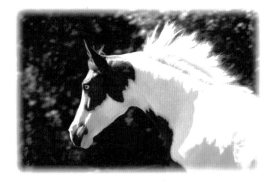

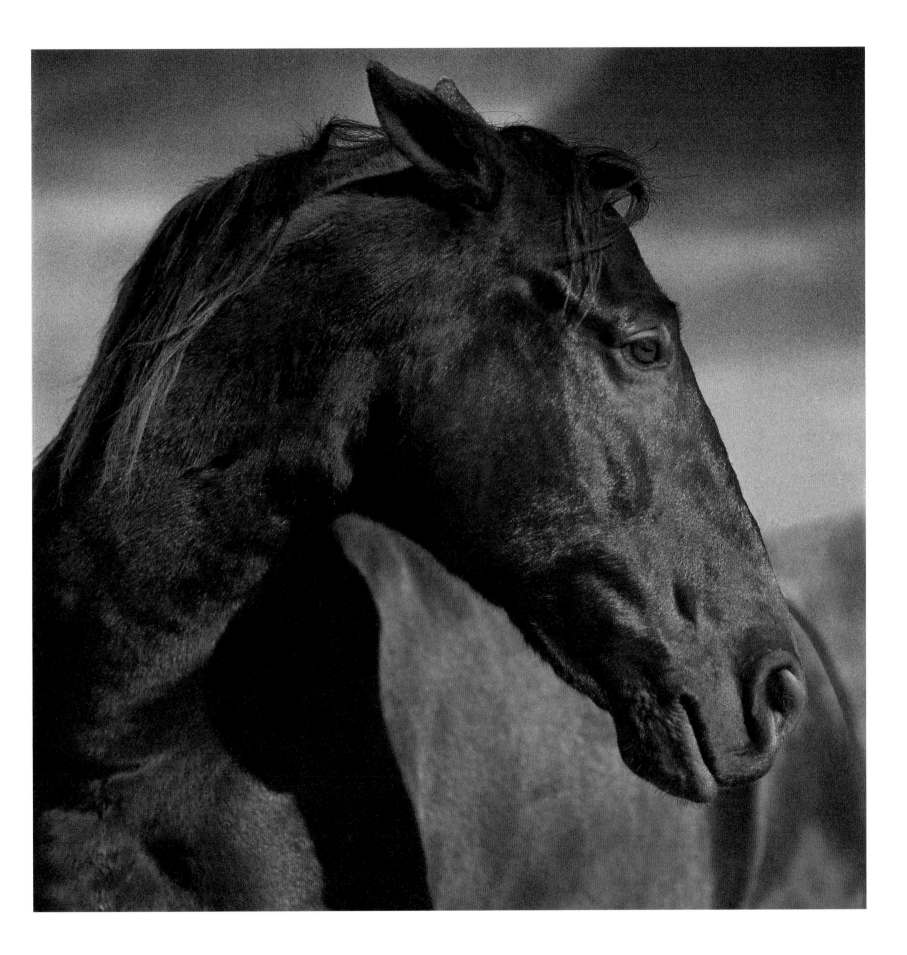

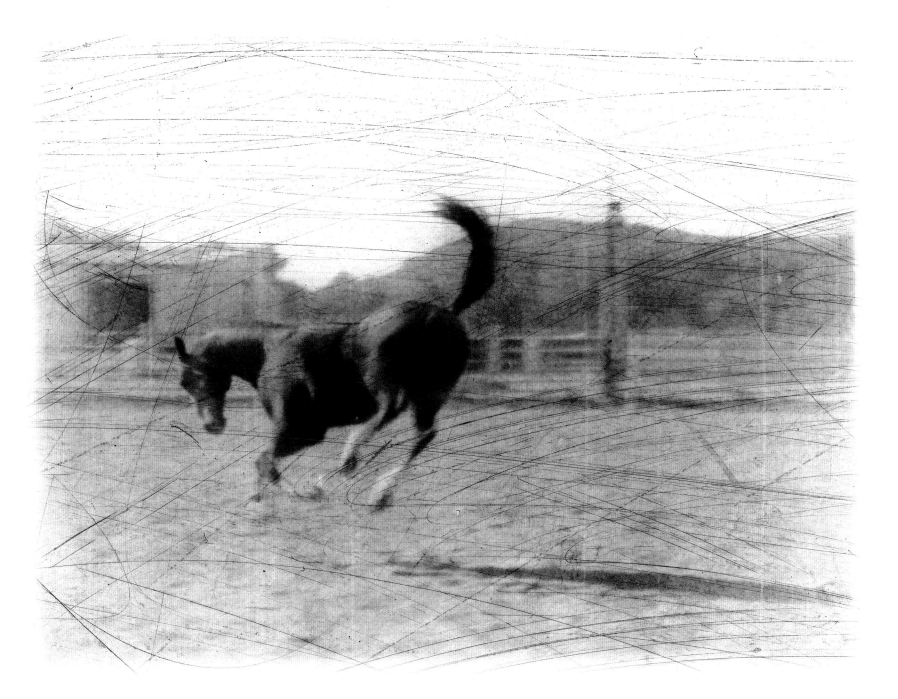

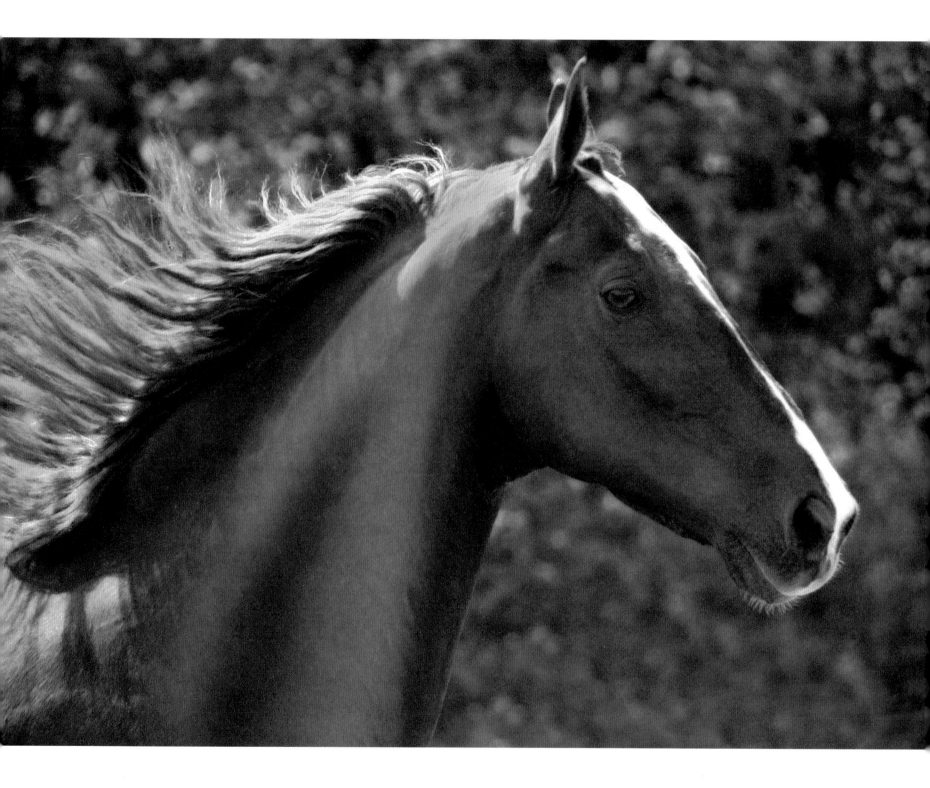

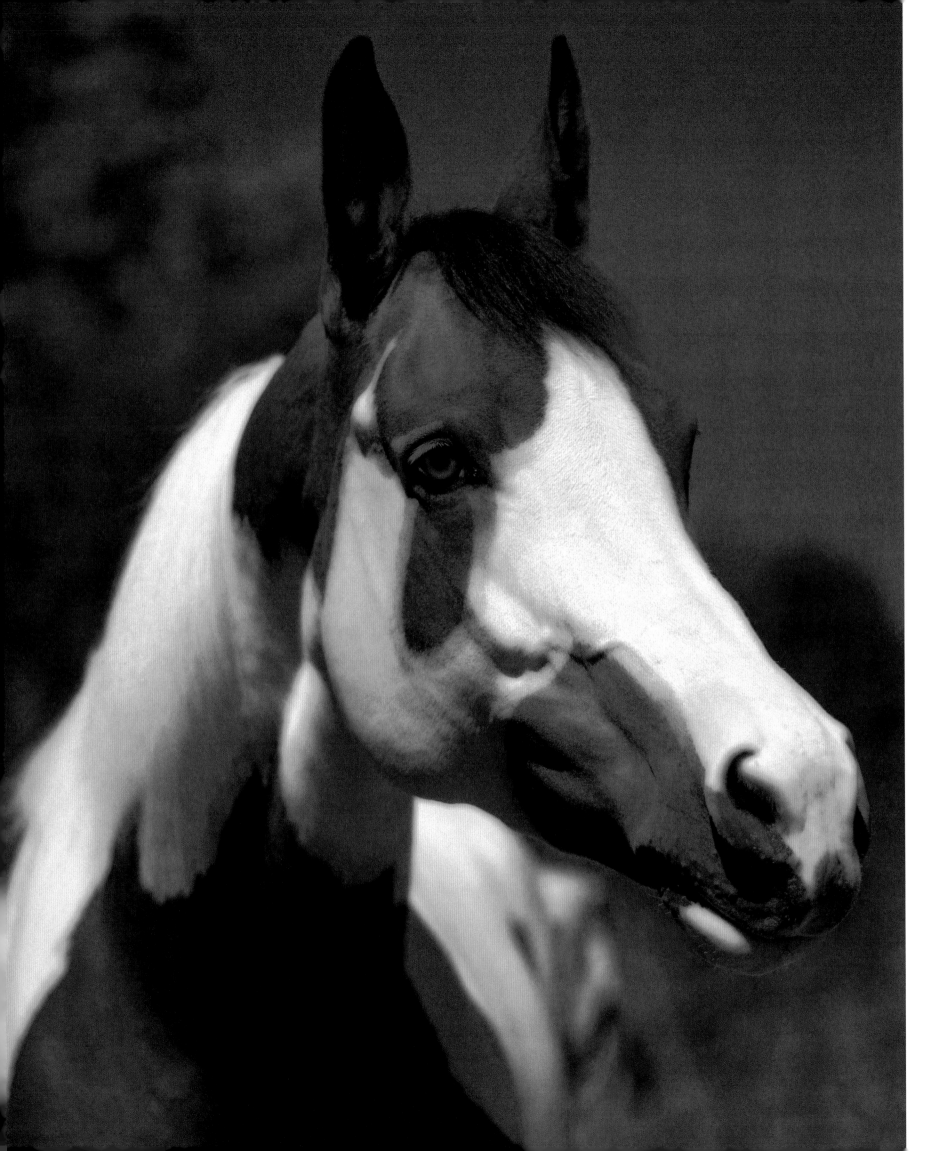

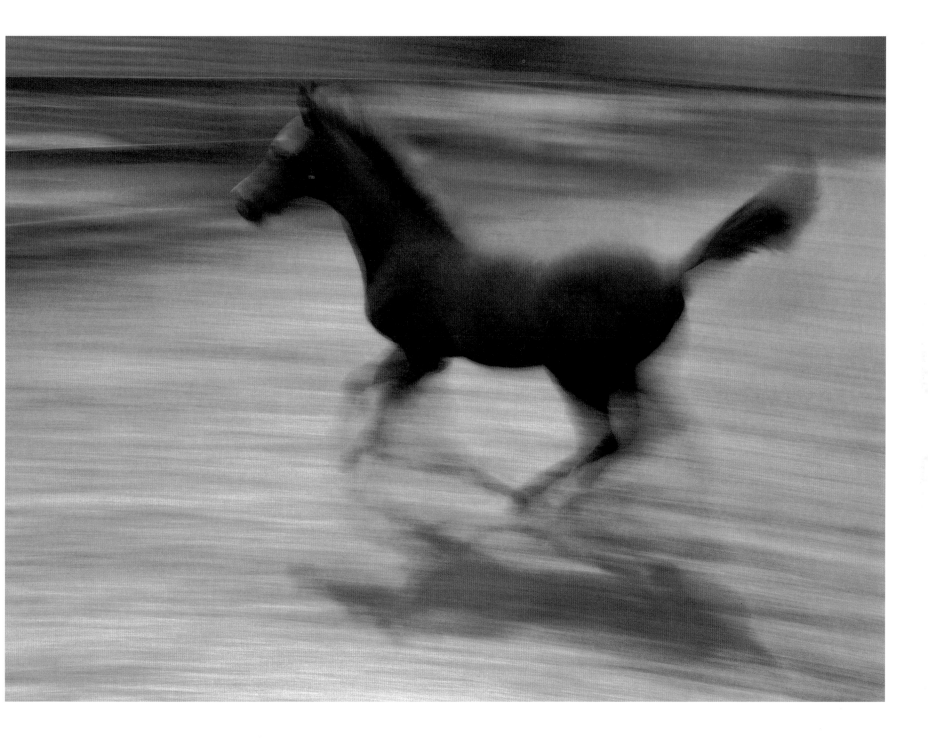

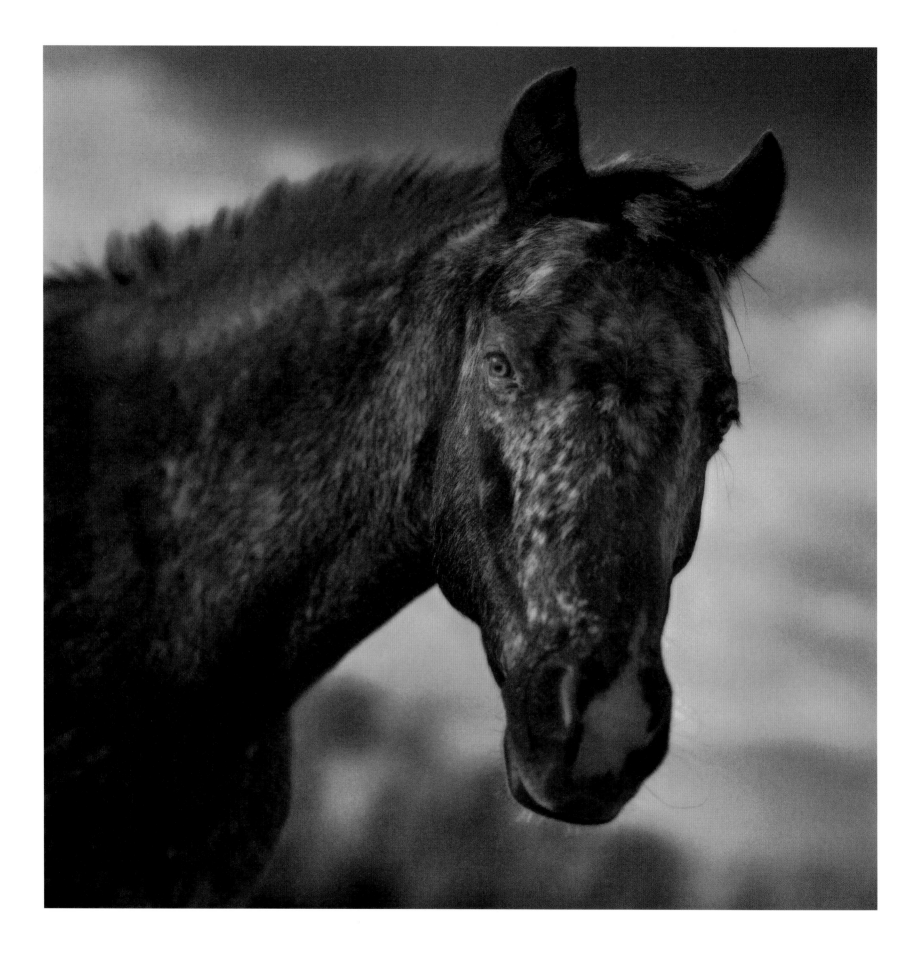

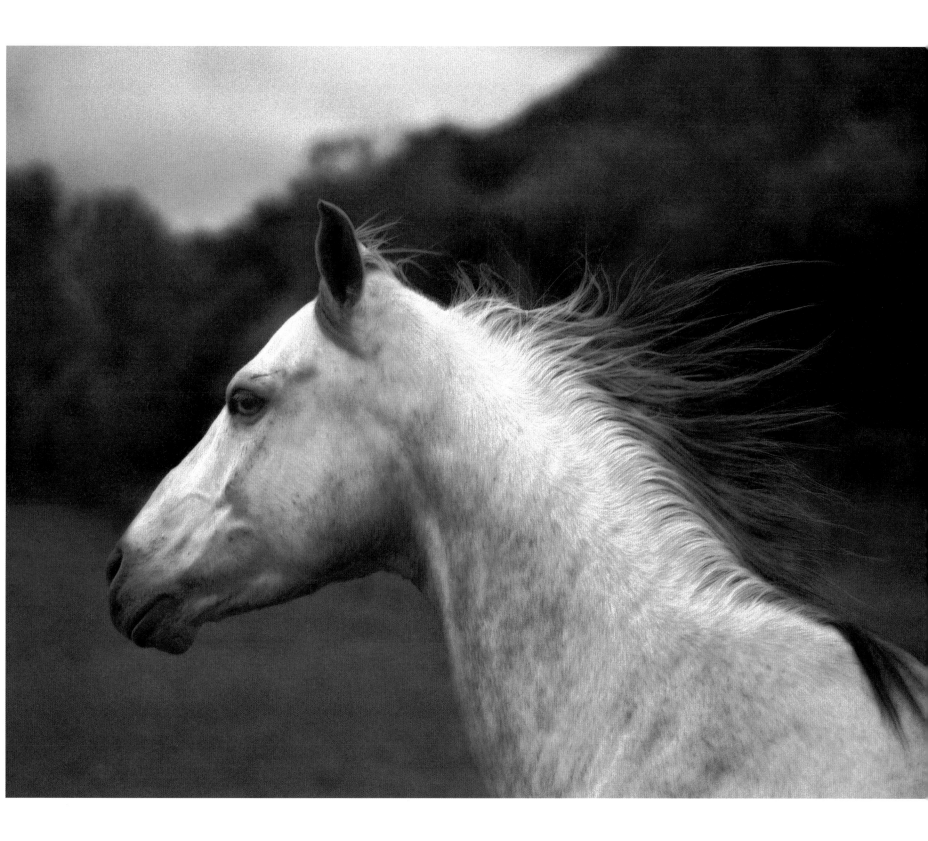

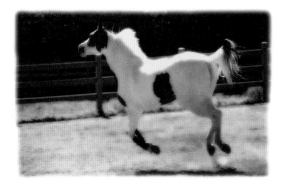
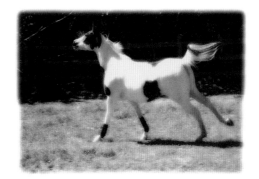
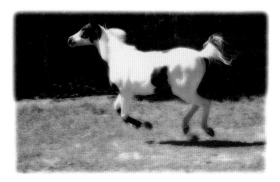

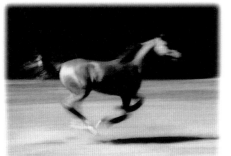
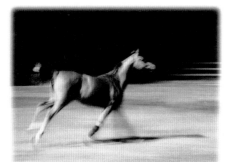
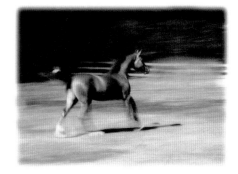

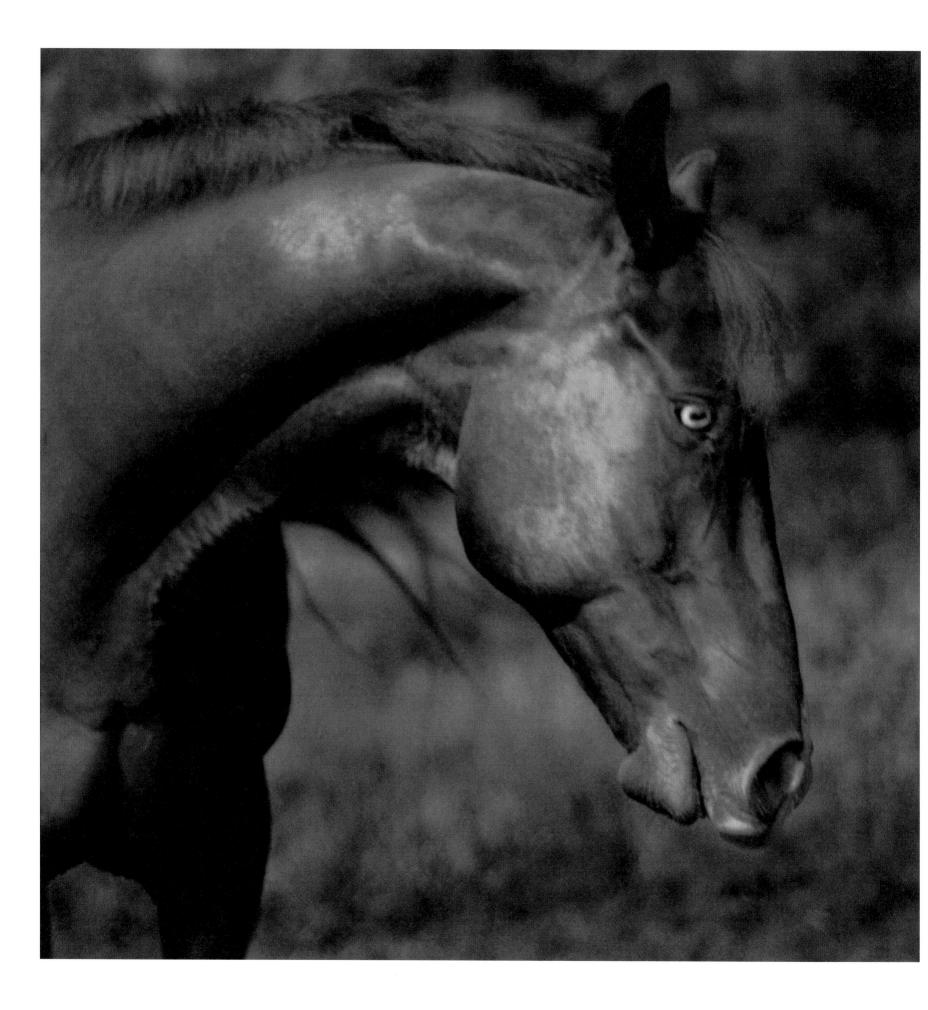

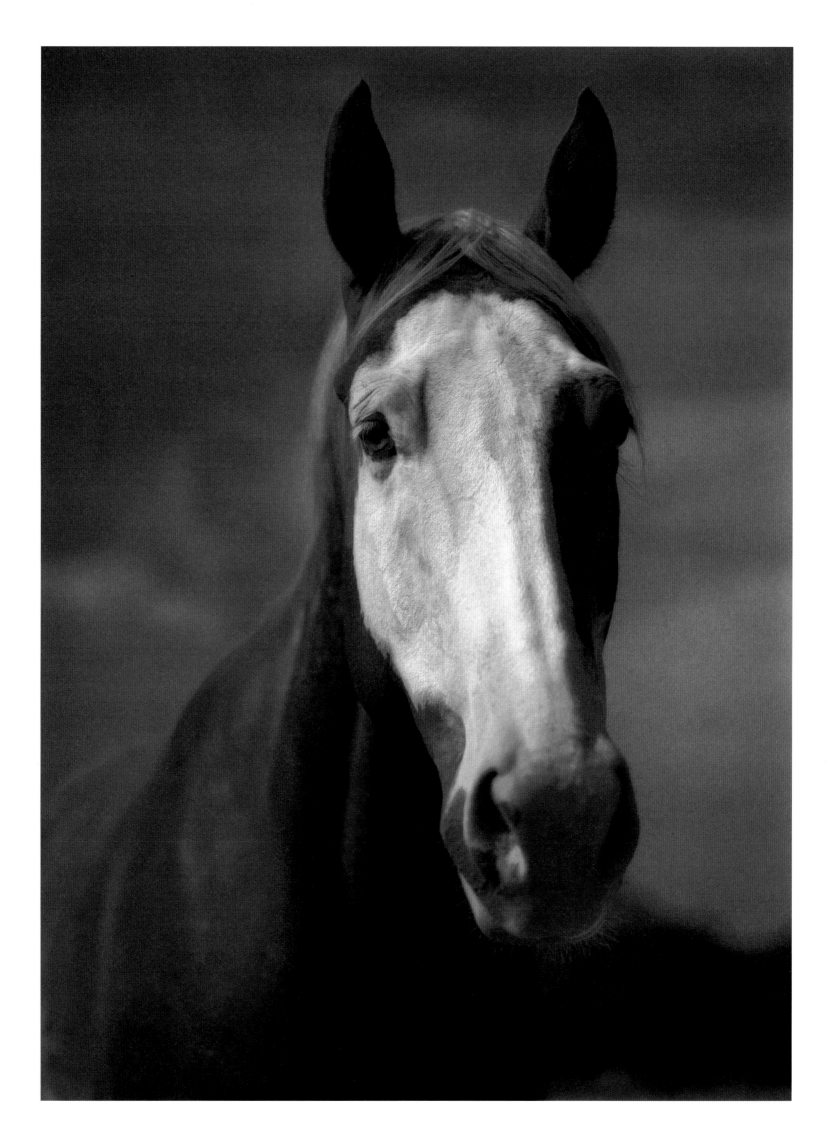

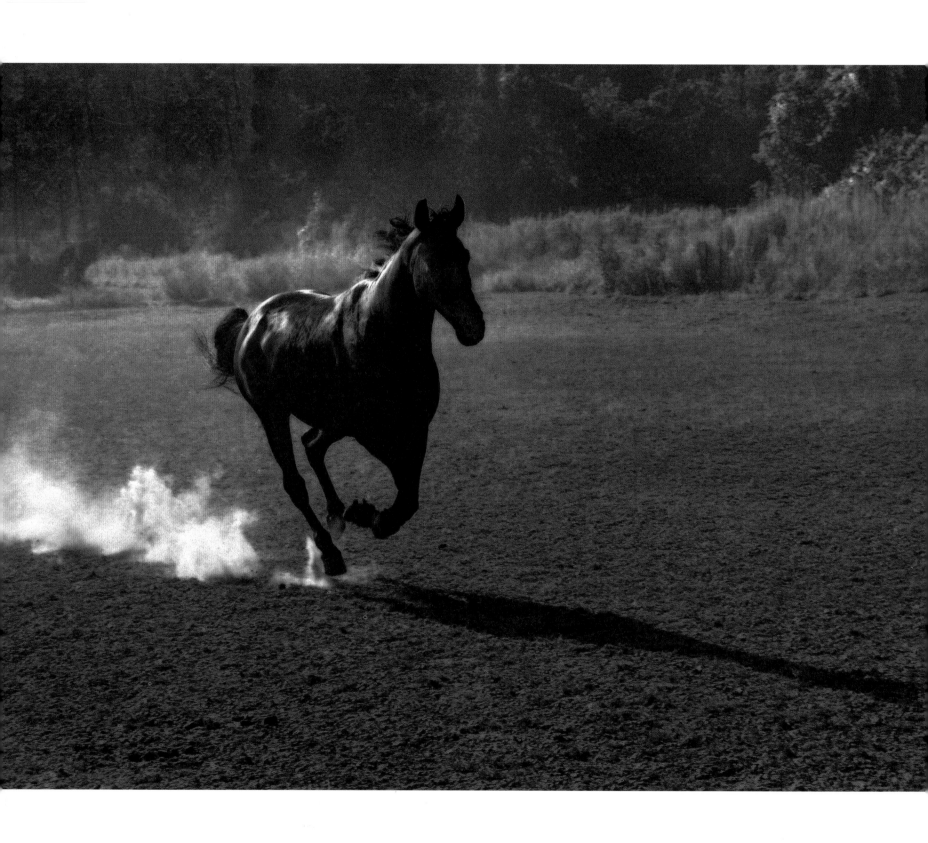

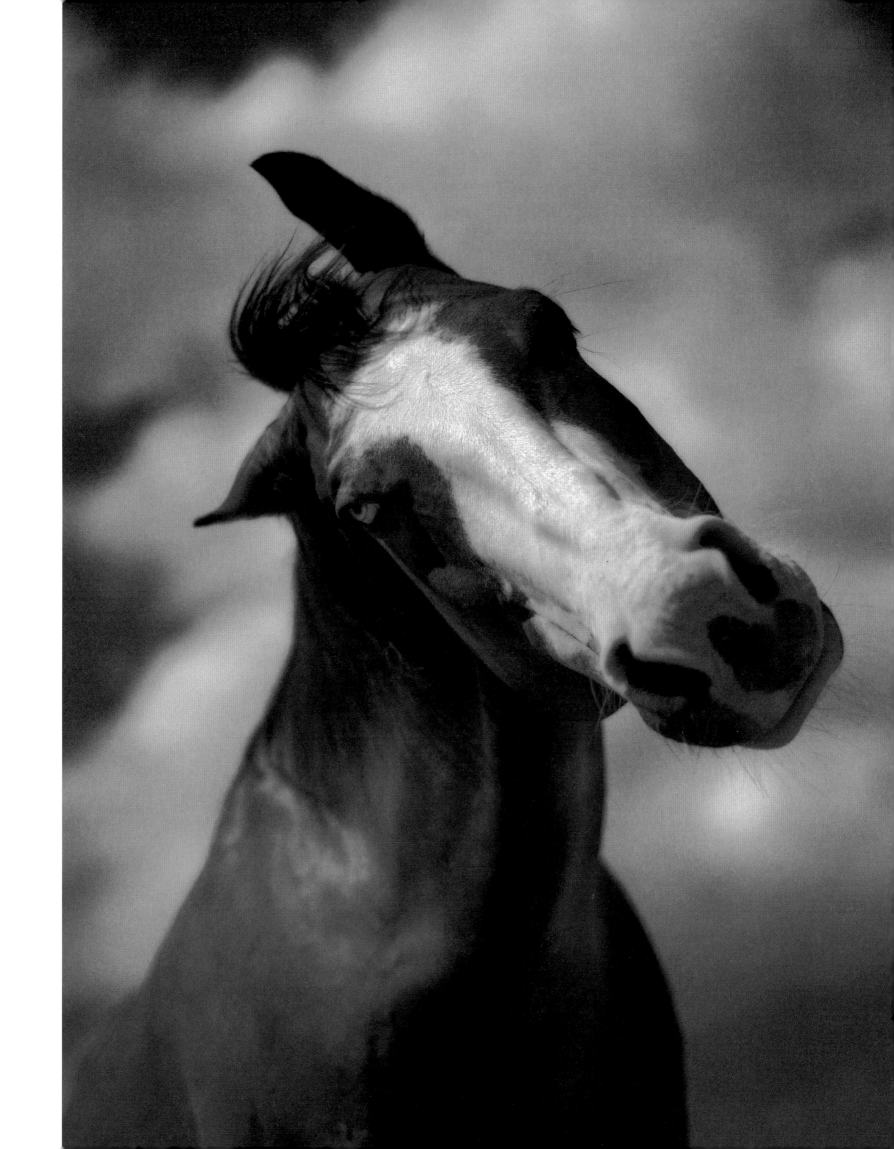

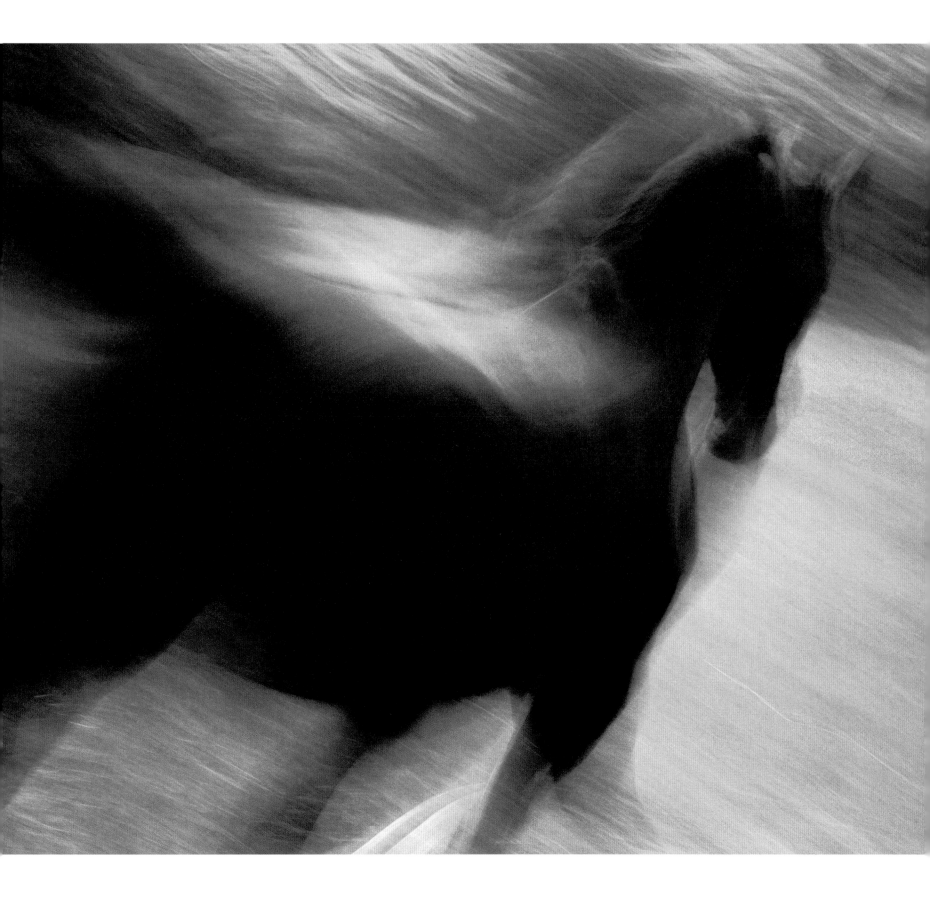

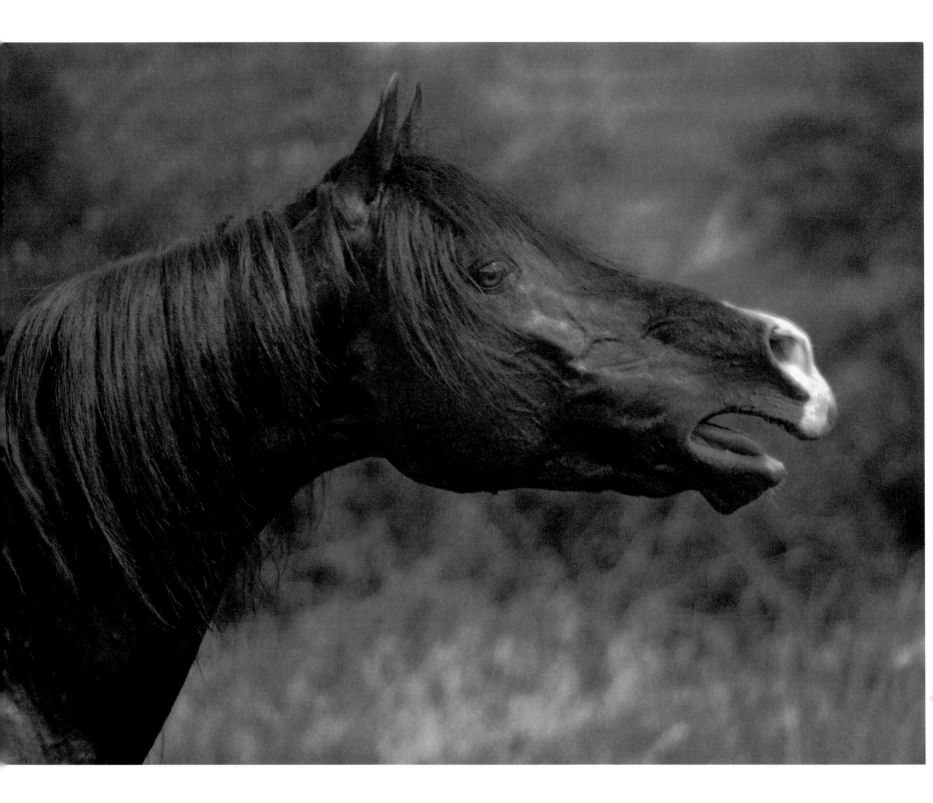

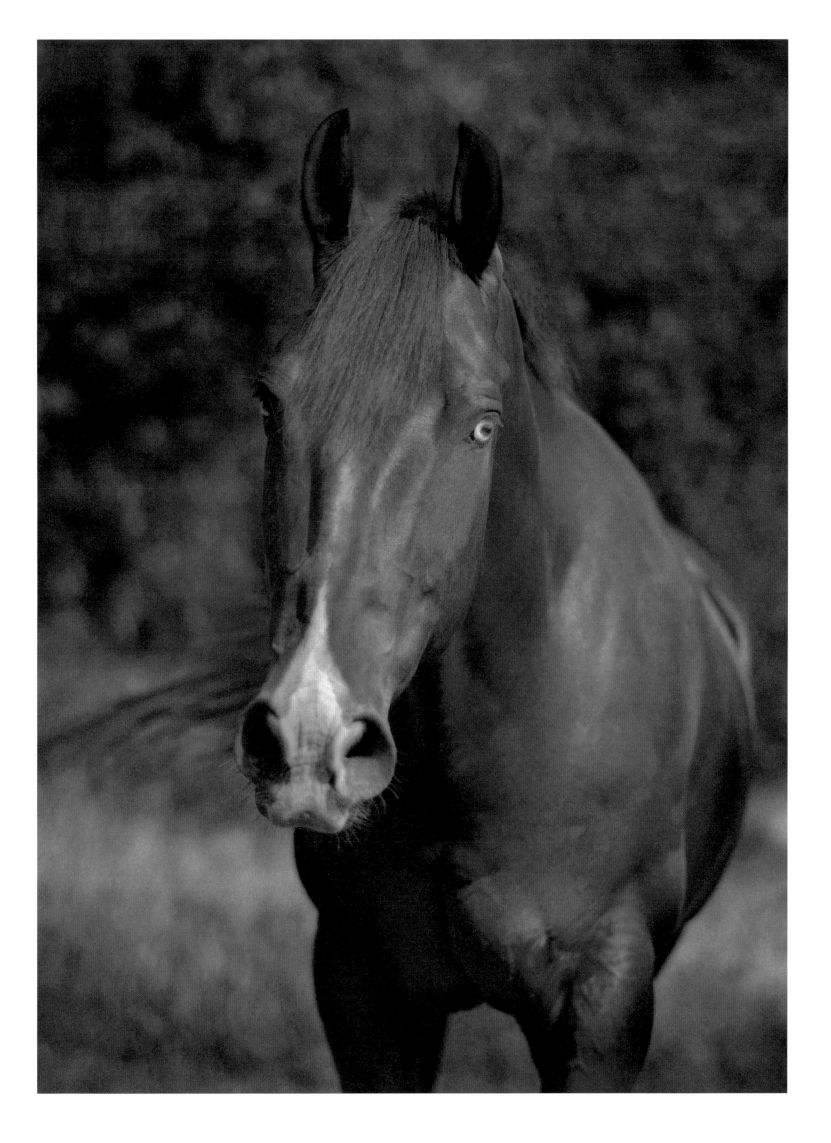

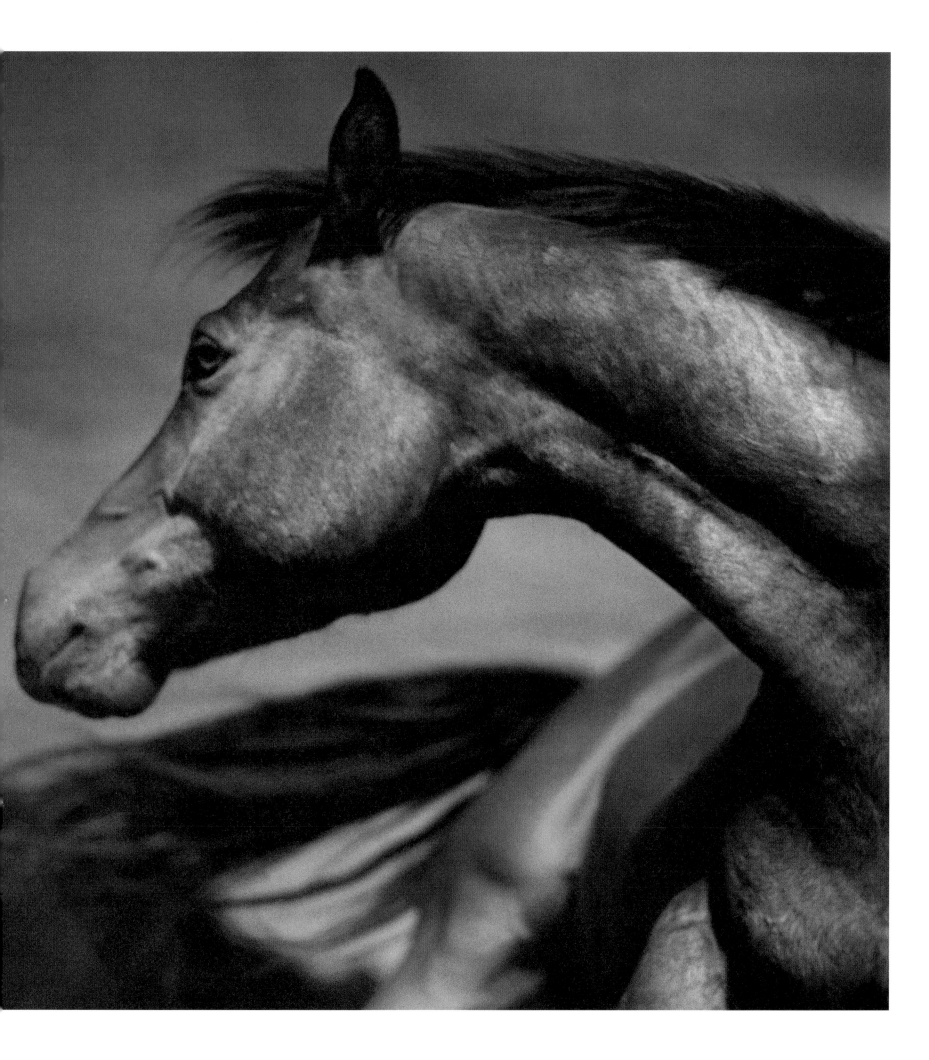

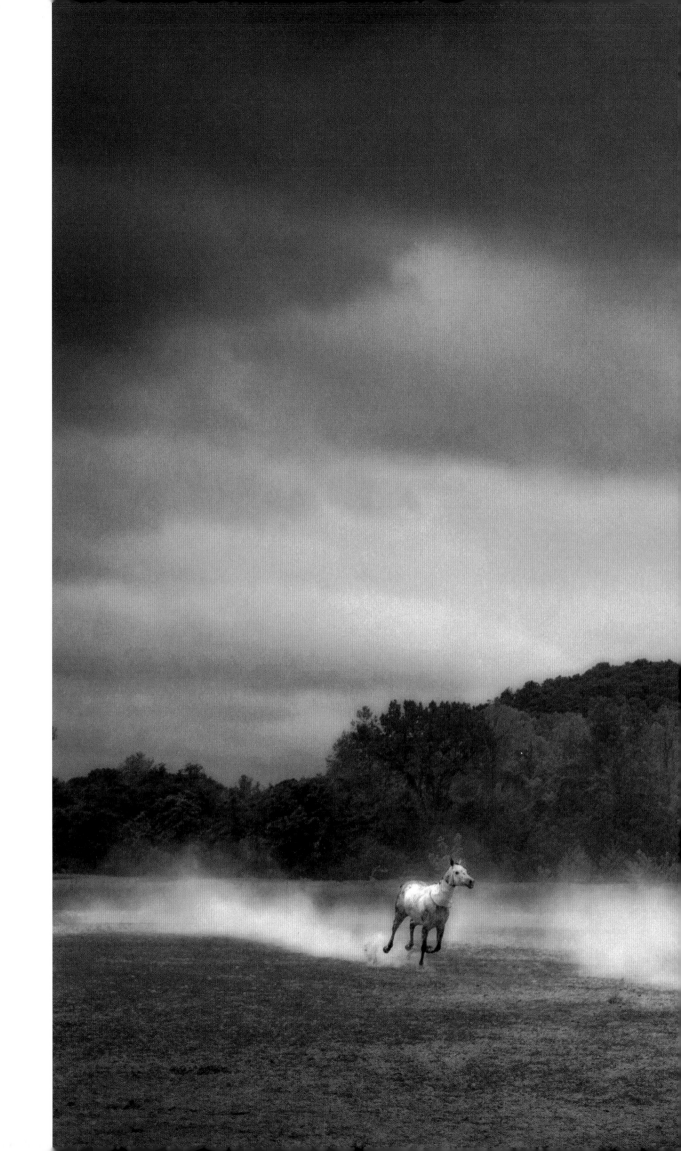

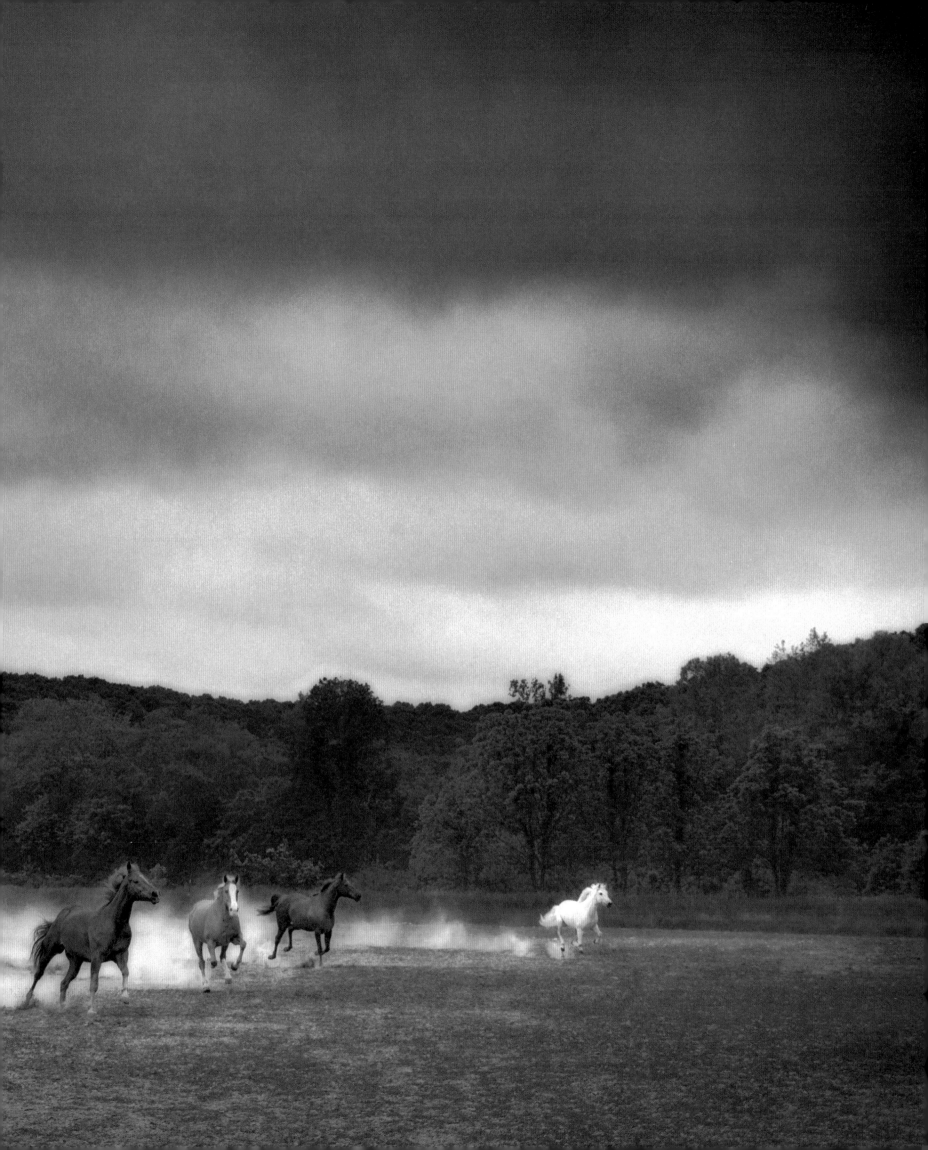

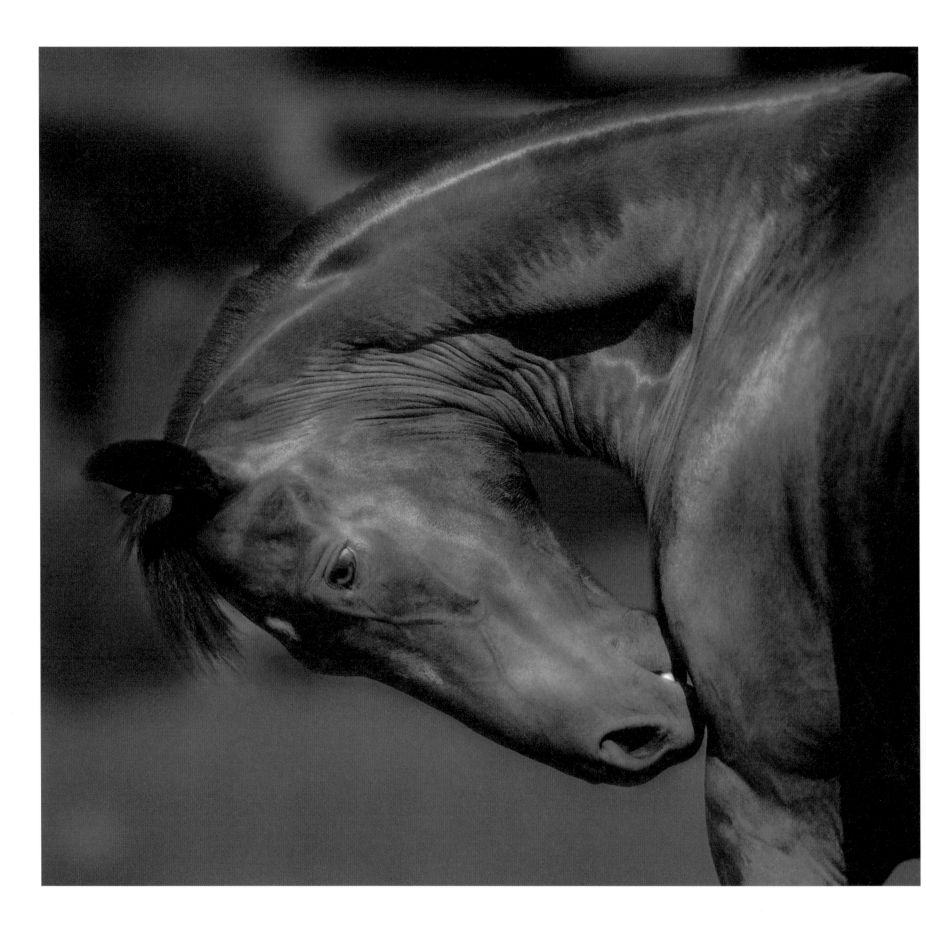

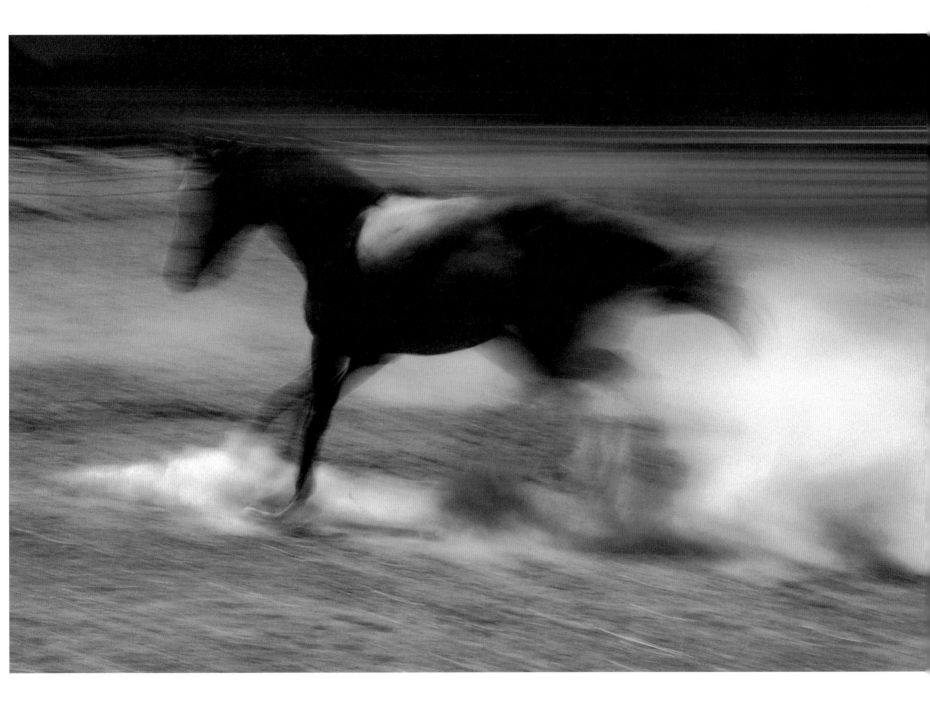

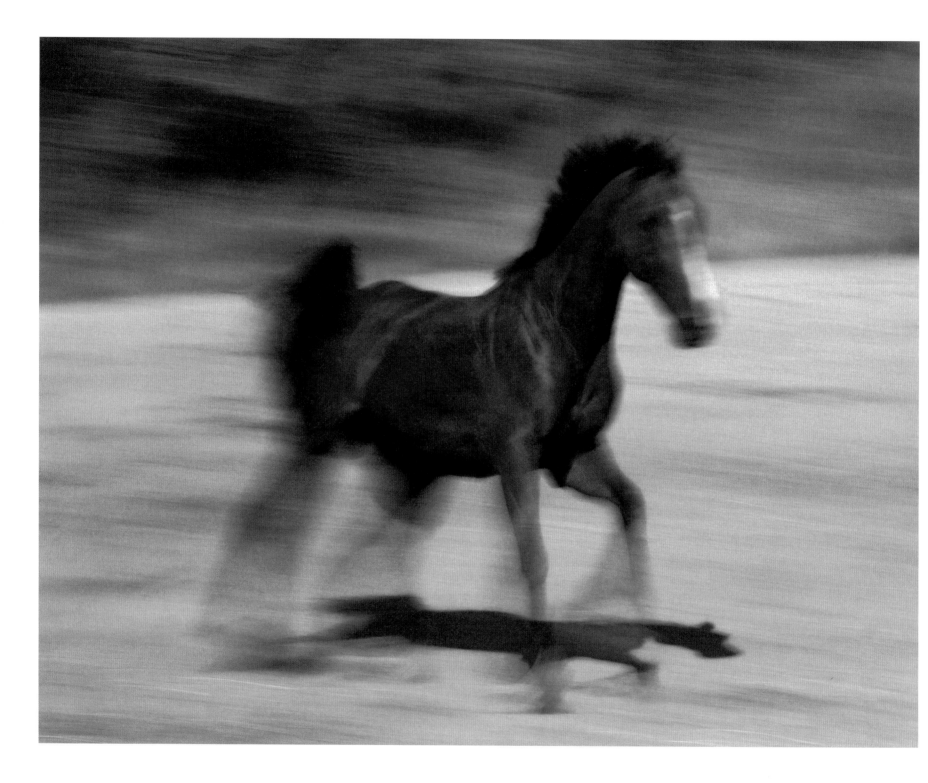

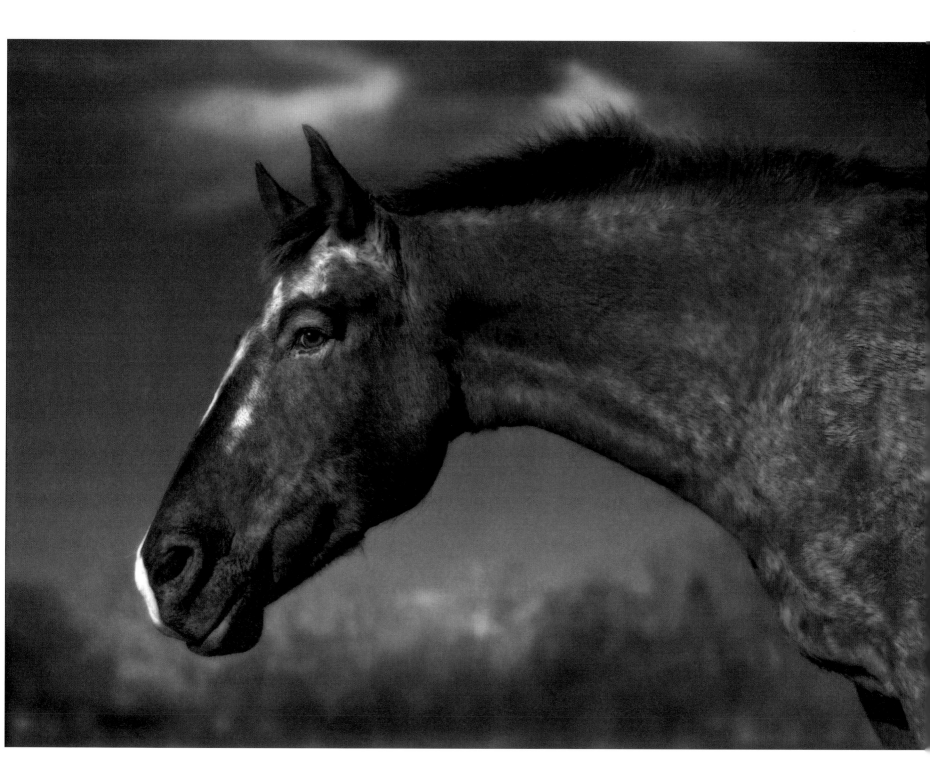

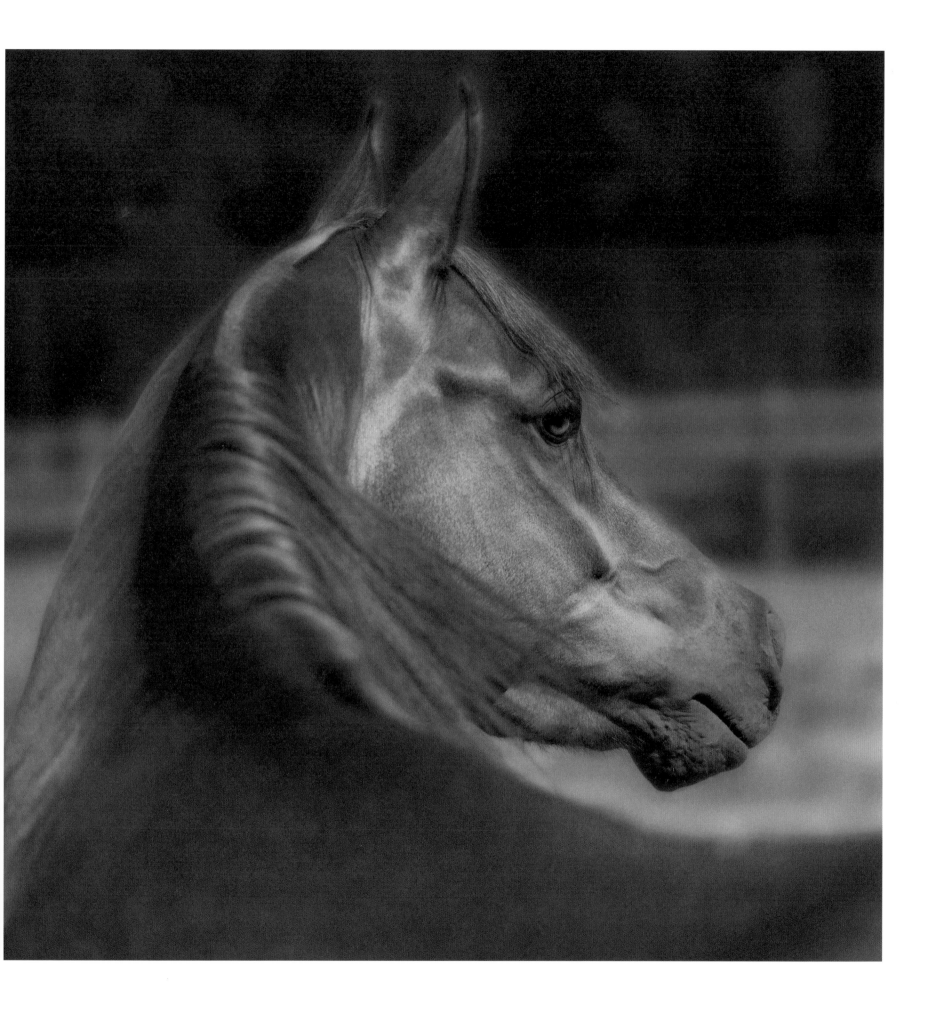

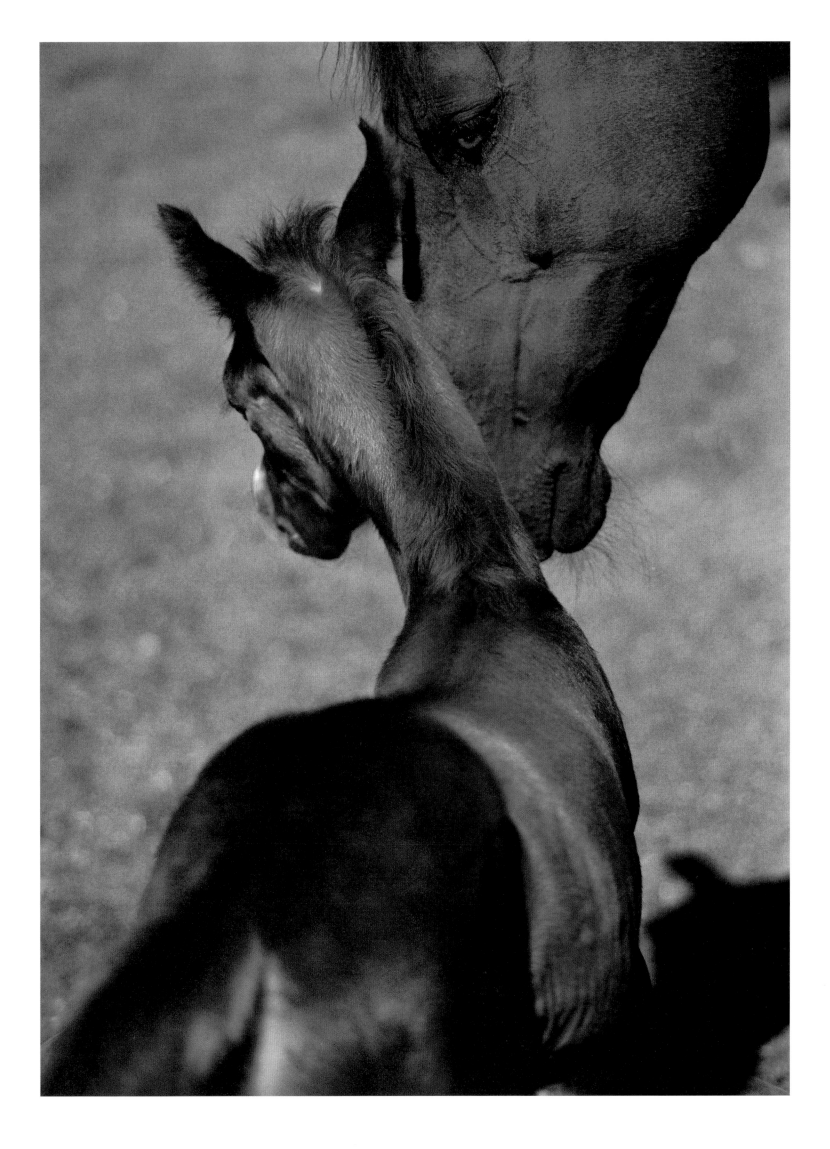

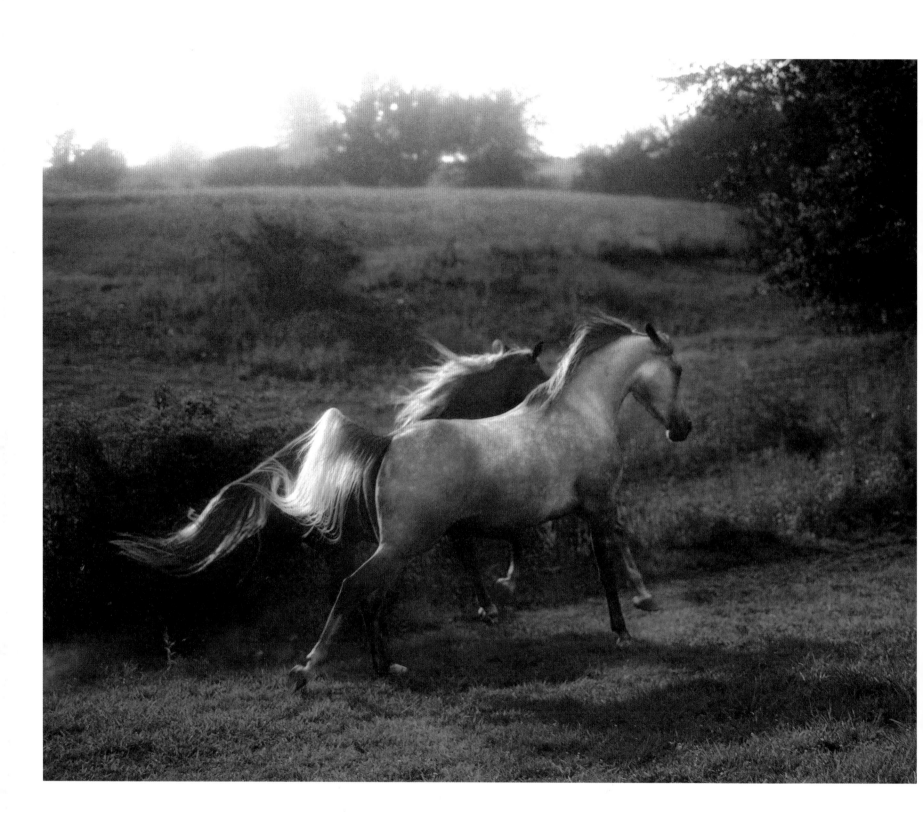

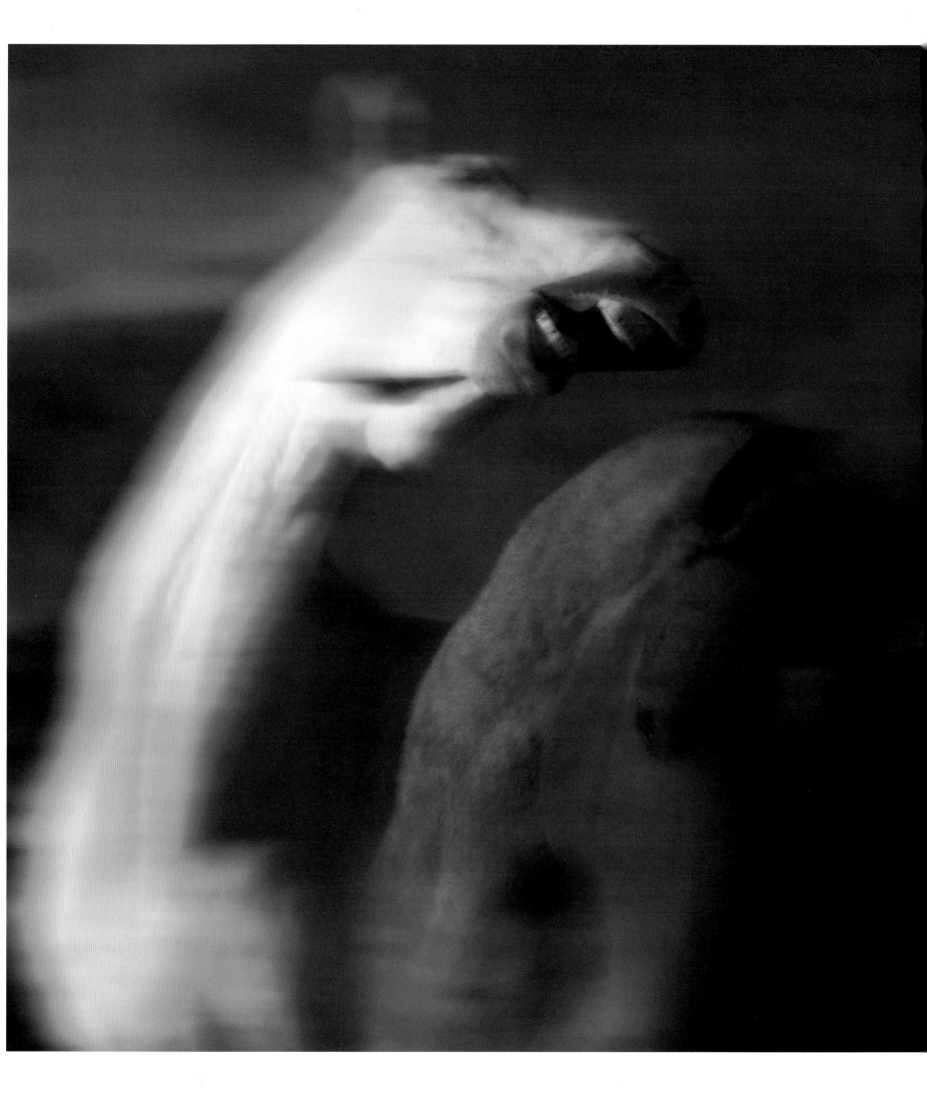

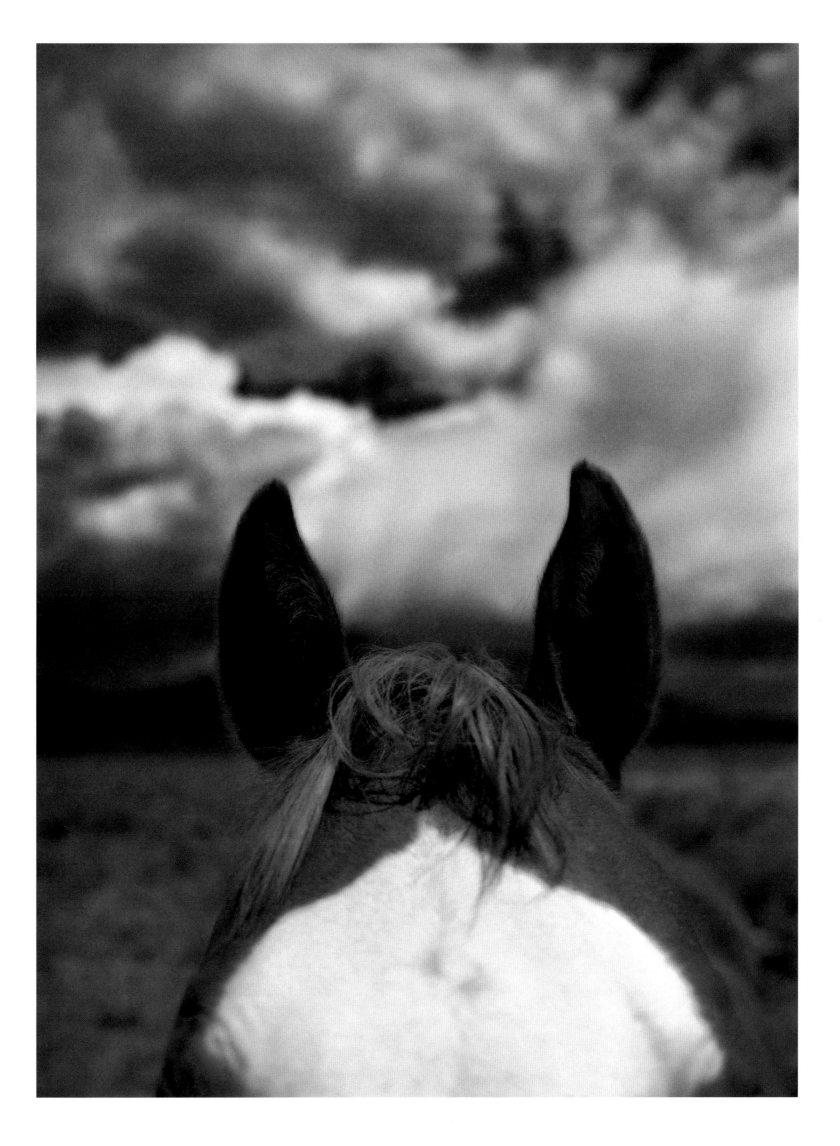

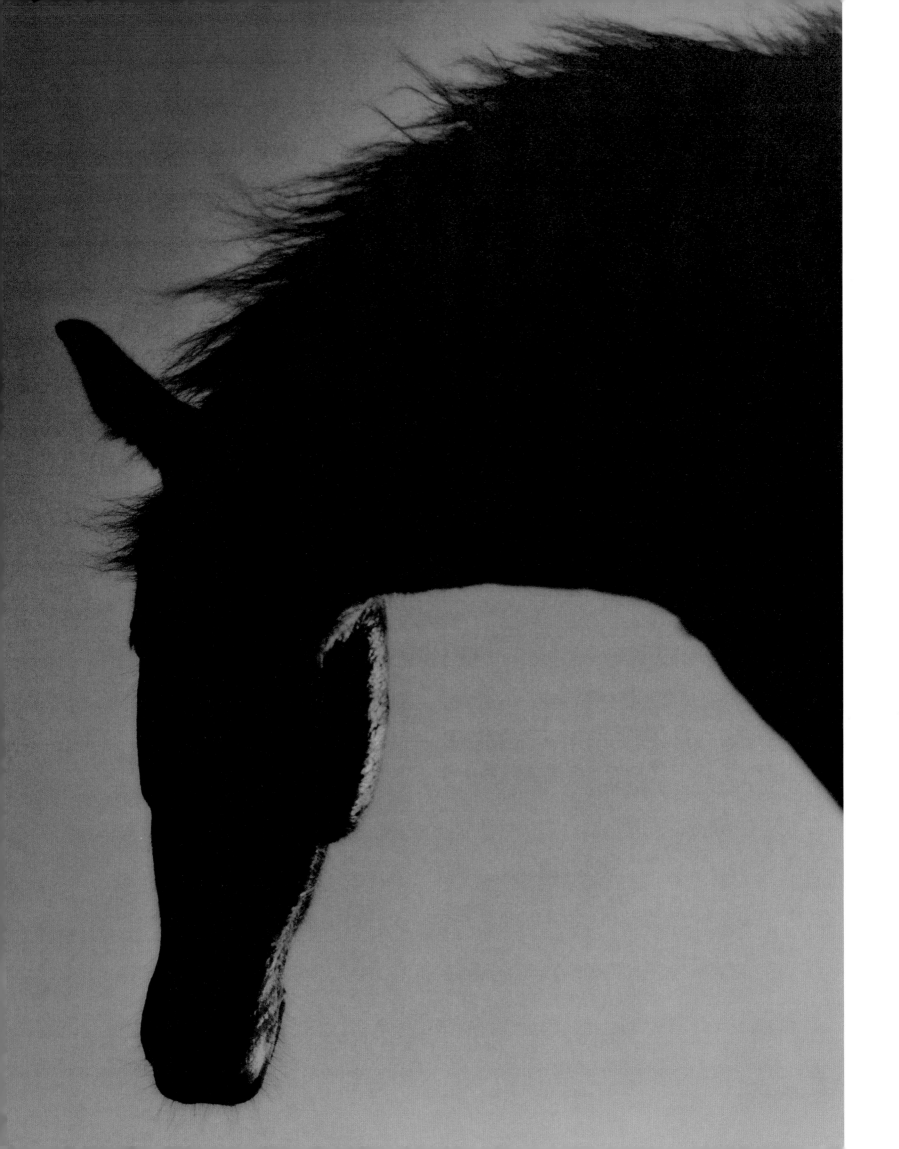

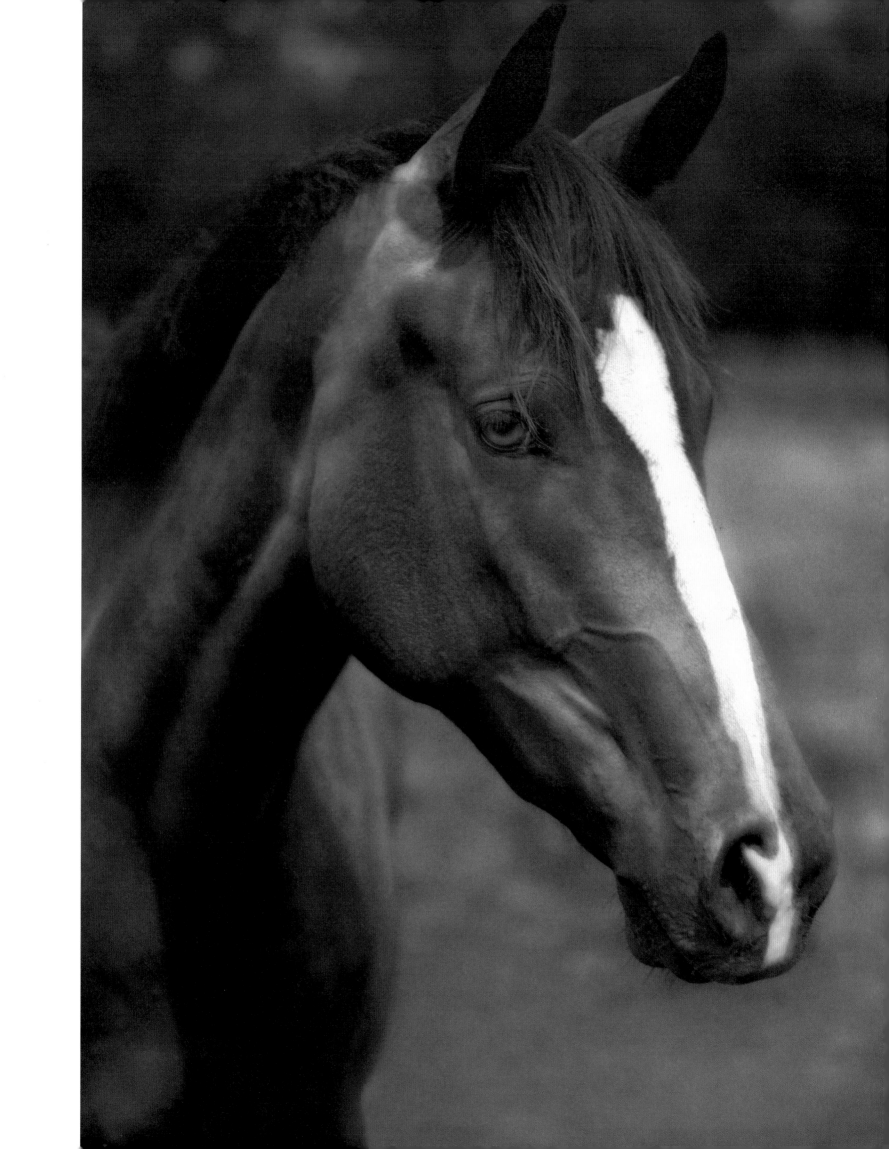

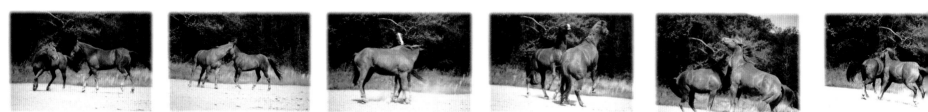

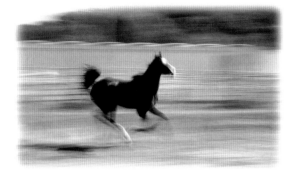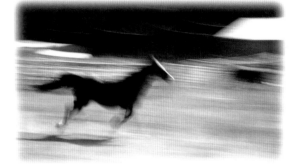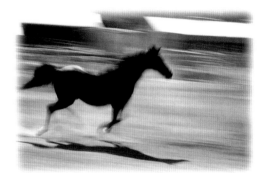

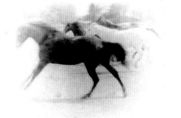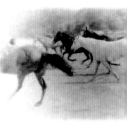

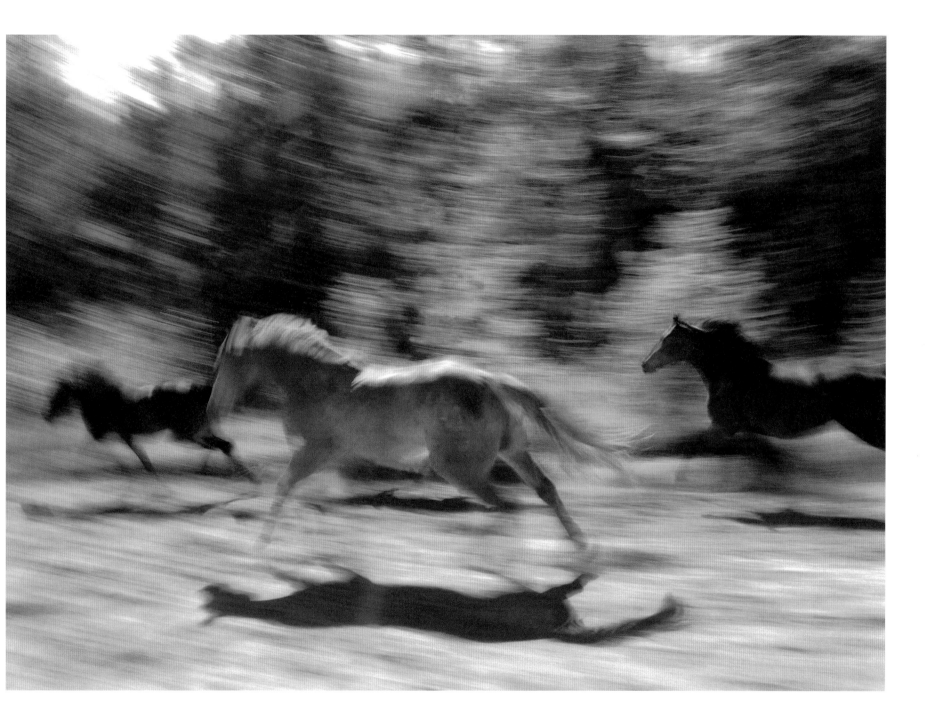

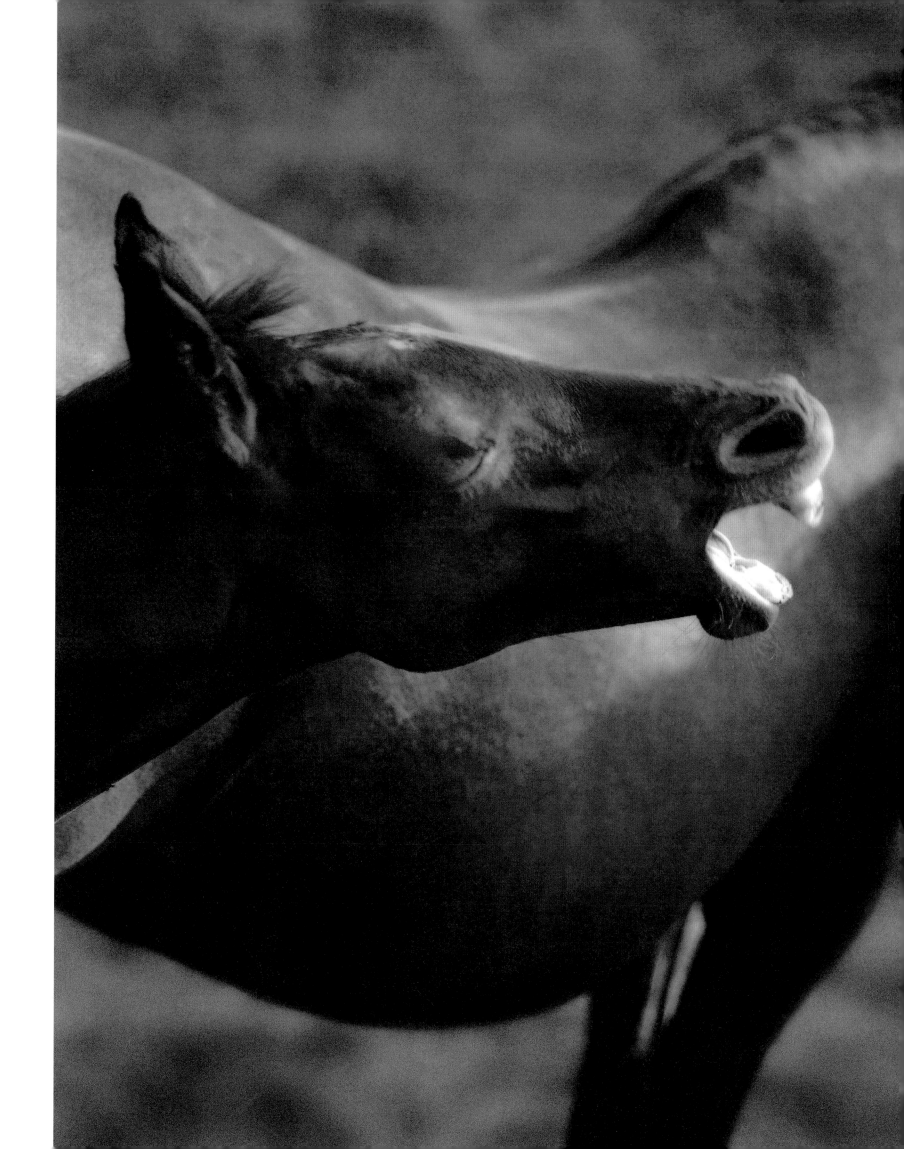

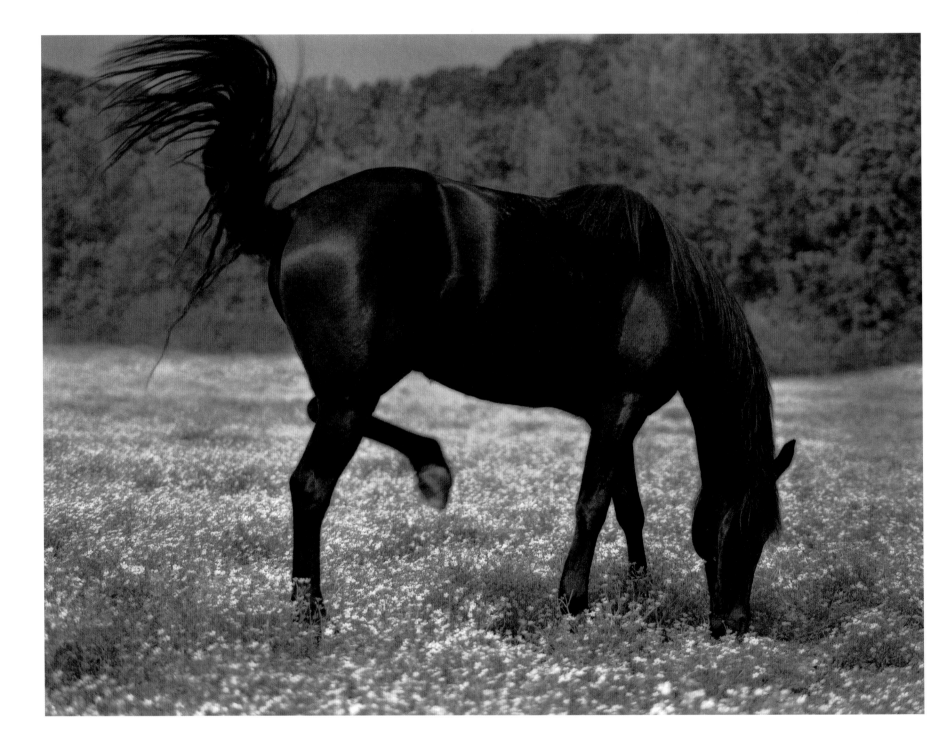

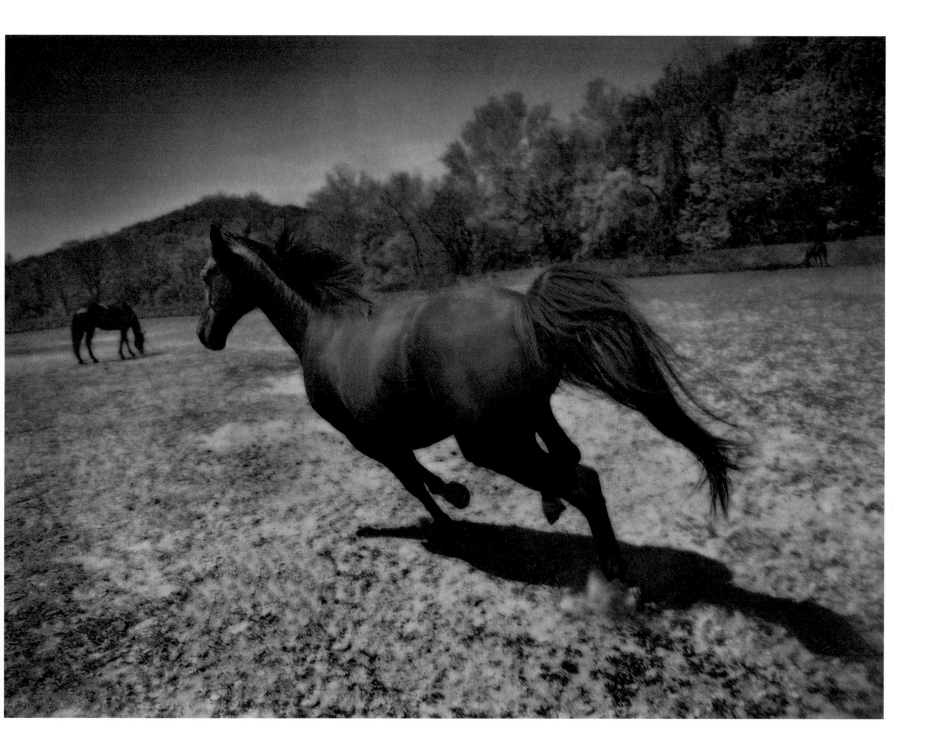

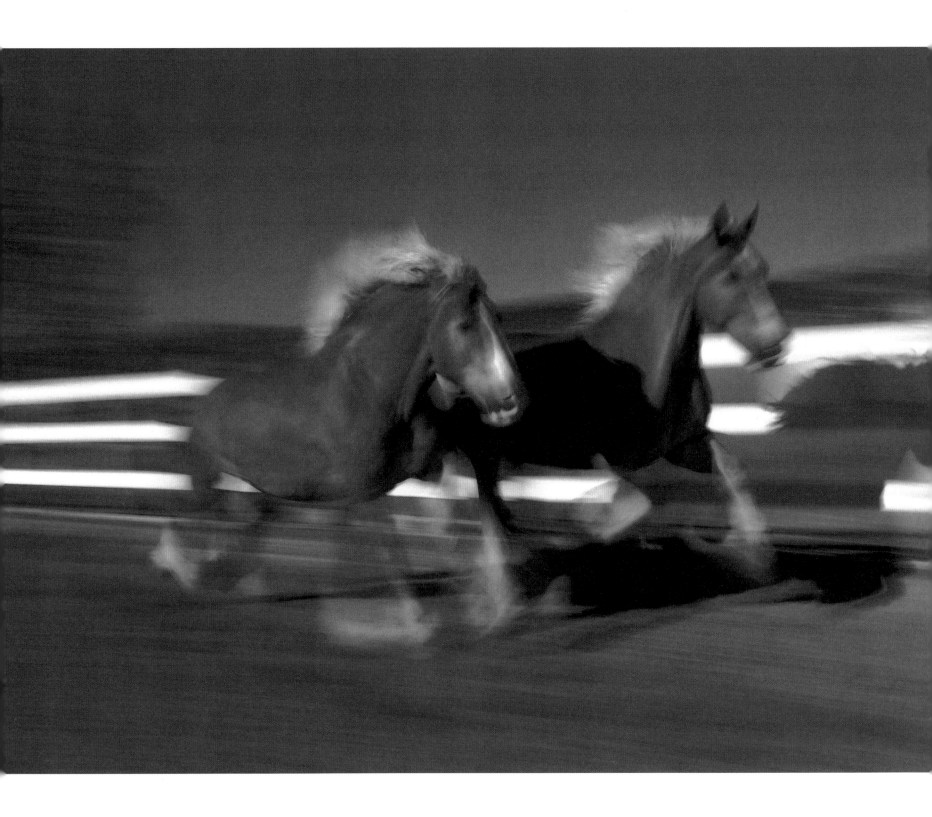

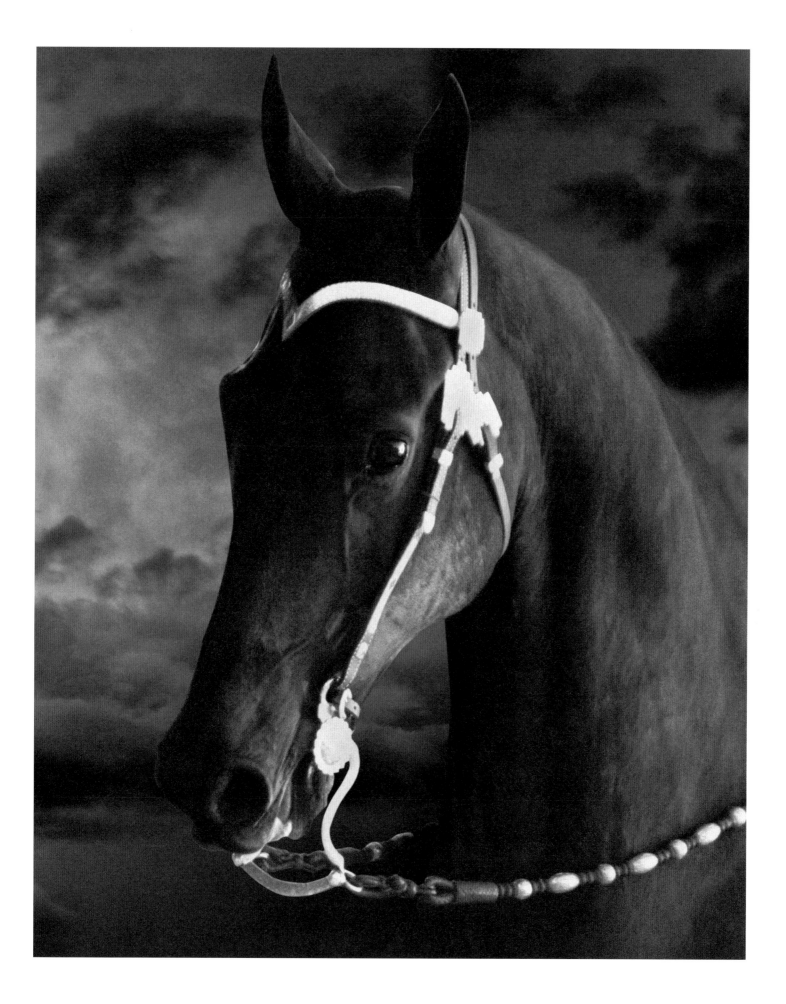

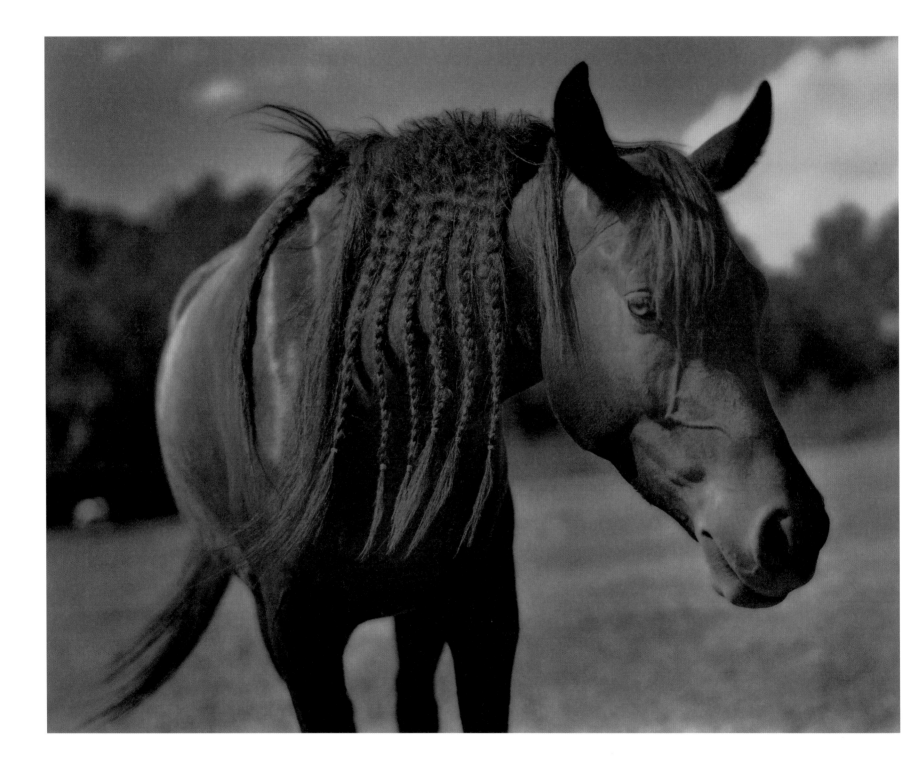

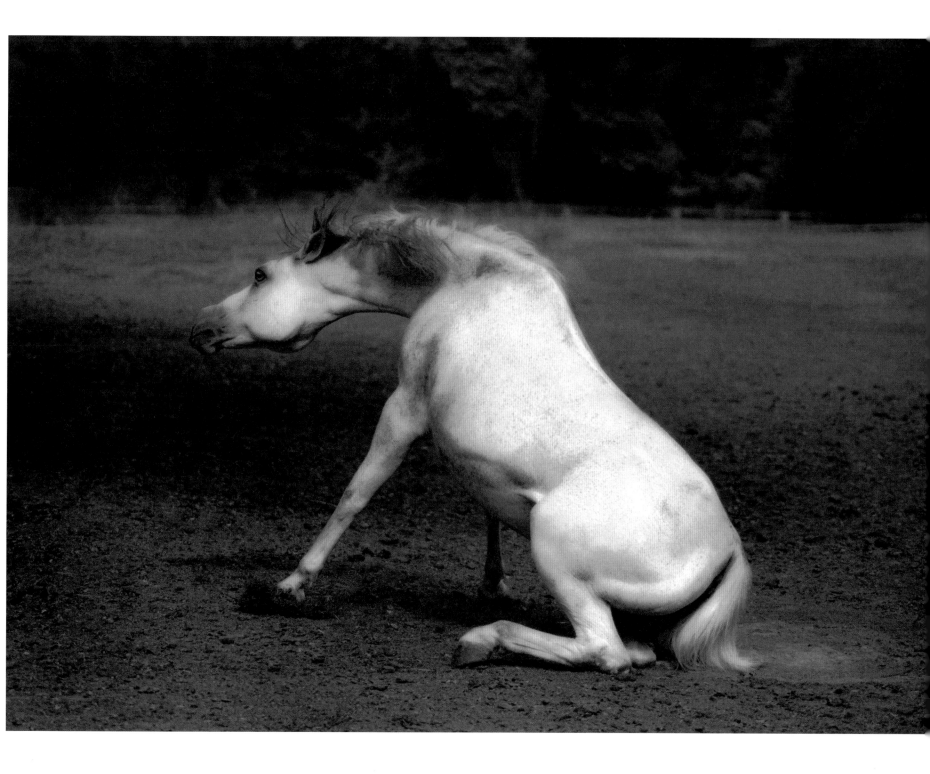

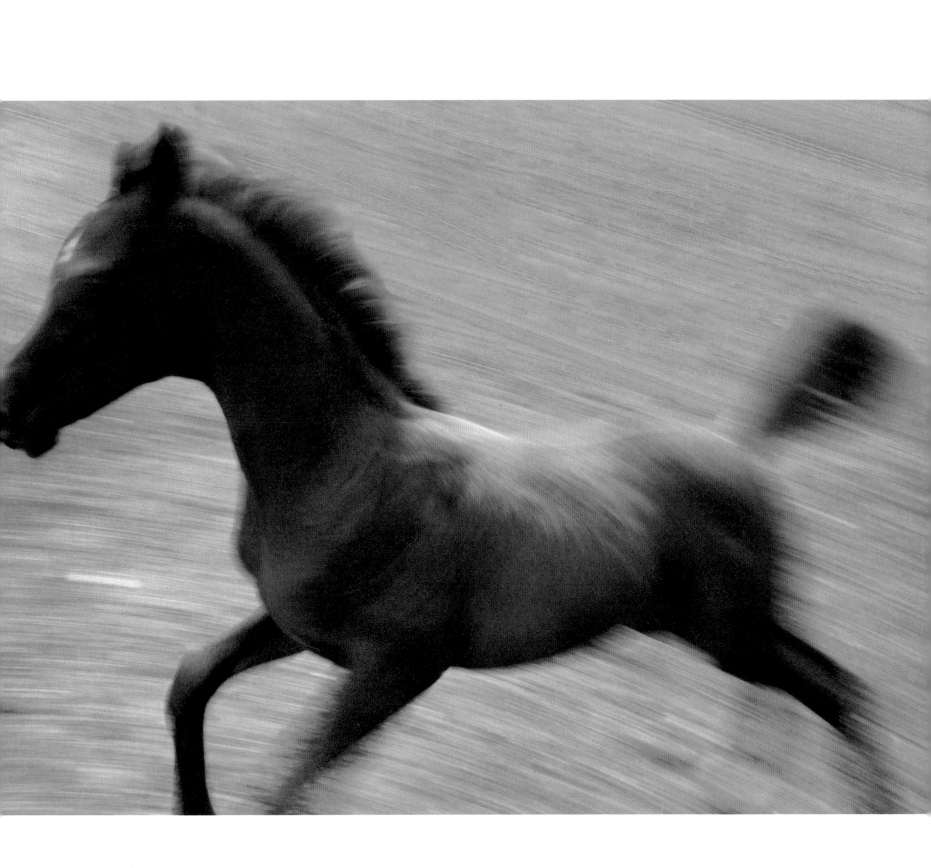

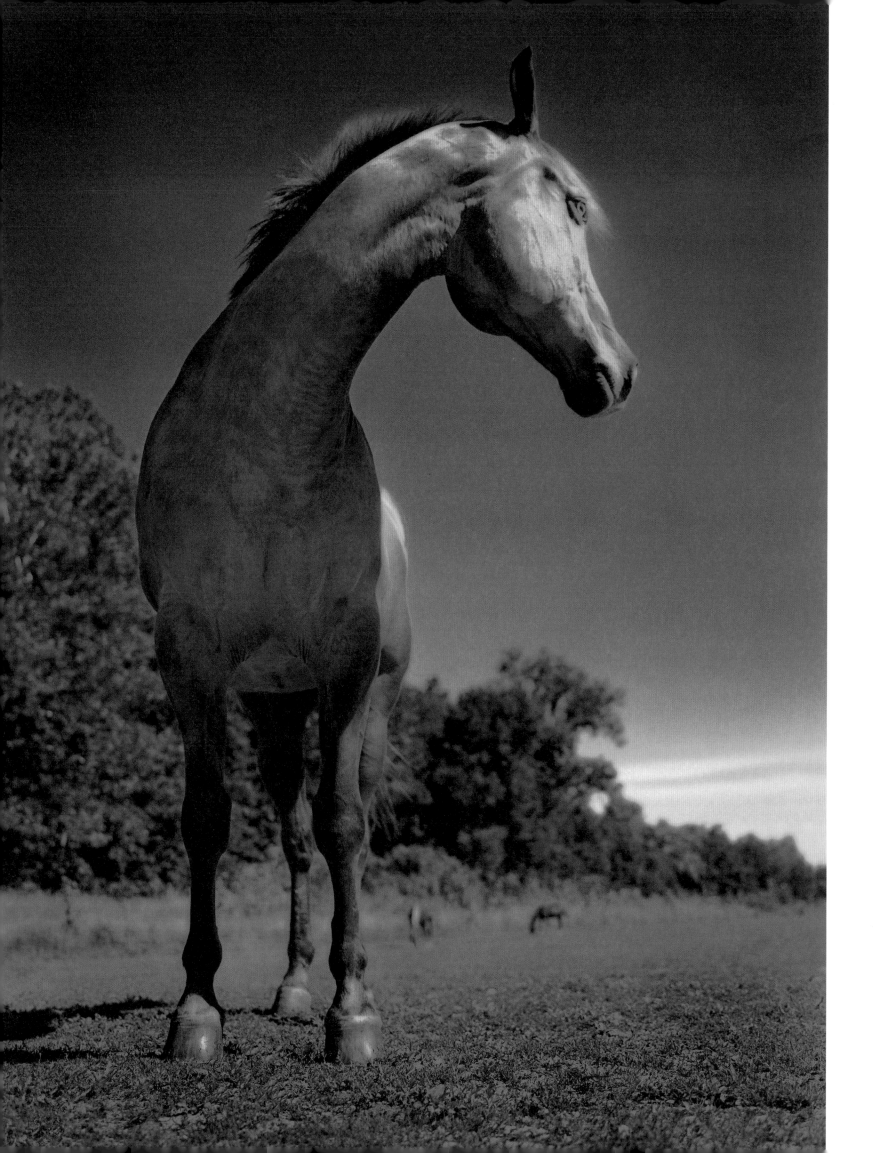

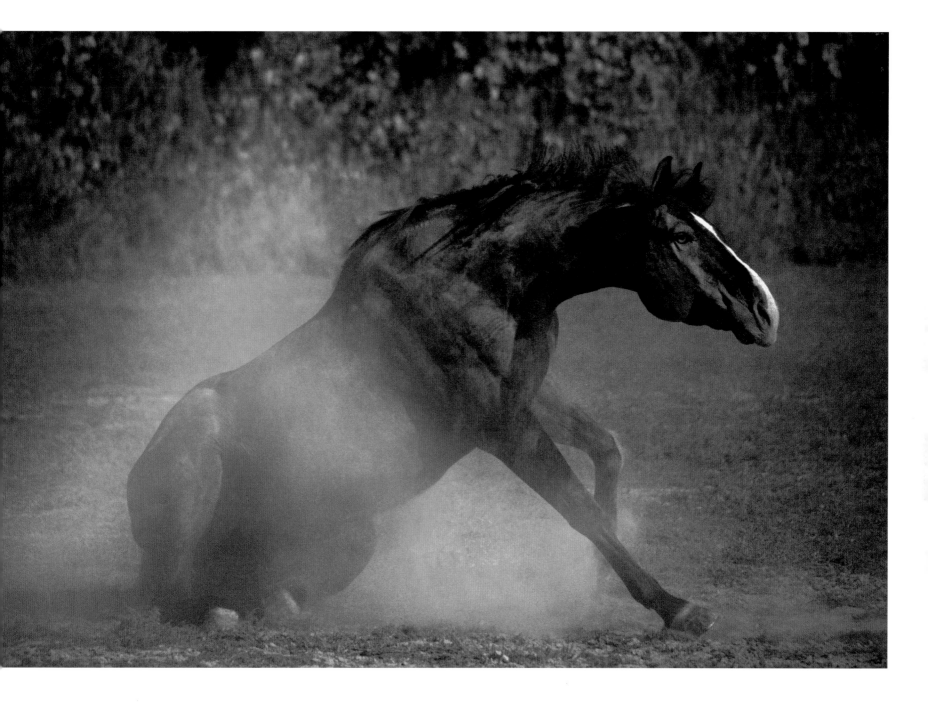

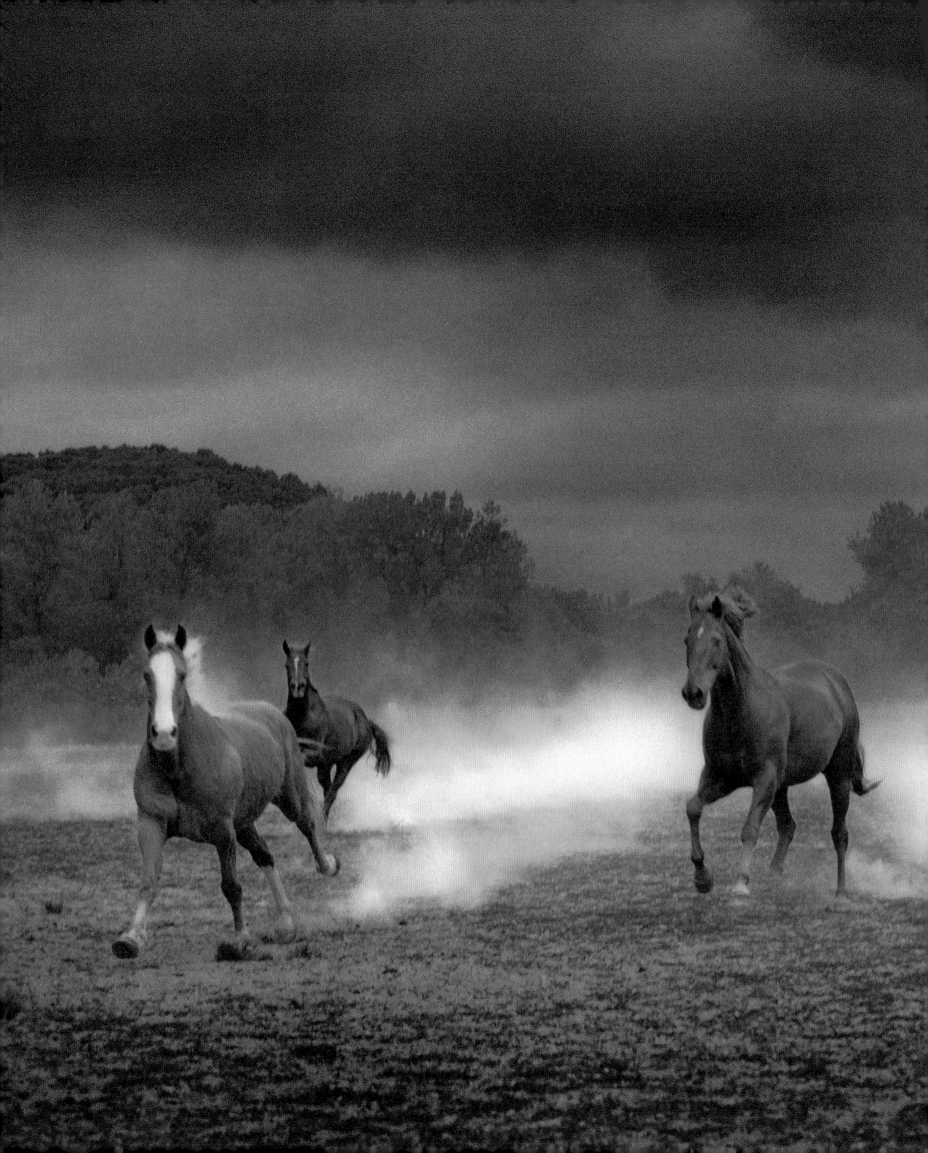

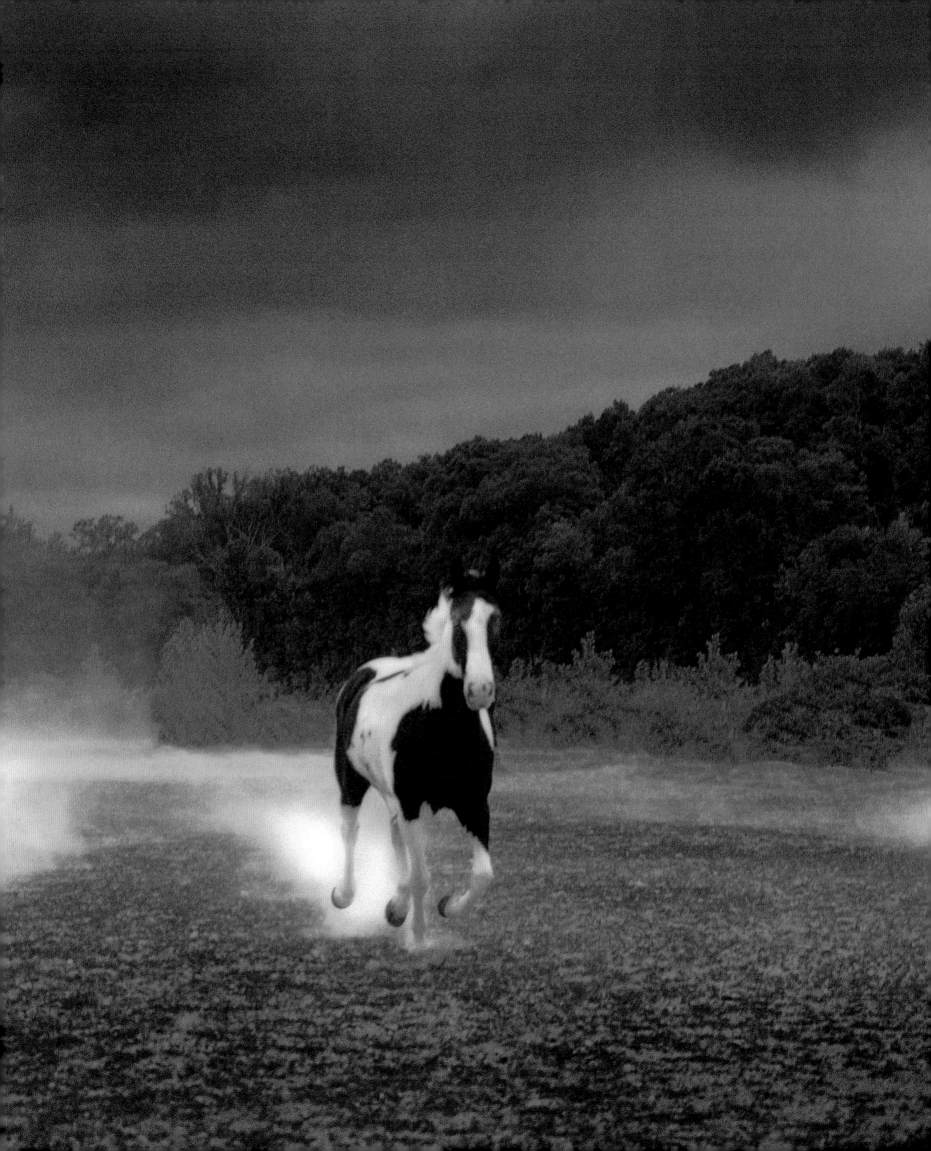

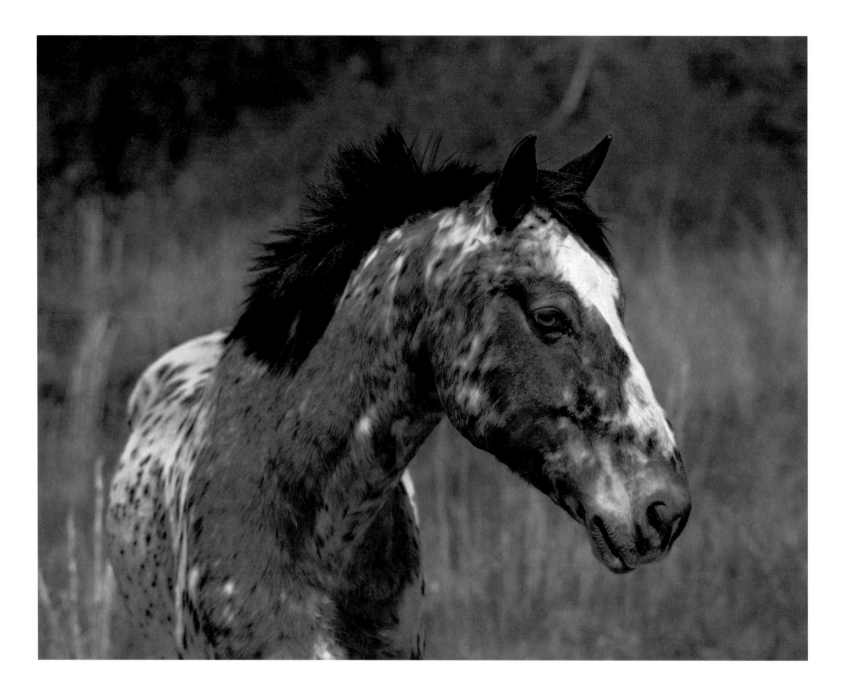

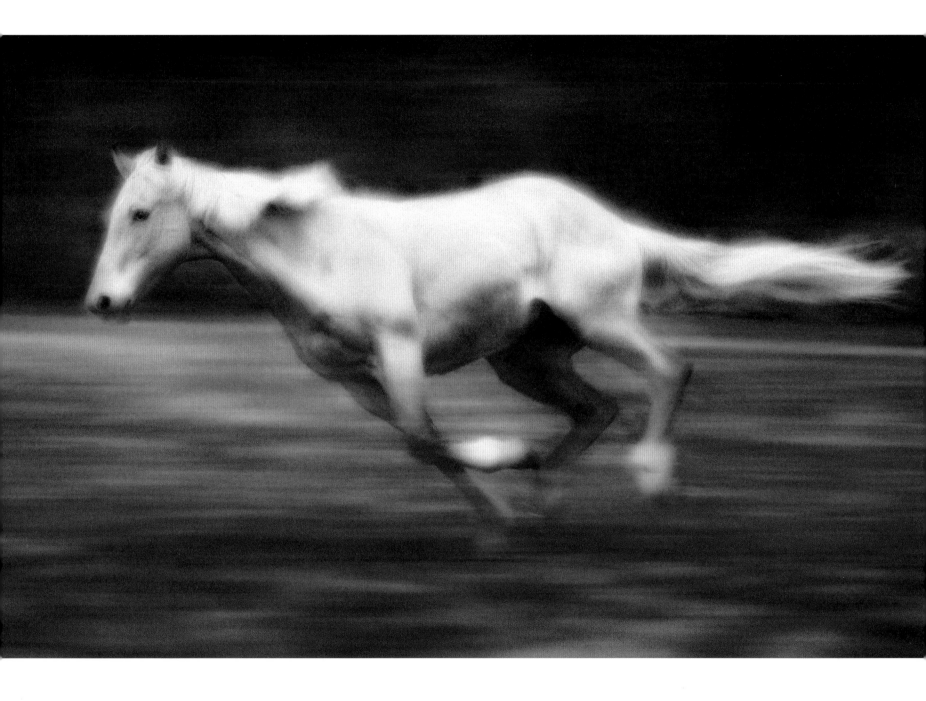

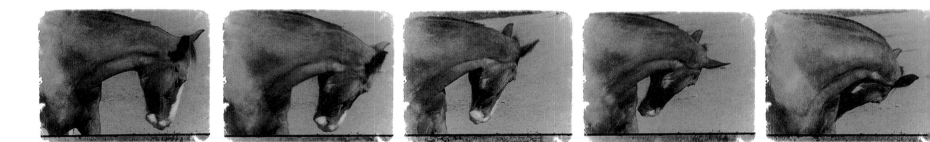

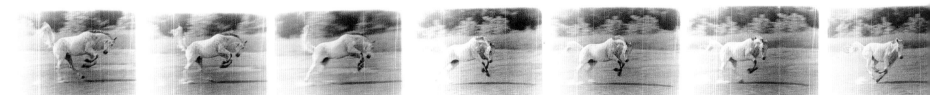

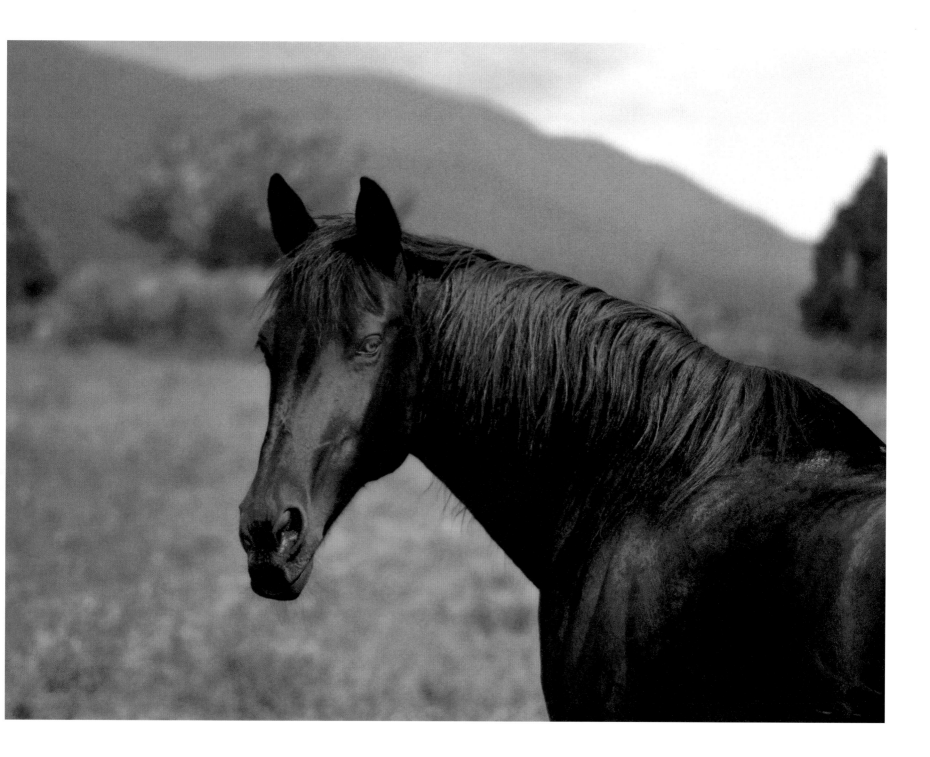

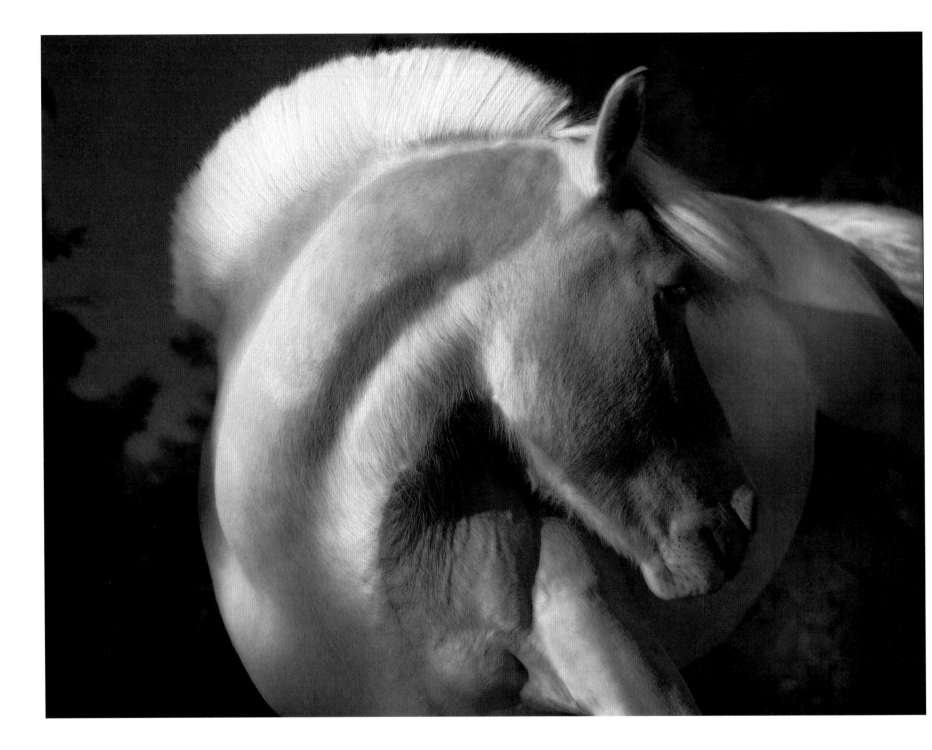

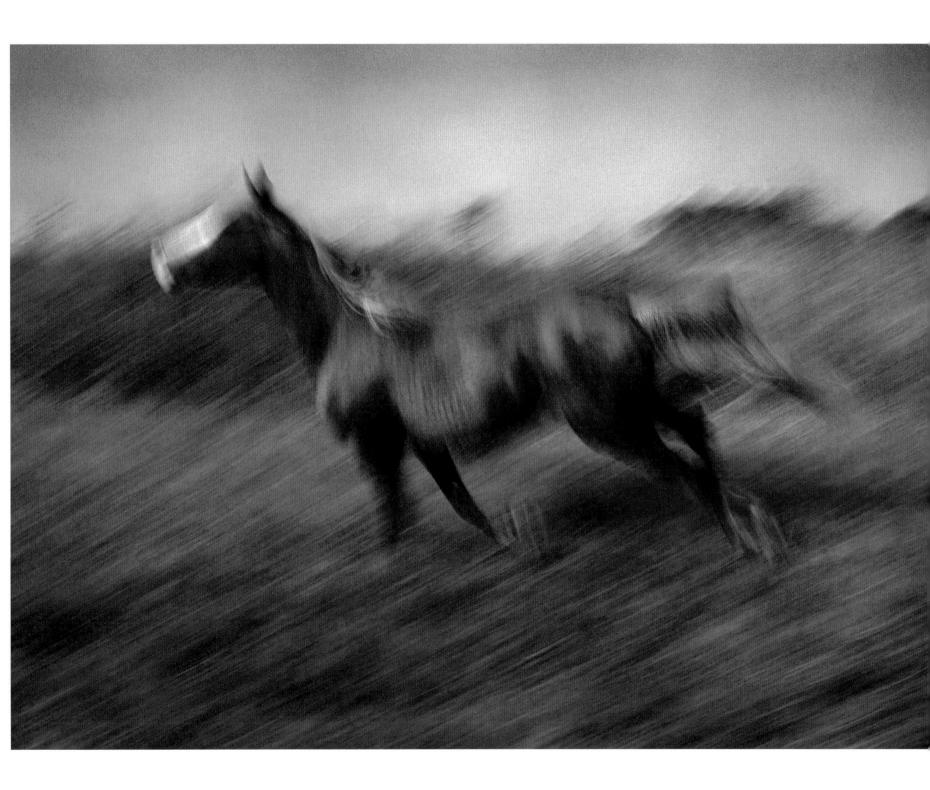

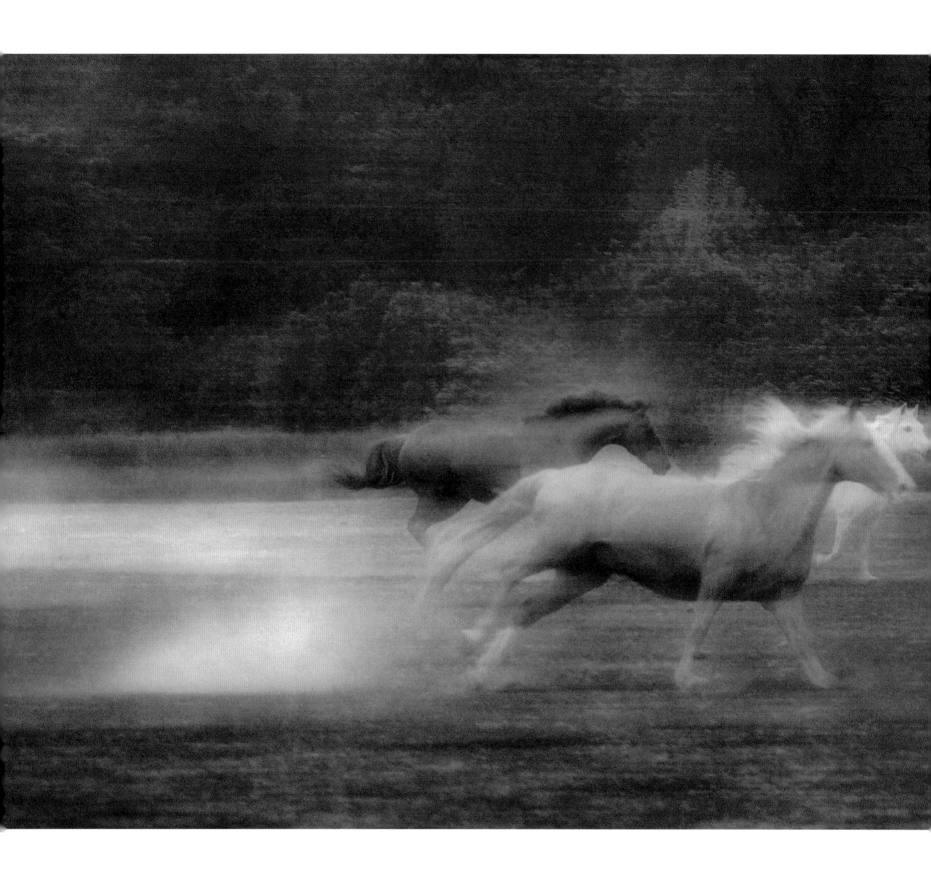

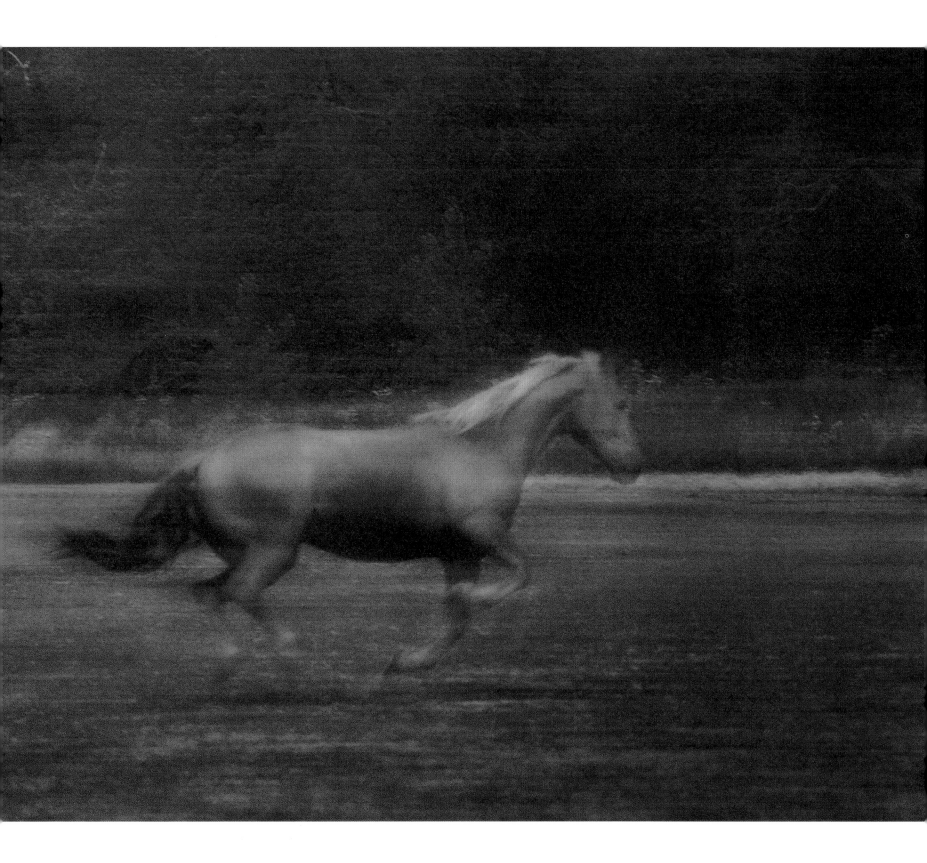

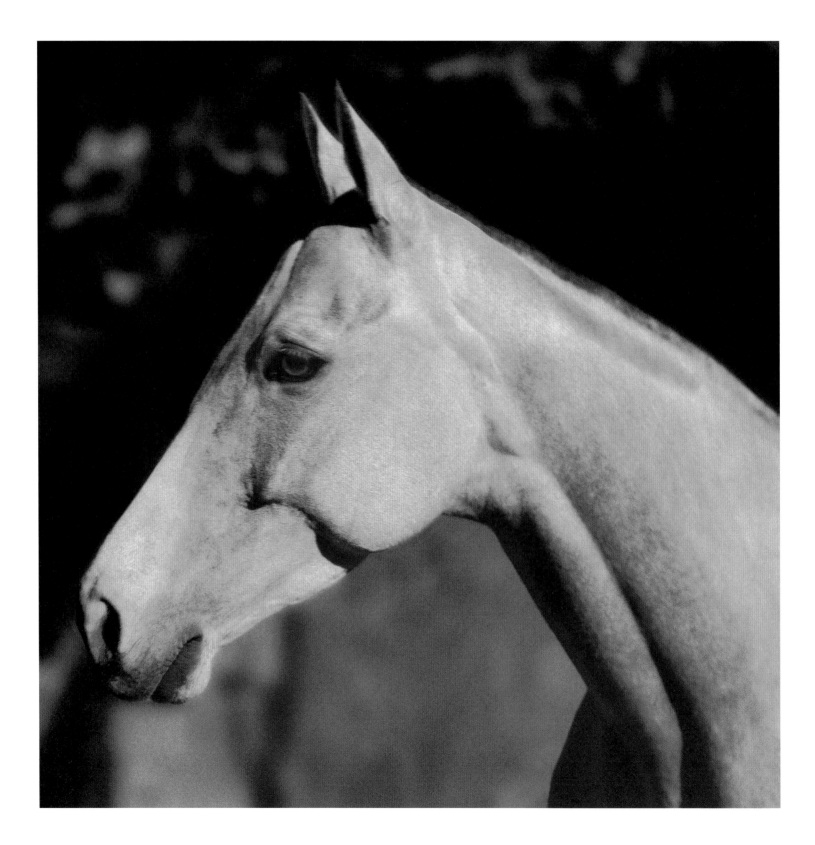

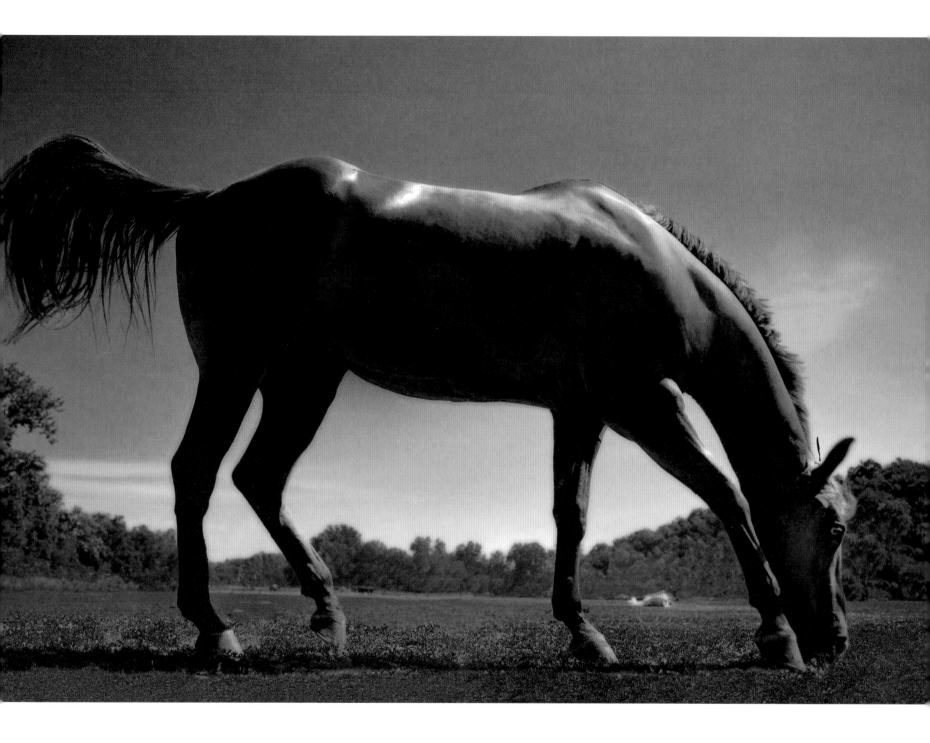

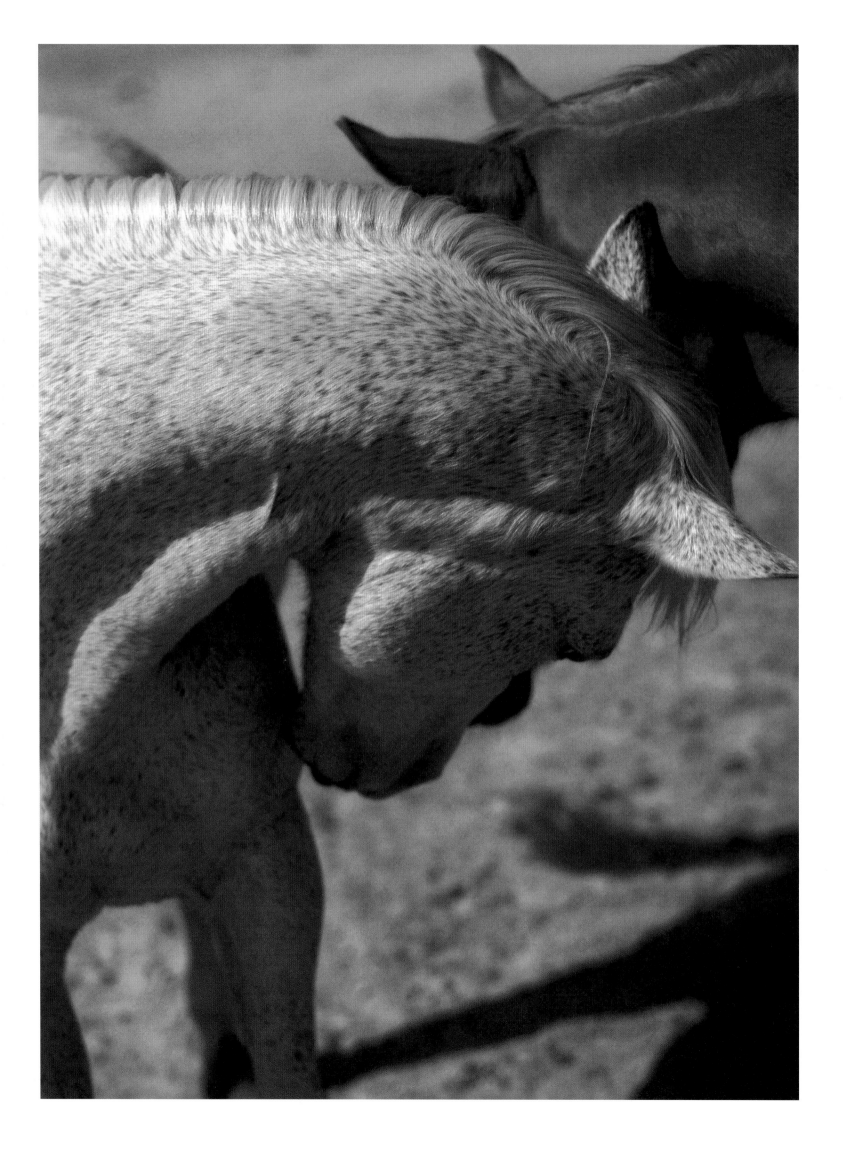

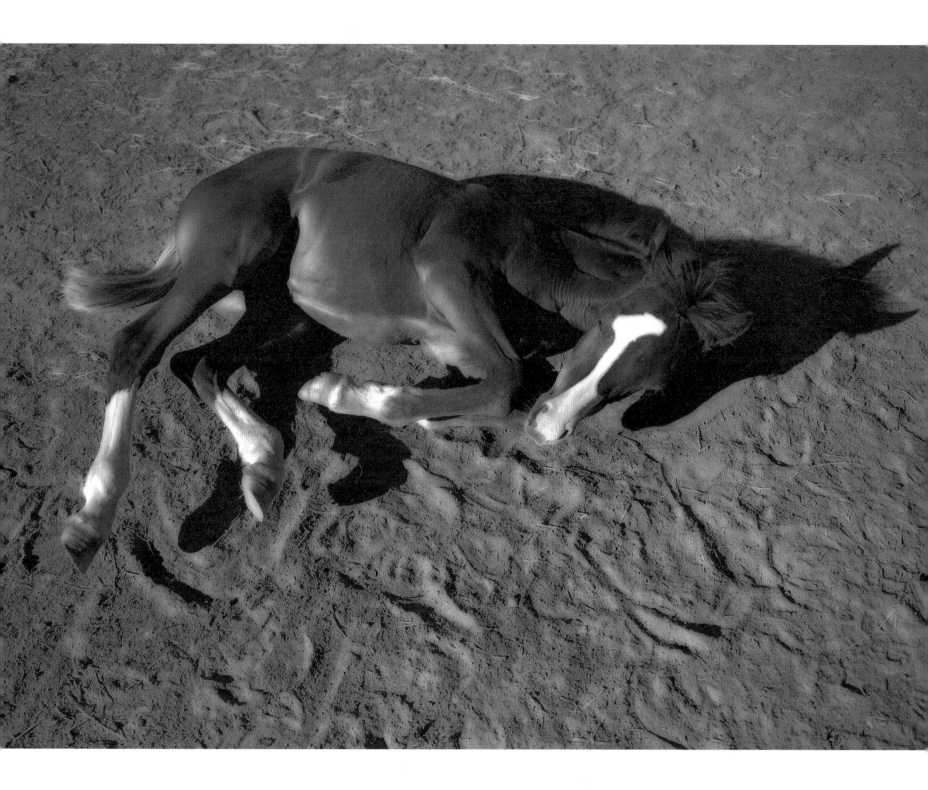

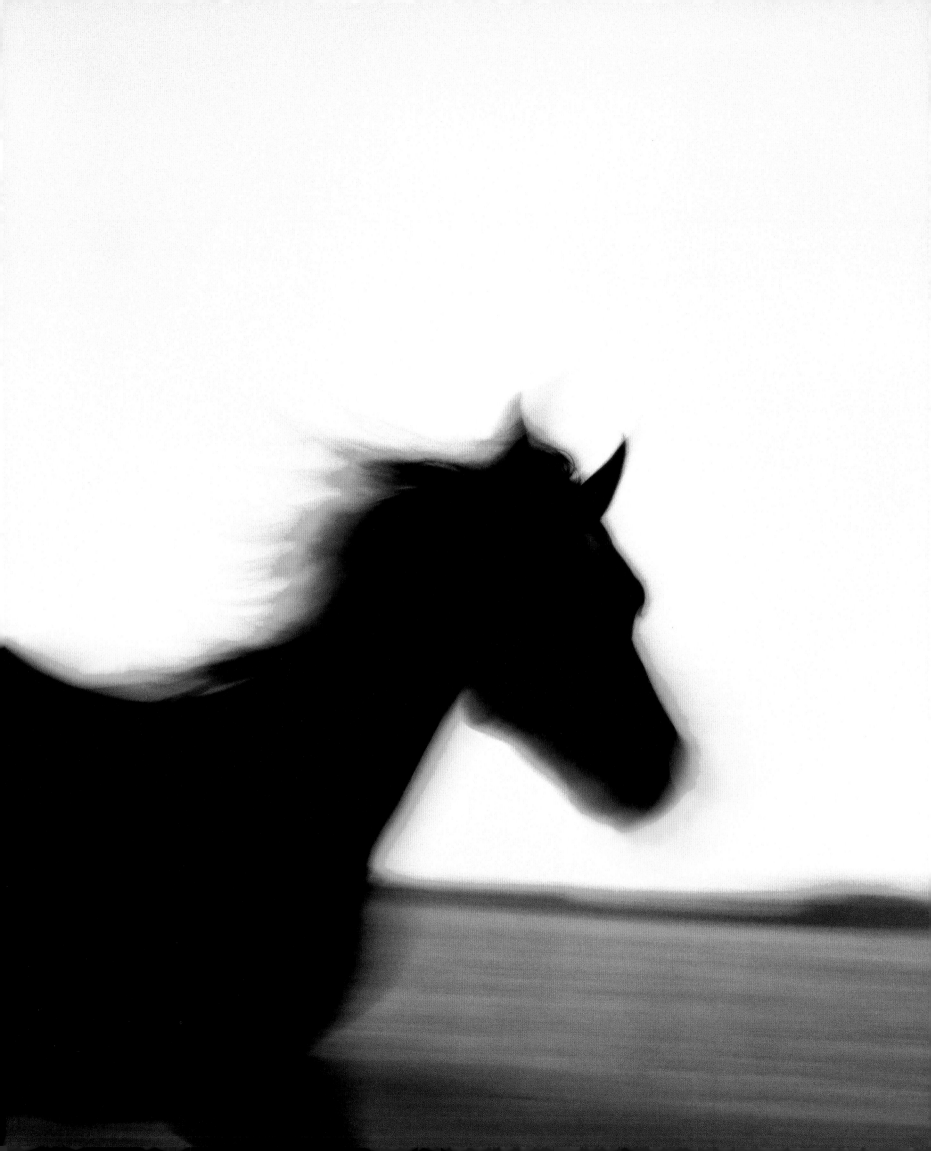

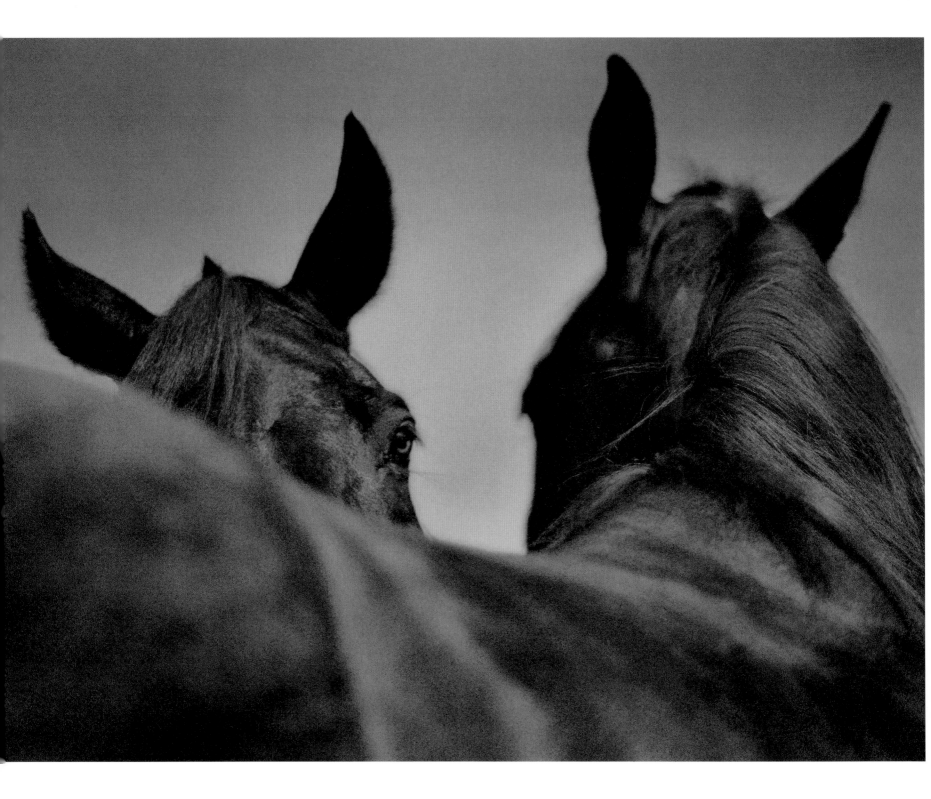

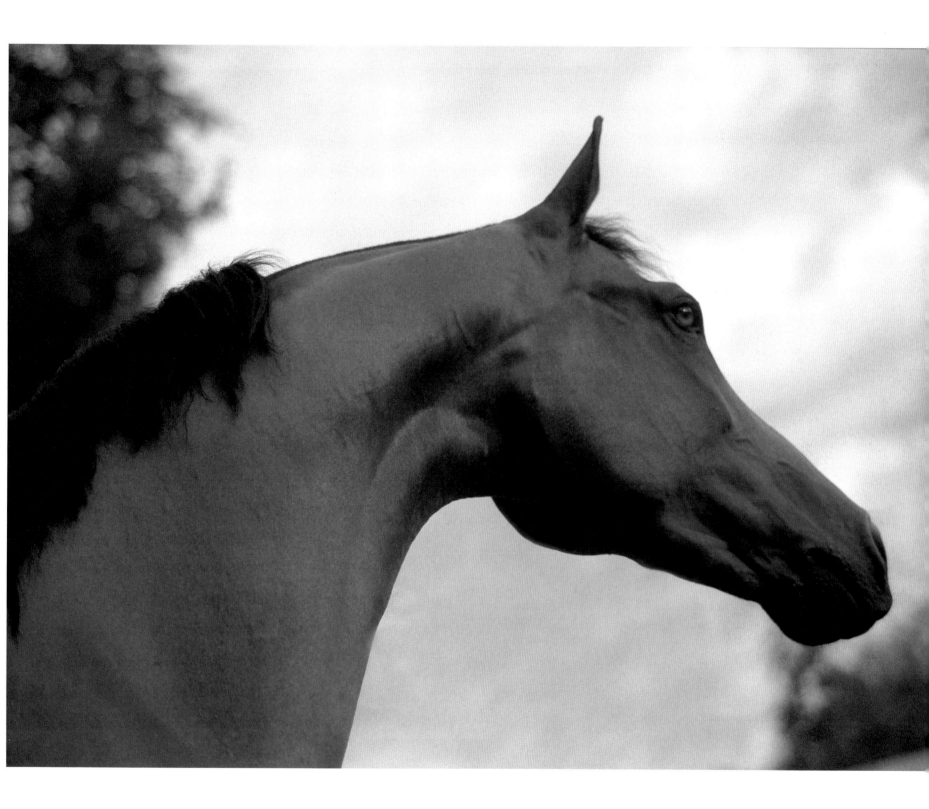

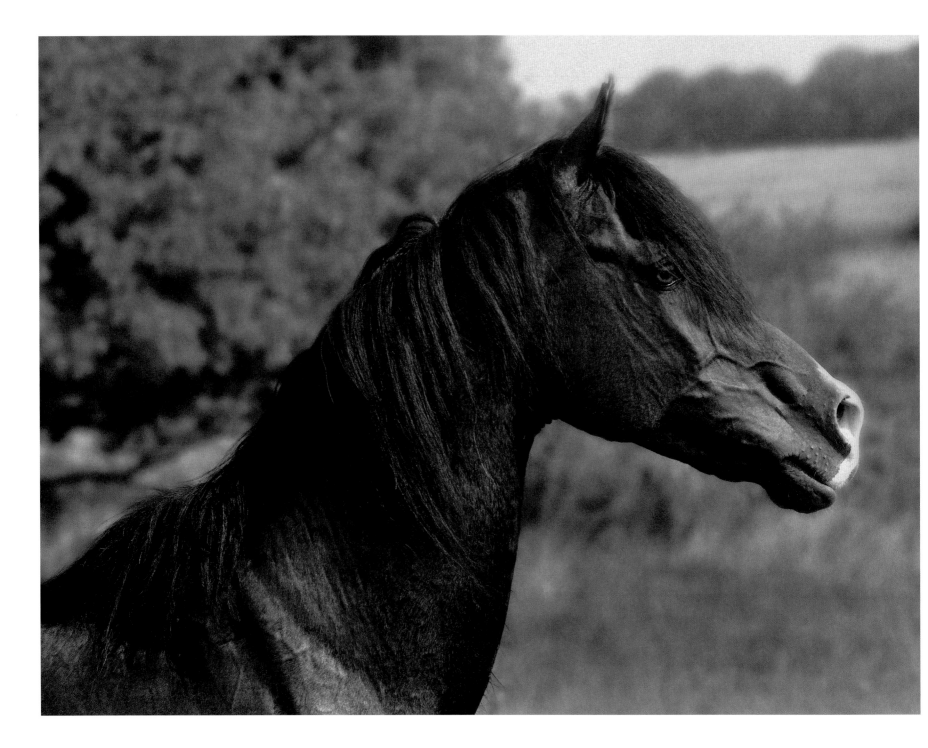

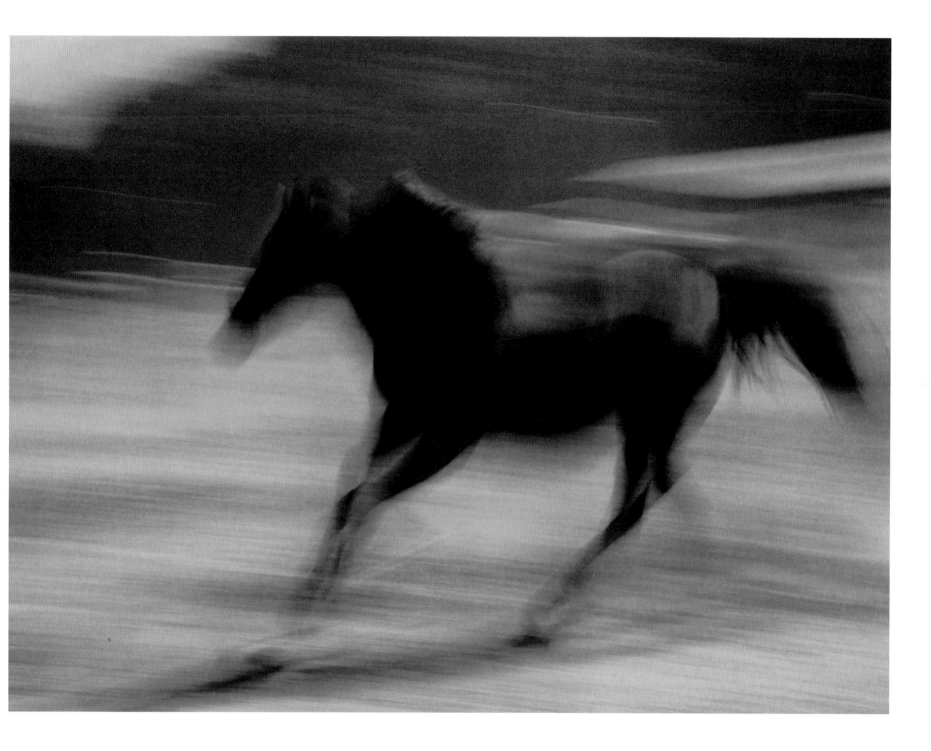

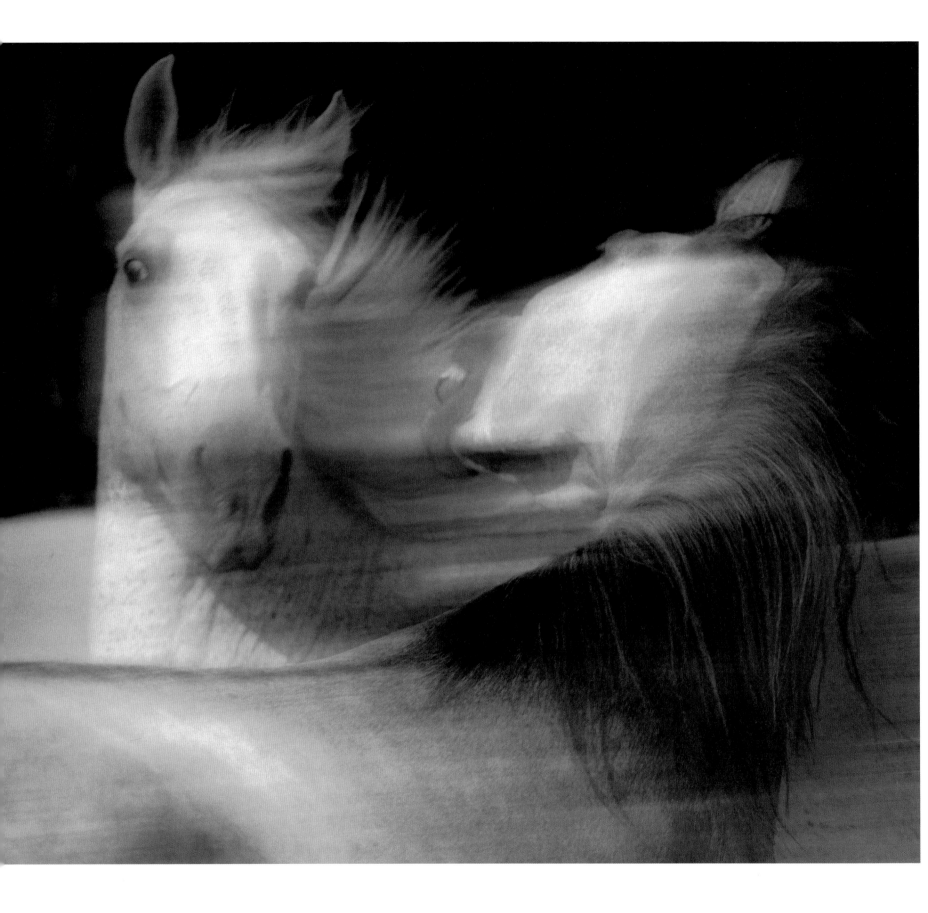

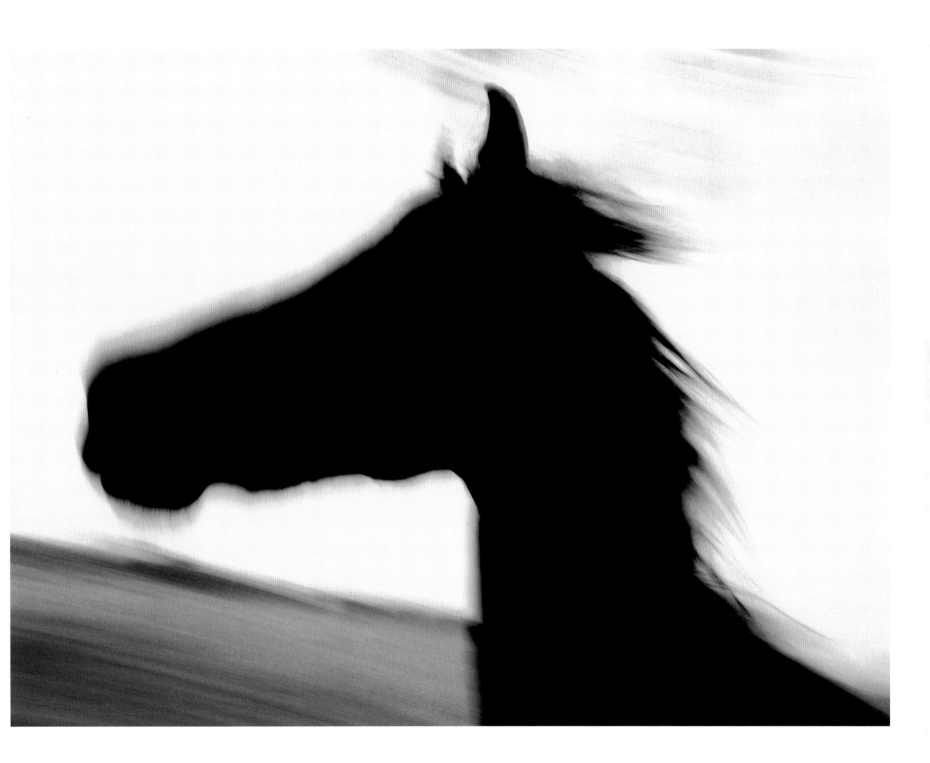

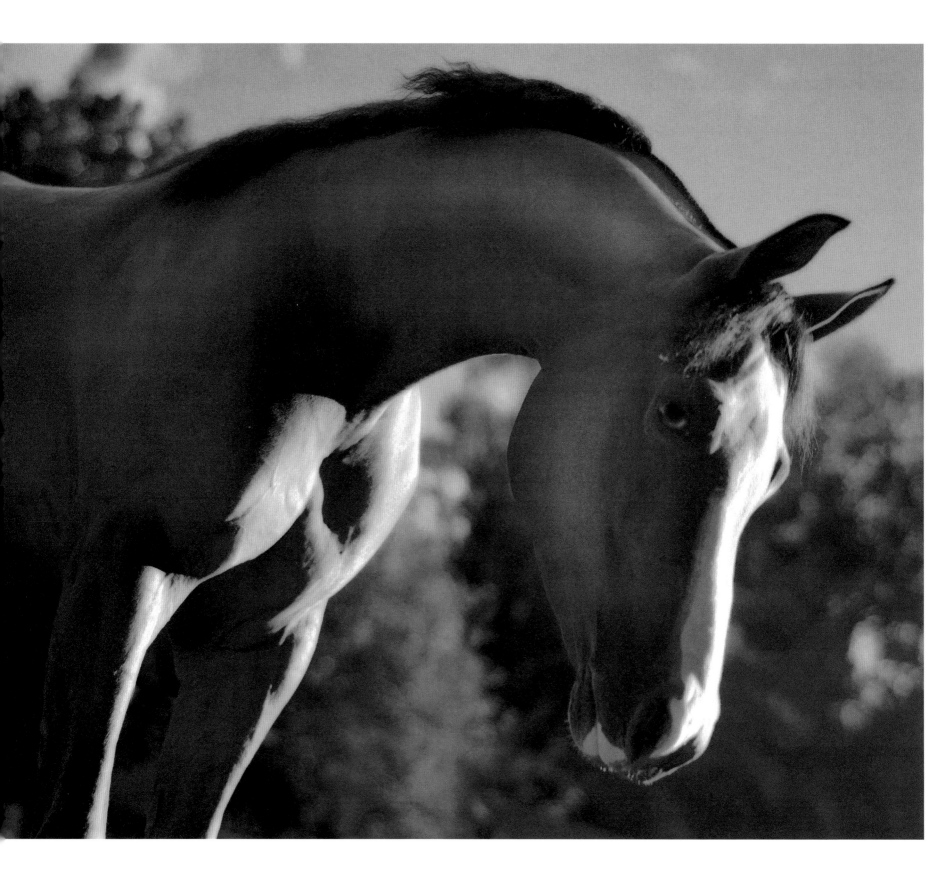

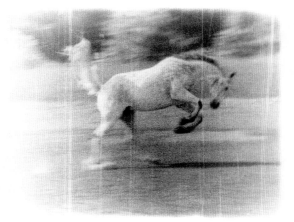
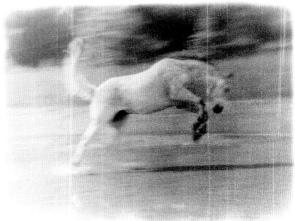

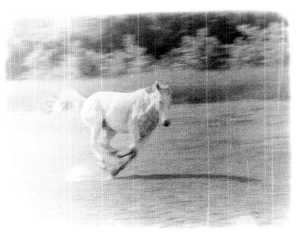
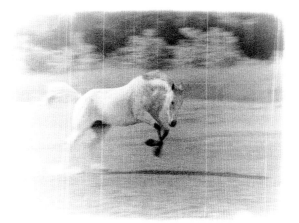
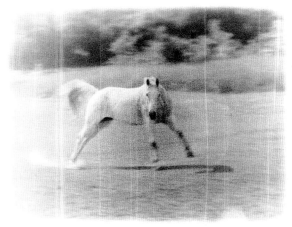

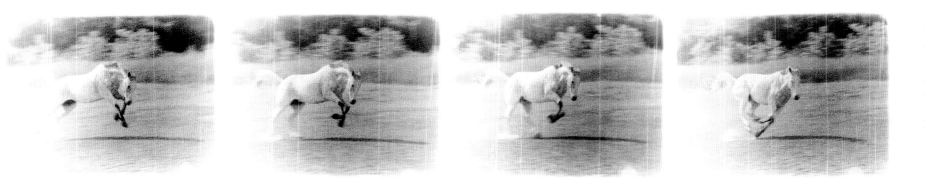

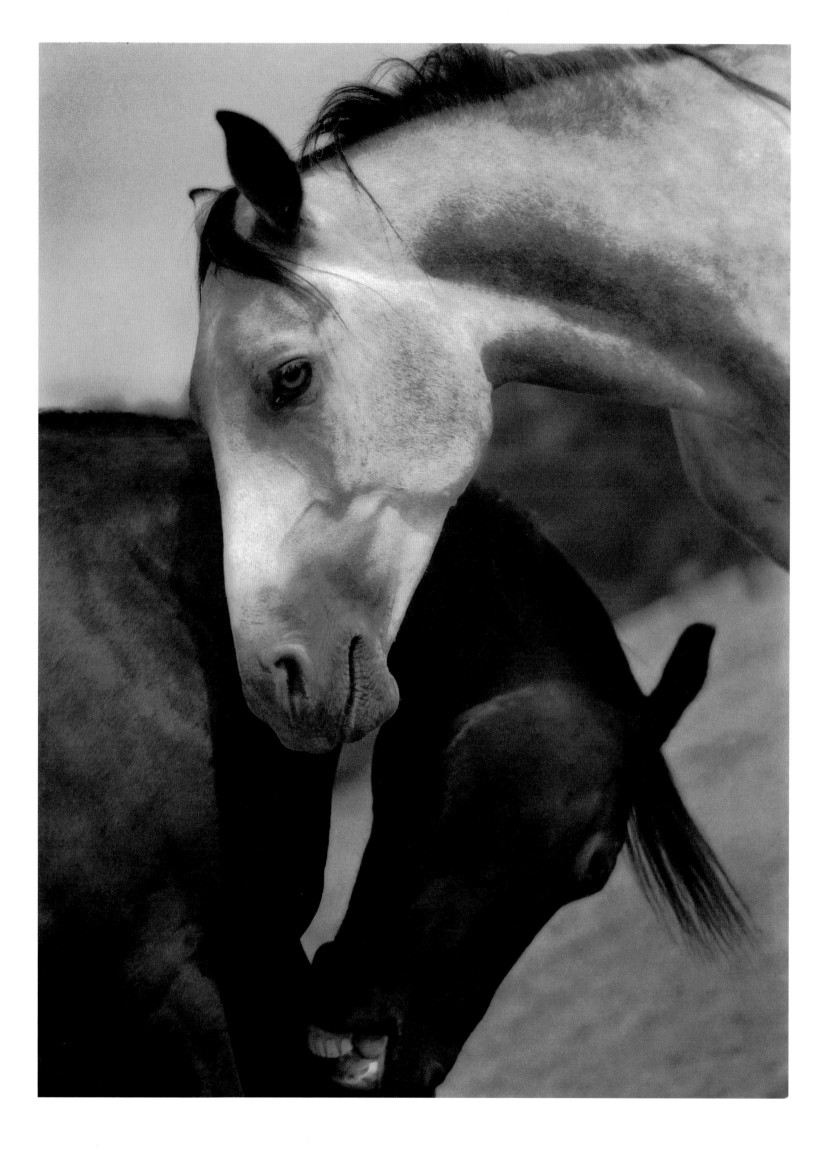

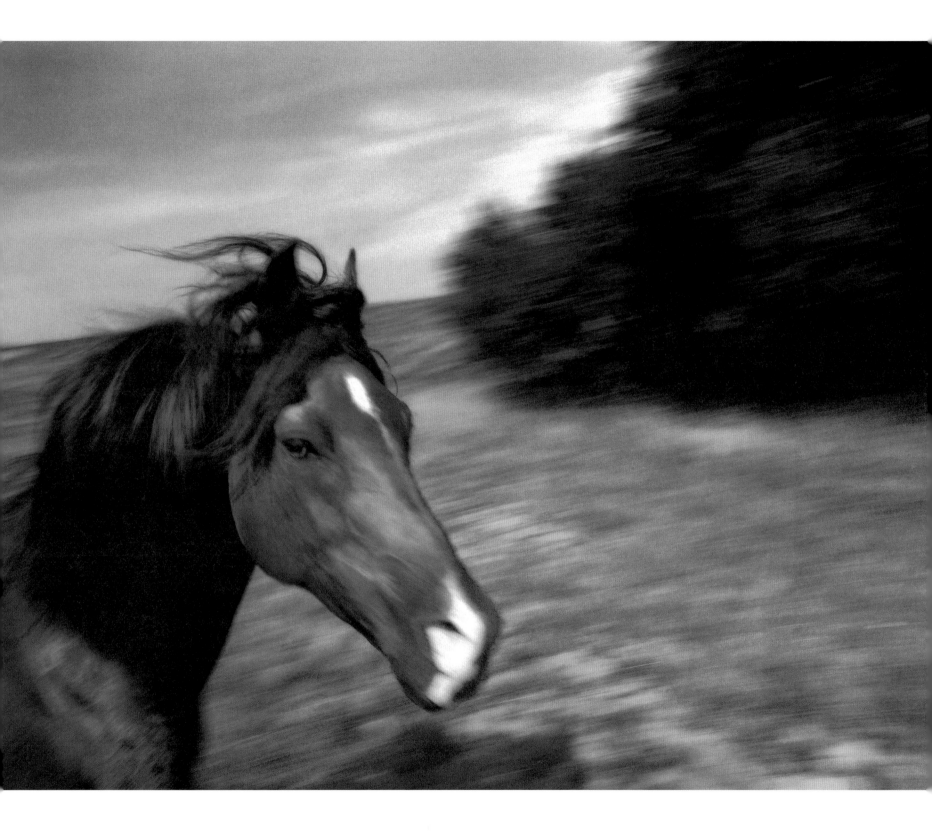

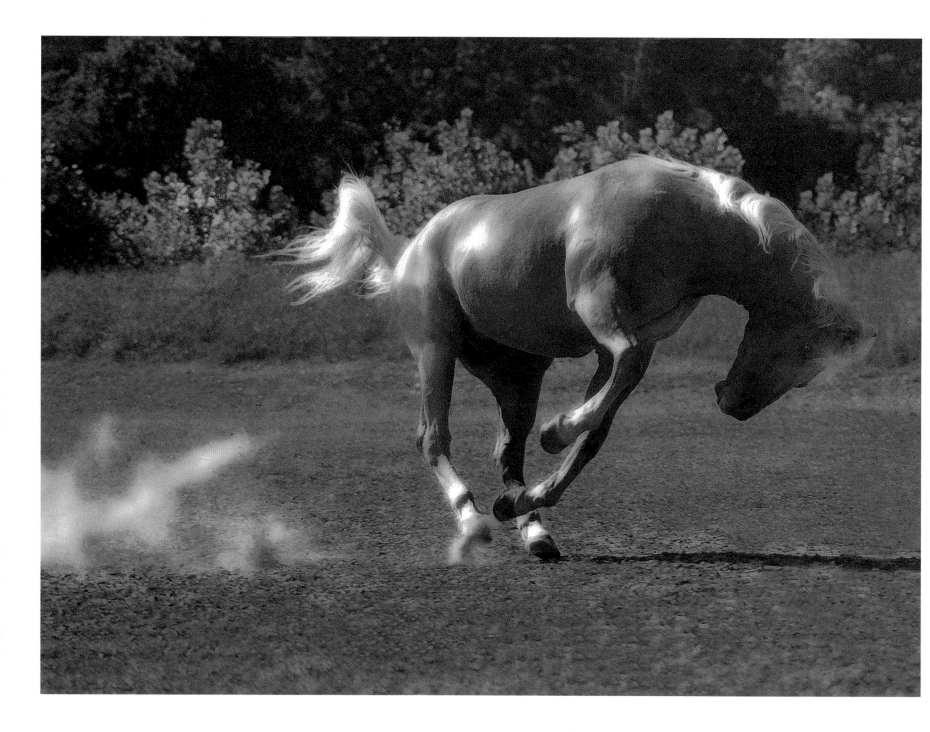

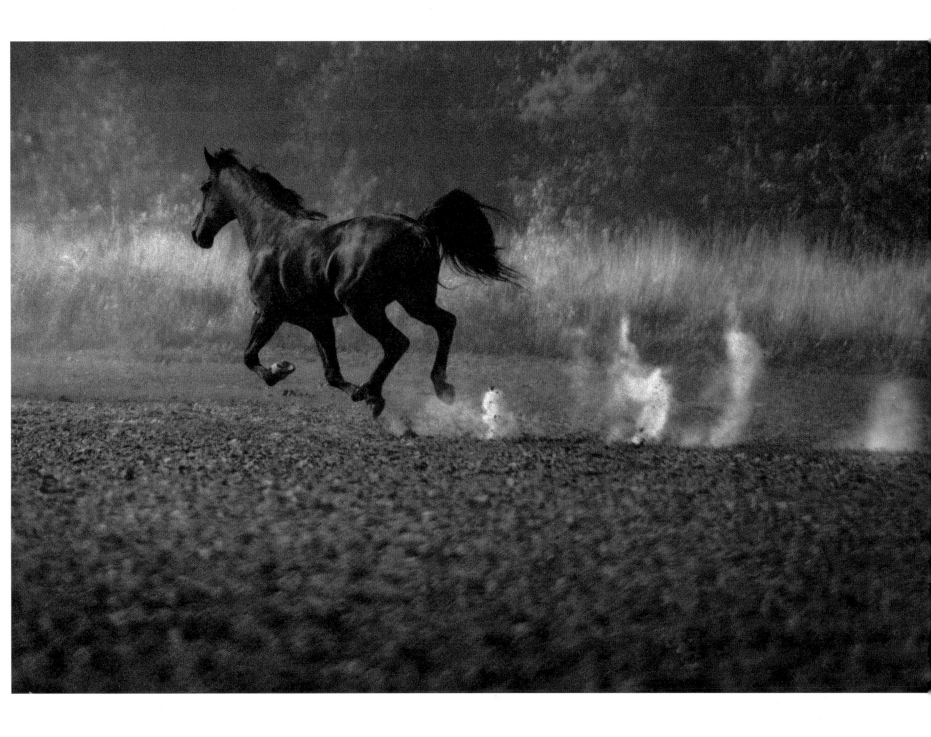

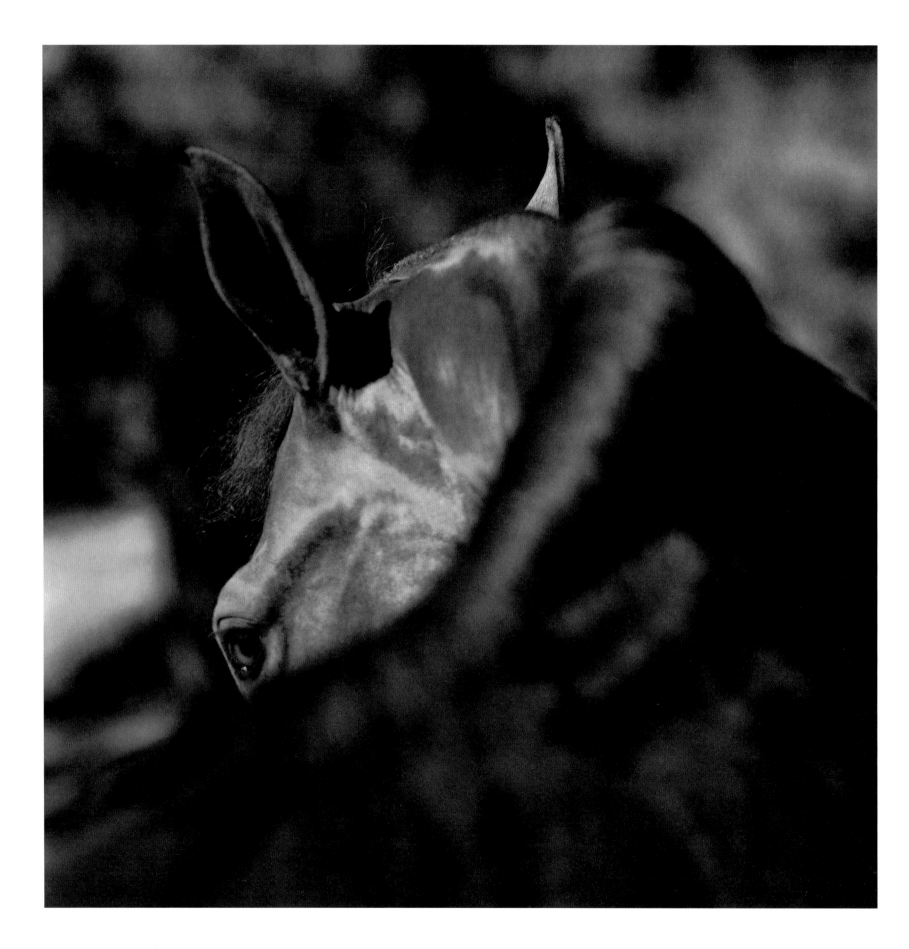

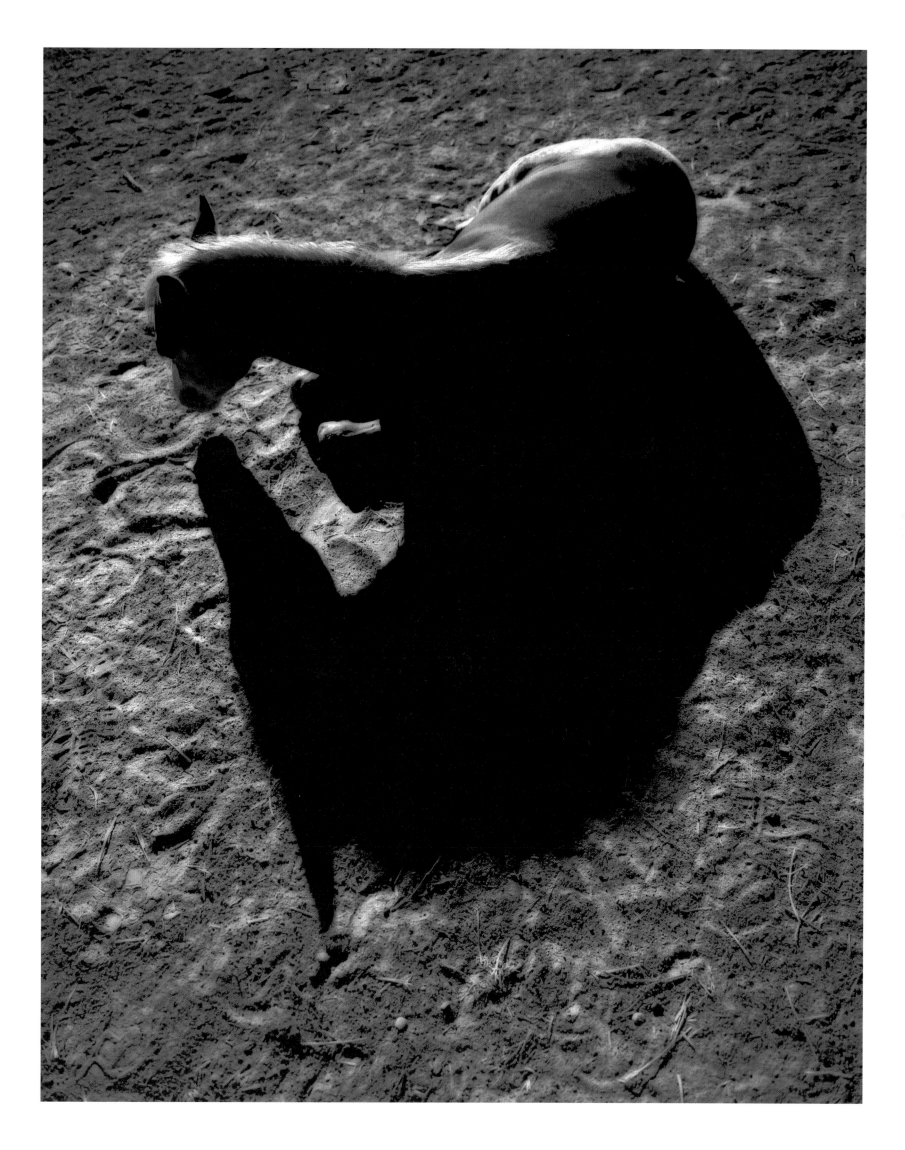

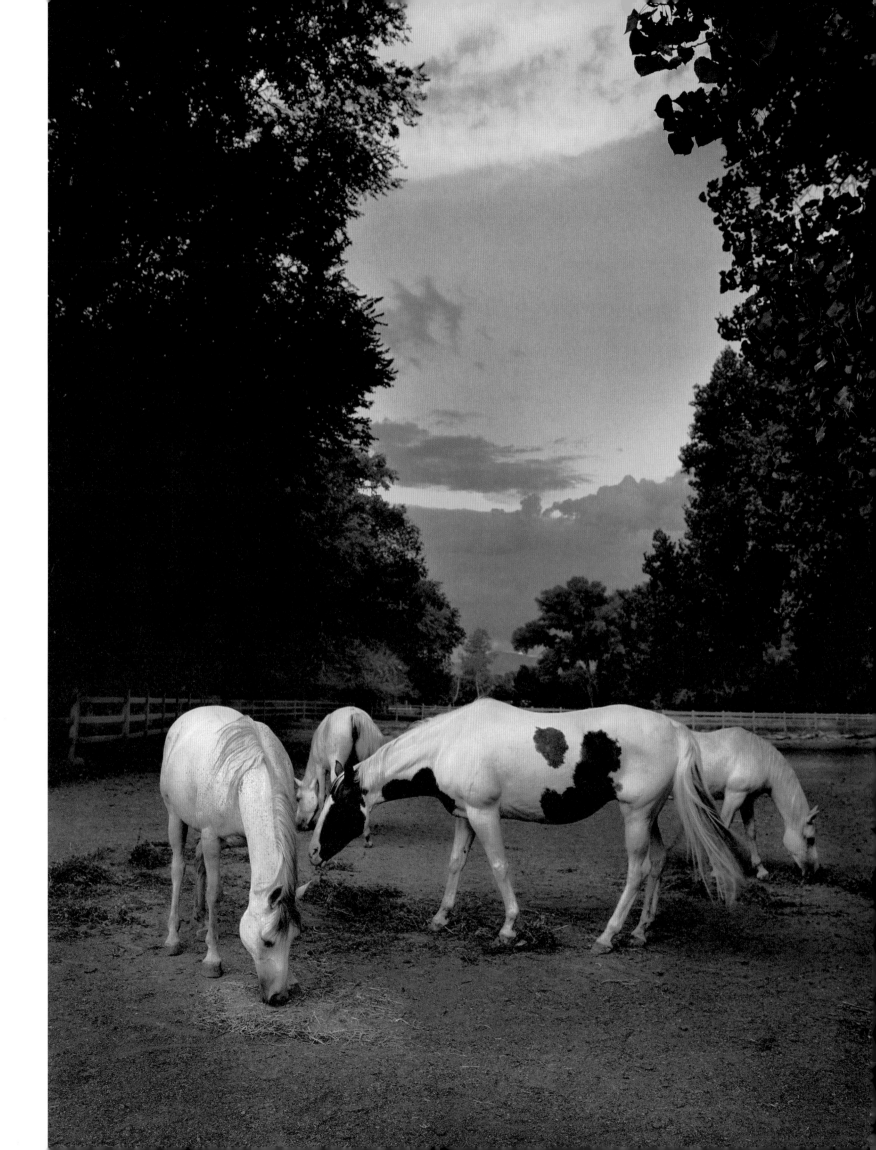

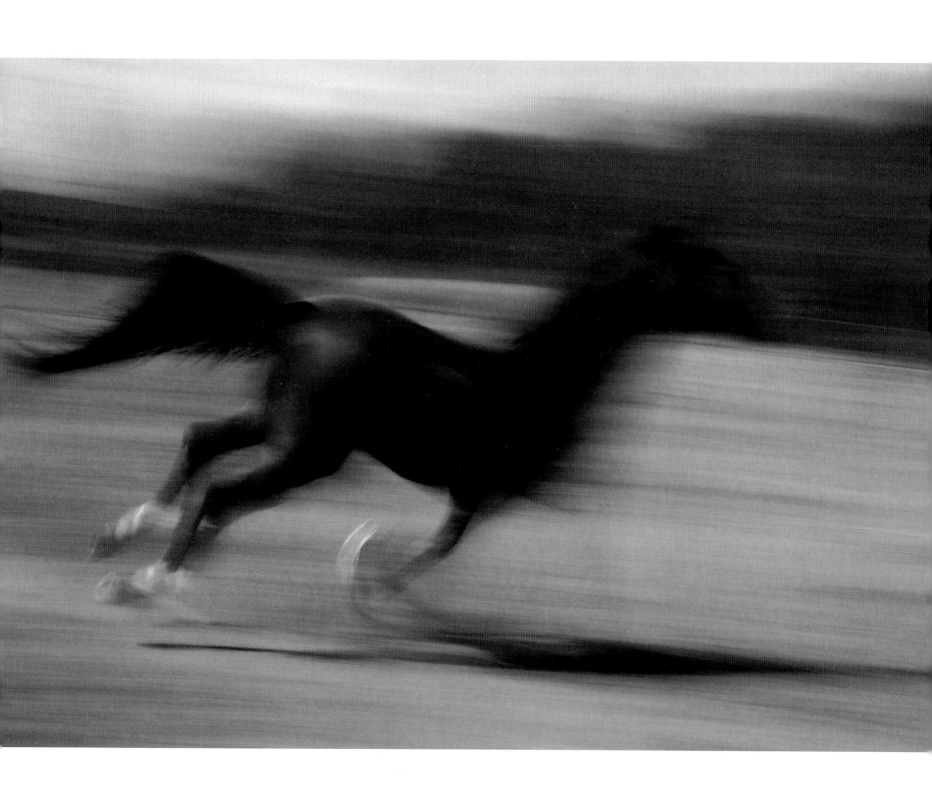

ACKNOWLEDGMENTS

Many people have helped to make this book a reality. My wife, Gayle, encouraged me from the very beginning of this project; her early belief in this work meant everything. Bill Gass greatly honors me with his wonderful words and his extraordinary friendship. I would like to thank Jane Smiley for her eloquent introduction, which expresses her deep love and understanding of horses. And I am indebted to Victoria Wilson, who championed this project from its onset; her support and enthusiasm never diminished.

There are others whose assistance was invaluable. They have opened their hearts, their homes, and their stables: Ron Bronitsky, Tuan Heidenreich, Julie Inghram, Steve Kodner, Jay Kraus, Tim Kraus, Allene Lapides, Robert Little, Catherine Milton, Penelope Whitman Mullinix, Jim Porcher, Milton C. Toby, and Tom Wobbe.

And to my dear friends whose support means everything to me; they have my deepest appreciation and gratitude: Andrea Berger, Allison Burgess, David Capes, Linda Freeman, Arthur Hochstein, John and Terri Mason, David Mesker, Dick and Sara Rochester, John Rochester and Larry Fodor, and Mark and Monique Rochester.

And to my family, who was there long before the horses appeared in my life. Thank you for your understanding, your patience, and your love: Eva Eastman and Eric Vigando and Lilla Bartko. And to my parents, Leonard and Marion Eastman, who provided such wonderful opportunities.

And to a golden horse named Mike who led the way on a late afternoon in June 1998 in Taos, New Mexico.

A NOTE ON THE TYPE

This book was set in Bodoni, a typeface named after Giambattista Bodoni (1740–1813), the celebrated printer and type designer of Parma. While the early modern revivals were designed not as faithful reproductions of any one of the Bodoni fonts but rather as a composite of the Bodoni manner, recent versions have shown more of the idiosyncracies of the originals. The Bodoni used in this book was adapted by the German graphic artist Gert Wiescher in 1994–95.

Printed and bound by Conti Tipocolor, Florence, Italy

Designed by Peter A. Andersen